D1479437

VIEWS OF ROME

THEN AND NOW

41 ETCHINGS BY

Giovanni Battista Piranesi

CORRESPONDING
PHOTOGRAPHS AND TEXT BY
Herschel Levit

DOVER PUBLICATIONS, INC., NEW YORK

Published in Canada by General Publishing Company, Ltd., 30 Lesmill Road, Don Mills, Toronto, Ontario.
Published in the United Kingdom by Constable and Company, Ltd., 10 Orange Street, London WC 2.

Views of Rome Then and Now is a new work, first published by Dover Publications, Inc., in 1976.

International Standard Book Number: 0-486-23339-1
Library of Congress Catalog Card Number: 76-3237

Manufactured in the United States of America
Dover Publications, Inc.
180 Varick Street
New York, N.Y. 10014

BIBLIOGRAPHIC NOTE

The collections in which the Piranesi etchings were published for the very first time are indicated in the Introduction and in the Notes. Here we list the specific publications from which we have reproduced the impressions that appear in this volume:

Le Antichità Romane di Giamb. Piranesi, Archit. Venez.; Tomo Terzo Contenente gli Avanzi de' Monumenti Sepolcrali di Roma e dell'Agro Romano, n.d.: Plate 9.

Le Antichità Romane di Giambatista Piranesi, Architetto Veneziano; Tomo Quarto Contenente i Ponti Antichi gli Avanzi de' Teatri, de' Portici e di Altri Monumenti di Roma, n.d.: Plates 4 and 18.

Opere Varie di Architettura, Prospettive, Groteschi, Antichitá sul Gusto degli Antichi Romani Inventate, ed Incise da Gio. Battista Piranesi, Architetto Veneziano, Rome, 1799: Plates 7, 11, 15, 16 and 26 (Plate 15 is in a section titled *Trofei di Ottaviano Augusto Innalzati per la Vittoria ad Actium e Conquista dell'Egitto con Varj Altri Ornamenti Antichi Disegnati ed Incisi dal Cavalier Gio. Batta. Piranesi*; the others are in a section titled *Alcune Vedute di Archi Trionfali, ed Altri Monumenti Inalzati da Romani, Parte de Quali si Veggono in Roma, e Parte per l'Italia, Disegnati ed Incisi dal Cavalier Gio. Battista Piranesi*).

Vedute di Roma Disegnate ed Incise da Giambattista Piranesi, Architetto Veneziano, n.d.; Plates 1, 2, 3, 5, 6, 8, 10, 12, 13, 14, 17, 19, 20, 21, 22, 23, 24, 25 and 27 through 41.

BIOGRAPHIC NOTE

Herschel Levit lives in New York City, where he is a professor of art at the Pratt Institute. In the ten-year period 1963–1973, Mr. Levit frequently traveled in Western Europe, especially Italy, making photographic records of the great monuments.

Mr. Levit used a Hasselblad camera with Zeiss lenses of 80 mm (normal), 50 mm (wide-angle) and 250 mm (telephoto).

FOREWORD

As the hub of pagan and Christian civilizations, where world history has been made for well over twenty centuries, Rome contains more art treasures than any other city in the world. Frescoes, mosaics, paintings and sculpture abound, dating from the Etruscan era to the present day; but, above all, Rome has great architecture.

Among the ancient constructions, the Colosseum is truly colossal, even by today's standards. The Pantheon, an almost perfectly preserved ancient masterpiece, has a superbly proportioned interior. The great dome, the inspiration for all subsequent domes, rises above the beautiful circular walls to its apex, open to the Roman skies for almost two thousand years. All that remains of ancient Rome, the forums, the arches, the Palatine Hill, the baths, the Via Appia, resound with their deep echoes of history.

Most of the structures of the subsequent periods, Byzantine, Romanesque and Gothic, were torn down and replaced in the Renaissance and Baroque eras, when there was extensive new building. Much of the present character of Rome is due to the vigorously creative Baroque style.

Recording my own impressions of Rome with the camera, I was reminded of another record of the city, the one left by the eighteenth-century Venetian architect Giovanni Battista Piranesi (1720–1778). Piranesi's etchings are world-famous, and as an artist I was especially familiar with his *Vedute di Roma* (Views of Rome) and *Carceri* (Prisons). The present book contrasts eighteenth-century Rome as revealed by Piranesi through his etchings and contemporary Rome as I have captured it through the medium of photography. The relationship between these two series of pictures dramatizes both the change and the continuity. The kinship that I have always felt for Piranesi's work, with his dark romanticism and his enthusiasm for structures on a grand scale, prompted me to produce these photographs, which are composed, as much as possible, on the model of his etchings.

It was frequently difficult, and in some cases impossible, to correlate the views. Piranesi almost always used a complete panoramic sweep of 180°. In drawing his sketches he turned his head to the left and to the right. The camera cannot duplicate this without catastrophic distortions, such as those produced by a fisheye lens. Exaggerations of scale and perspective are other familiar aspects of Piranesi's etchings. An additional difficulty is his frequent use of an imaginary point of view far above the ground level. One of his etchings of the Colosseum shows a bird's-eye view that I would estimate to be from 500 feet above the normal level. In most of the views, the level would be between 30 to 50 feet above the ground. Nevertheless, the amount of correlation that proved possible is quite gratifying.

There are many individuals and institutions to whom I am deeply indebted for their kind cooperation: Mr. Richardson Pratt, Pratt Institute, Brooklyn, N.Y., for my leave of absence; Mr. A. Hyatt Mayor, Curator Emeritus, Department of Prints, the Metropolitan Museum of Art, New York; Professor Adolf K. Placzek, Avery Librarian, Avery Architectural Library, Columbia University, New York; Mr. Herbert Mitchell, Bibliographer of the Avery Library; the Istituto Italiano di Cultura, New York; The Watson Library and its staff, The Metropolitan Museum of Art, New York; The Art Reference Room and its staff, Pratt Institute, Brooklyn, N.Y.; Miss Leideke Galema, The Foyer Unitas, Rome; and my wife, Janice, who did invaluable research and translations and who survived all the vicissitudes of seeing my work through to completion.

New York, November, 1975 HERSCHEL LEVIT

BIBLIOGRAPHY

Bottari, Stefano, catalogue of an exhibition at the Villa Farnesina, Rome, 1963.

Caradente, Giovanni, *Rome,* New York, 1971.

Dizionario enciclopedico italiano, Rome, 1958.

Focillon, Henri, *Giovanni Battista Piranesi,* Paris, 1918.
> The most important work on the artist, the man and the background of his time. The Italian edition, *Piranesi* (translated by Giuseppe Guglielmi, Bologna, 1963), also includes Focillon's complete catalogue of the work of Piranesi (the source of the Focillon numbers in the present volume).

Fokker, T. H., *Roman Baroque Art,* London, 1938.

Hind, A. M., *Giovanni Battista Piranesi; A Critical Study with a List of His Published Works and Detailed Catalogues of The Prisons and The Views of Rome,* London, 1922.
> Source of the Hind numbers in the present volume.

Lanciani, Rodolfo, *Wanderings Through Ancient Roman Churches,* New York, 1924.

La Pauze, Henri, *Histoire de l'Académie de France,* Paris, 1924.

Legrand, J. G., *Notice historique sur la vie et les oeuvres de G. B. Piranesi,* Paris, 1799.
> Quoted extensively by Focillon.

Mayor, A. Hyatt, *Giovanni Battista Piranesi,* New York, 1952.

Nash, Ernest, *Pictorial Dictionary of Ancient Rome,* 2 vols., New York, 1961–62.
> A major source of information for the present volume.

Robathan, Dorothy M., *The Monuments of Ancient Rome,* Rome, 1950.

Scherer, Margaret, *Marvels of Ancient Rome,* edited with foreword by Charles Rufus Morey, New York, 1955.

Stannard, Harold, *Rome and Her Monuments,* New York, 1924.

INTRODUCTION

The majestic ruins of Roman antiquity found an eloquent interpreter in an artist born in the most splendid and theatrical of all Italian cities—Venice, impoverished but still vital in the eighteenth century while Florence, Rome and Naples seemed to lie dormant. Flourishing in the carnival spirit of eighteenth-century Venice were many gifted artists. There were great composers like Vivaldi and Marcello and painters like Guardi, Canaletto and that astonishing virtuoso Tiepolo. Piranesi passed his first twenty years in this amazing fairyland, where he received his education as an artist.

He studied architecture with his uncle Matteo Lucchesi, an engineer and architect. Later he studied perspective with the engraver Carlo Zucchi. He learned Latin as a child from his brother Angelo, a Carthusian monk, who sparked his first enthusiasm for ancient Rome. He absorbed the illustrated volumes on architecture by the ancient Roman Vitruvius and the late Renaissance architect Palladio, who used the Roman classic principles as the perfect model. Not far from Venice, in Ferrara, Rimini and Verona, were important remains of Roman architecture, all of which were a source of inspiration to Piranesi in his formative years.

Zucchi's pupils became masters of perspective, which was used to create fantastic stage designs for the Venetian theater. Piranesi was certainly one of the most masterful and used his skill with enormous effect in his later work. Among Piranesi's other teachers were the architect Scalfurotto and the stage designers Valeriani and Ferdinando Bibiena.

Young Piranesi was ready to put all his training to professional use, but public funds were scarce. By 1740, when Piranesi was twenty years old, the great building projects were at a halt. An inventive architect with Bernini's passion and Palladio's reverence for classicism was adrift without a commission. But in that very year Piranesi had his first opportunity to visit Rome as draftsman for the Venetian ambassador to the papal court. Here he had his first encounter with Roman antiquities on a vast scale. Rome became a fascinating adventure that was to last his whole life through.

At this time, he studied etching and engraving with Giuseppe Vasi and Felice Polanzani. The latter, a Venetian, became a close friend who etched a portrait of Piranesi in 1750. Piranesi's friendship with Monsignor Bottari, a custodian of the Vatican Library, gave him the opportunity of seeing the very rich print collection of Cardinal Corsini. Piranesi was especially impressed by the work of Rembrandt and Jacques Callot. In Rome in 1743, Piranesi published his first work, *La Prima Parte di Architetture e Prospettive* (The First Part of the Architectural and Perspective Views). In this volume Piranesi included the etching "Carcere Oscura" (Dark Prison), in which it is possible to see his first ideas for the later *Carceri* (Prisons), which are much more freely and dramatically expressed.

Beginning in 1738, the excavations at Herculaneum were exciting Italy and, indeed, all of Europe. While at Rome, Piranesi undertook a trip to Naples, from which he was able to visit the ancient city. He greatly admired the many art objects, bronze utensils and paintings housed at the museum in nearby Portici. He made friends with Carlo Paderni,* the director of the museum, who, seeing Piranesi's theatrical perspective etchings with their prodigious facility, advised him to continue making prints and to interpret Roman antiquities.

After leaving Naples, Piranesi was obliged to return to Venice since his father could no longer continue his small allowance. He looked in vain for work as an architect. He also wanted to paint and there is some conjecture that he worked in Tiepolo's studio. But he soon learned that with etching he could express everything, that he could thereby realize his ambitions as architect, archeologist and painter. Indeed, in his black-and-white work Piranesi became one of the most expressive "painters." Etching became a total art for him.

In 1744, he turned to the *Capricci* (Fanciful Compositions) and the *Invenzioni di Carceri* (Inventions of Prisons). When it is recalled that Piranesi was only 24 when he produced this first version of the "Prisons," his precocious genius becomes apparent. These prints are a staggering display of Piranesi's skill as an etcher, but are also a comment on the waste of an architect's potential. They represented not only Piranesi's architectural fantasies but also his frustrations in the real world.

Fortunately, about this time Piranesi met a print dealer who was to exercise a decisive influence on his destiny: Giuseppe Wagner, a German who had settled in Venice. Piranesi showed him his efforts and spoke of his project to draw and engrave the monuments of antique Rome. Wagner, who understood their potentiality, proposed that Piranesi take the plates belonging to his firm and establish in Rome a studio similar to the Wagner shop in Venice. Little more is known of this union except that it brought Piranesi back to Rome in 1745.

Piranesi now definitely established himself in Rome and entered the career to which he would dedicate his life. He installed his presses and Wagner's stock in a studio opposite the French Academy on the Via del Corso, one of Rome's most important streets, which runs for a mile in a straight line from the Piazza Venezia to the Piazza del Popolo.

* The name also appears in the literature as Maderno.

The proximity of the French Academy cemented Piranesi's relations with French painters and architects. Hubert Robert (1733–1808), a painter of antique ruins, was a close friend whose paintings differed widely from Piranesi's work. Robert's ruins were conceived romantically, with picturesque peasants posed charmingly against the monuments, which were depicted not as actual sites but as remembered dreams —while Piranesi's work was fundamentally based on direct observation. In fact, Piranesi's passion for knowledge of the methods of the ancient Roman builders led him to examine the ruins with microscopic thoroughness. He learned the inner details of the construction of walls and of the foundations of antique bridges and other monuments. Nothing seemed to escape his attention. It was this particular kind of absorption that enabled him to work with such authority on his subsequent series *Le Vedute di Roma* (The Views of Rome). Yet his interpretations are not dry documents of dull facts. Because he was, above all, an artist who believed in the beauty of the ruins, he was able to infuse a special kind of grandeur and nobility into them.

In 1748, thirty small etchings by Piranesi were published with the title *Antichità Romane de'Tempi della Repubblica* (Roman Antiquities from the Time of the Republic); four etchings from this collection are included in the present volume (Nos. 7, 11, 16 and 26). That same year he began the large *Views*, a project which was to occupy him for the rest of his life. To this majestic series, which eventually numbered 135 items, several important plates were added regularly each year. This body of work finally constituted the most durable aspect of his fame. (Two other groups of Piranesi's large-scale etchings are represented in this book: *Le Magnificenze di Roma*, ca. 1751 [No. 15] and *Antichità Romane*, 1756 [Nos. 4, 9 and 18].)

In reference to Piranesi's method of work on the *Views*, one of the more astonishing aspects is the manner in which he sketched an actual site for later development on the copper plate. These sketches were never finished or detailed studies, but merely shorthand references of his mental images. First he drew a heavy stroke in sanguine, over which he returned with a pen or paintbrush. This was a sufficient personal memo. To an outsider it was impossible to distinguish what he had fixed on paper. He once told his friend Hubert Robert, who was perplexed that Piranesi could content himself with so few indications to produce plates so vastly rich in detail, "The drawing is not on my paper but entirely in my head and you will see it on the finished etching." Piranesi, without doubt, was blessed with an amazing photographic visual memory which permitted him to bypass ordinary conventions and to schematize in his own fashion from his graphic notes. He was thus able to create his effect directly on the copper plate, making it the original.

Of course, Piranesi still often needed to fill in small areas of his sketches with certain significant details, such as capitals, portions of a frieze or motifs of decoration. In order to trace these in reverse on the plate, it was necessary to oil the paper to render it transparent. He was now able to scratch the essential characteristics of the drawing through the paper with his etching needle. With the broad outlines of the scheme now transferred to the copper, Piranesi devoted his attention to the development of his image.

From nature he had observed the play of light and shade at different hours of the day and, above all, by moonlight. He felt that each particular architectural ensemble had to be interpreted with the proper effect of chiaroscuro which would create the greatest sense of its mystery and logic. He similarly controlled the architectural volumes and their perspective to produce the most dramatic and striking effects. In some of the views these volumes are seen so close up that they burst through the margins. This embraces the viewer with its startling immediacy. Far from appearing like real-estate documents, the views combine all the strength of reality with a poetic and abstract vision.

Human presence is an important feature of the views. Rome, in the eighteenth century, was a city of extreme contrasts. While episodes of outdoor life, on the streets and in the squares and marketplaces, were often accented by the pomp and pageantry of prelates, great lords and foreign travellers, flocks strayed from the Campo Vaccino (cow pasture), now the largest of the forums, and shops were set up against ancient and august ruins. Many of the figures that inhabit the scenes were inspired by the most sordid beggars from the Trastevere (a section of Rome across the Tiber River generally much poorer than the center of the city). These figures are shown clad in long capes, torn and frayed at the edges. Piranesi took a great delight in drawing the most repulsive infirmities. Ulcerated legs, broken arms and hunched backs are depicted with relish. Sticks and crutches support the men, who frequently point to something unseen with long thin arms and crooked bony fingers. To enhance even further the monumental scale of the architecture, the figures are reduced to tiny dwarfs. All the elements of the composition, the masses of architecture audaciously placed on the page, the foliage which decorates it and the strange models which animate it, were more and more adroitly unified in scenes of overwhelming grandeur.

Many visitors to Rome, having first experienced the etchings in places far from that city, complained about Piranesi's lack of fidelity. In matters of scale, perhaps, and of certain imagined picturesqueness, they were indeed correct. But Piranesi's genius lies in the perfect marriage of the hard fact with an incomparable poetic eloquence. Thus, when confronted with the actual sites, individuals lacking Piranesi's imagination failed to grasp the essence of his penetrating vision.

NOTES TO THE PLATES

The sequence of the views is chronological, based on the date of the principal monument illustrated. The F numbers are those assigned to the etchings in Focillon's complete catalogue of Piranesi's work; the H numbers are those in Hind's catalogue of the *Vedute* alone (see Bibliography for full titles). The dimensions are in millimeters, height before width. The etchings are from the series *Le Vedute di Roma* (The Views of Rome) unless otherwise stated.

1. VEDUTA DI CAMPO VACCINO
[First] View of the Cow Pasture
[Roman Forum] (F.803, H.40; 405 x 544)

THE ETCHING

The overall view of the Roman Forum, which in the eighteenth century was still called Campo Vaccino (cow pasture) as it had been since the Renaissance, provides one with an opportunity to see the ancient monuments as Piranesi saw them. Nowhere else in Rome has more historic drama been packed into so small a space. Great temples, law courts and government buildings rose in this area. From the time of the early Christian emperors, the pagan temples in the Forum were closed. The Gothic wars of the sixth century depleted the Roman treasury and the old buildings could not be kept in good repair. The temples that survived did so because they were transformed into churches. In 847, an earthquake hastened the destruction of the Colosseum and the structures in the Forum. In the centuries that followed, the erosion of the earth from the surrounding hills, the burning of marble fragments of sculpture and temples for lime, and the looting of whole sections of buildings, such as columns and decorated entablatures, for the construction of churches and palaces elsewhere in Rome and beyond, continued the sad saga of destruction. Earth now covered most of the desolate ruin, leaving only the tops of the tallest columns and the upper portion of arches above ground. The identity of these ruins was, for the most part, forgotten and for a long time they were given a succession of erroneous titles. Correct names have been restored by modern scholarship. The following briefly identifies the structures visible in the etching. The Arch of Septimius Severus (erected 203 A.D.) is at the lower left and, working clockwise, to the left of the arch is the Curia (with triangular pediment), which was the chamber in which the Senate deliberated (last ancient remodeling late third century). In the seventh century it became the church of S. Adriano. There was attached to this a row of houses, now all removed to reveal the foundations of the Basilica Aemilia (later Roman remodeling of a structure dating from 179 B.C.). The columns that can be seen next in the same line

belong to the Temple of Antoninus and Faustina (141 A.D.), into which was built the church of S. Lorenzo in Miranda in the eleventh century (remodeled 1602). Next in line is the small round temple believed to be the Temple of Divus Romulus, built by Maxentius in memory of his son Romulus, who died in 309 A.D. In the sixth century it was joined as a vestibule to the church of SS. Cosmas and Damian (527, remodeled 1632). Behind this, to the left, is the Basilica of Maxentius, completed by Constantine, and behind that, to the right, is the Colosseum. This (right, clockwise) is followed by the twelfth-century Romanesque campanile (bell tower) and the Baroque facade (1615) of S. Francesca Romana. Attached to the church on the right was a long two-story structure, probably the convent of the church, which was joined to the Arch of Titus (ca. 100 A.D.), of which only the central portion remained, badly mutilated. At right angles to the arch were the wall and gate, designed by the sixteenth-century architect Vignola, which enclosed the once famous Farnese Gardens, built on the slope of the Palatine Hill. This leads to the three columns of the Temple of Castor and Pollux (remodeling in 6 A.D., and later, of a very ancient shrine). To the immediate right of the three columns was the Baroque facade of S. Maria Liberatrice (thirteenth century, remodeled in eighteenth), demolished in 1902 to reveal the sixth-century (or older) S. Maria Antiqua. On the extreme right side of the etching is a portion of the Temple of Saturn (final remodeling fourth century A.D.). In the bottom right foreground can be seen the top of the Temple of Vespasian (81 A.D. with later remodeling). Toward the center is the lone column of the Byzantine emperor Phocas (608 A.D.), unidentified in Piranesi's day.

THE PHOTOGRAPH

I was very fortunate in being able to take this picture from the second floor of the Palazzo Senatorio (Senators' Palace), which is now Rome's city hall. Through the kind cooperation of an official I discovered the proper window from which to relate the view with Piranesi's etching. It was in the office of the Mayor of Rome, who was away for the day. The photograph reveals to a startling degree the extent of the excavations as they now exist. The Via Sacra extends from the central opening of the Arch of Septimius Severus to the Arch of Titus, now restored, with much of the original paving. The portico of the Temple of Antoninus and Faustina can now be fully seen, with a flight of steps (modern) leading down to the Via Sacra. At the right of the photograph are the remains of the Basilica Julia, named for Julius Caesar, who began its construction. In the shadows at the upper right are the extensive excavations on the Palatine Hill which have displaced

the earlier buildings on the site. The Column of Phocas, identified when its inscribed base was unearthed, was antique Roman (first or second century A.D.), but reused as a gigantic pedestal for Phocas' bronze statue in 608 A.D. Immediately below the column are the foundations of the Rostrum, an orators' platform.

2. VEDUTA DI CAMPO VACCINO
[Second] View of the Cow Pasture
[Roman Forum] (F.748, H.100; 474 x 708)

THE ETCHING

Piranesi probably made his sketch from the unidentified building immediately to the right of the column of Phocas seen in the previous overall view of the Campo Vaccino. This places us approximately in the center of the Forum, from where the monuments can be seen in greater detail. Most of them can be easily recognized from the preceding description; only a few additional facts are offered here. In the foreground, to the left of center, is a fountain used as a watering trough. Piranesi refers to it in his caption as "an antique basin of granite in one piece situated in the place where the Lacus Curtius once was." (The Lacus Curtius was the original marsh situated where the Forum later developed.) The basin was removed in 1818 and placed in the Piazza del Quirinale as part of the sculptured group *The Horse Tamers* (Dioscuri). On the far left is the temple of Antoninus and Faustina with the church of S. Lorenzo in Miranda set within the columned portico. To the right is the temple of Divus Romulus. The Baroque facade was demolished at the time of its excavation, and the original bronze doors, almost seventeen hundred years old, were replaced in their original site, but the small seventeenth-century cupola atop the tiled roof remains today. In the etching, Piranesi refers to the three columns of Castor and Pollux as the Temple of Jupiter Stator. The three fluted columns, with their Corinthian capitals and the decorated architrave, have been much admired for centuries and have been the subject of artists' sketches and paintings since the Renaissance.

THE PHOTOGRAPH

An attempt to raise my point of view as high as possible, by standing on a marble pedestal, was helpful, but the camera's eye was still well below that of Piranesi's view, because of the subsequent deep excavations. The Basilica Julia, begun in the first century B.C., primarily as a law court, occupies the right foreground of the photograph. Its marble steps lead to the ancient Via Sacra. On the far left is a large brick pedestal, its marble facing long since gone, supporting a column. It probably held a statue of some notable on top of its capital, like the Phocas column. Slightly to the right of center is the circular Temple of Vesta (last remodeling about 200 A.D.), partially reconstructed with the original fragments found during the excavations. Behind this, but concealed in this view, was the House of the Vestal Virgins, whose duty it was to guard the sacred flame in the Temple of Vesta. To its right, in the background, is the restored Arch of Titus.

3. VEDUTA DELL'ISOLA TIBERINA
View of the Isola Tiberina (Tiber Island)
(F.836, H.121; 470 x 711)

THE ETCHING

The island in the Tiber was also known in ancient times as the Insula Aesculapii. The legend was that on the advice of a sibylline oracle, a snake was brought from the Aesculapium (temple of the god of medicine) at Epidaurus in 292 B.C. On arriving in Rome, it escaped from the ship and swam to the island, where a new temple was built to Aesculapius on the south end of the island, the point of which faces the viewer in the etching. The island as a whole suggests a ship and the Romans designed this end as the prow. The remains of this first-century B.C. embankment are clearly visible in the print. The god, with the snake on his staff (caduceus), is shown at the letter B. Piranesi invented the sculpture to suit himself. The temple was really somewhat further back, where the Church of S. Bartolomeo (letter C) stands (late tenth century, remodeled 1624). The island was originally covered with temples to various deities but nothing remains except the marble prow. In addition to the Church of S. Bartolomeo, there is the Hospital of S. Giovanni di Dio (1640, 1711) which perpetuates the island's connection with Aesculapius. In this view of the island we can see both of the ancient bridges, the Ponte Fabricio (Pons Fabricius) on the right and the Ponte Cestio (Pons Cestius) on the left. In another of Piranesi's departures from fact, the island is drawn as though it continued in a straight line from the foreground, making it seem very long. The river, in fact, makes one of its pronounced curves here, and the island at this point follows the curve in parallel fashion. The north end of the island is simply not visible from this point, turning out of sight immediately after the Ponte Fabricio. Piranesi's view is more impressive because of the deep perspective of the island. Mere fact is not nearly as interesting.

THE PHOTOGRAPH

A wide quay has been built around the island and an additional wing has been built over the ancient prow, which is visible underneath a stairway to the terrace. These additions have drastically altered the position of the prow, now an insignificant but fascinating vestige of the island's ancient history.

4. VEDUTA DEL PONTE FABRIZIO
View of the Ponte Fabricio (Fabrician Bridge)
(F.351; 385 x 586)

THE ETCHING

This etching, as also Nos. 9 and 18, are from Piranesi's collection *Antichità Romane* (Roman Antiquities) of 1756. The bridge connects the east bank of Rome, on the right of the etching, to the Isola Tiberina. This ancient bridge was built by the Roman consul L. Fabricius in 62 B.C. Inscriptions on the arches of the bridge record the name and date of the builder. On the left arch an additional inscription names the consuls Lollius and Lepidus (21 B.C.), referring either to a restoration on the left side or to the final approval of the structure. Much of the travertine marble facing was still intact in the eighteenth century though Piranesi states in his caption that bricks had recently been placed in areas near the top of the bridge where the marble was missing. There was originally a bronze railing but Innocent XI replaced this with a new parapet in 1679. Piranesi has included a number of fishing boats on the river. The figure on the far right, up to his thighs in the water, and carrying a large basket net, approaches a pile of antique rubble which Piranesi states came from the ruins of the vaults and walls of the Theater of Marcellus. This may have been possible since that building is nearby, out of sight on the far right. It must be remembered, however, that Piranesi frequently moved things around

for his own purposes. Thus, he has eliminated the bell tower with the small onion-shaped dome that normally would have been seen as it is in the photograph. Curiously enough, a careful examination of his view of the island (No. 3) clearly shows this tower on the right side of the bridge as it enters the island.

THE PHOTOGRAPH

Only the antique marble of the arches, containing the inscriptions, remains. The large stones of the buttress seen in the etching between the two large arches must have been extravagantly exaggerated by Piranesi. The photograph shows a much smaller structure. Otherwise, this ancient bridge has remained intact, once again confirming the remarkable ability of the Roman architects and engineers.

5. VEDUTA DEL TEMPIO DI CIBELE A PIAZZA DELLA BOCCA DELLA VERITÀ
View of the Temple of Cybele in the Piazza della Bocca della Verità [Temple of Vesta]
(F.820, H.47; 396 x 594)

THE ETCHING

The temple is now generally referred to as the Temple of Vesta, because of its circular form, though its actual identity is very much in doubt. The temple occupied a prominent place in the ancient Forum Boarium or cattle market. Built in the first century B.C., entirely of marble, in a pure Greek style, it was composed of a colonnade of twenty fluted Corinthian columns. The beautiful entablature, with its elaborately sculptured details supported by the columns, was long gone when Piranesi composed this view. In fact, the temple had been horribly defaced by a hideous wall that filled up the areas between the columns and by an ugly tiled roof (to enclose the tiny church dedicated to S. Maria del Sole). Carts and wheels are strewn about the church area. Large pieces of wood lean against its walls and, apparently, the cartwright conducted his shop on the right, in the attached building. A woman in the center has finished hanging her wash on a line, which is also attached to the church. A group of figures in the foreground are busily engaged in conversation, while a dog sniffs the ground. The squalid tone of the scene and the decrepit condition of S. Maria del Sole point to the probability that the church was no longer used and was lived in by squatters.

THE PHOTOGRAPH

In the beginning of the nineteenth century, the Napoleonic French removed the wall and the cella was restored to its present condition. The tiled roof, now flatter than originally, is like a lid on a pot, and still stifles the beauty of the columns. Nineteen of the twenty columns remain and excavations have cleared them to their foundations, also revealing a portion of the marble steps that ringed the base of the temple. The Piazza della Bocca della Verità is now a very pleasant square with some very wonderful things in it that link historical sites like pearls on a string. The name of the piazza, which literally means Mouth of Truth, comes from a large round disc in low relief, a large bearded face with an open mouth. The legend was that if you were lying and put your hand in the open mouth, you would lose it. This antique relief is in the portico of the church across from the round temple, the S. Maria in Cosmedin, which has a very rich history itself.

6. ALTRA VEDUTA DEL TEMPIO DELLA SIBILLA IN TIVOLI
Another° View of the Temple of the Sibyl in Tivoli (F.766, H.62; 441 x 658)

THE ETCHING

The little town of Tivoli, the ancient Tibur, lies about twenty miles northeast of Rome, perched on a hill overlooking the Roman countryside. From the late Republic, it was a resort area for well-to-do Romans. Under Hadrian, Tivoli had buildings of extraordinary splendor rivaling his own villa a few miles to the west. Later, both Tivoli and Hadrian's Villa were devastated by barbarians. Tivoli's fame today is largely due to the sixteenth-century Villa d'Este, with its spectacular fountains in the huge gardens, and to the remains of the beautiful circular Temple of the Sibyl. The name given to the temple is very uncertain and to this day its true identity is unknown. Because of its round form it has also been attributed to the goddess Vesta. Among Piranesi's several views of the temple, this one shows the least familiar aspect of the building. The temple dates from the last days of the Republic in the first century B.C. Of the original eighteen columns only ten survive. This view from the "back," as it were, shows the severely damaged circular cella with a large door on the right. The portico of fluted Corinthian columns, with its decorated entablature still intact, encircles the rest of the temple. In the Middle Ages it was transformed into a tiny church, S. Maria della Rotonda. At the same time, the small rectangular temple next to it, of equal antiquity, was transformed into the church of S. Giorgio. Its bell tower is seen on the left rising behind a wall. By the time Piranesi created this view in 1761 there was no trace of the church in the round temple.

THE PHOTOGRAPH

The backyard of a restaurant on the Via della Sibilla is the only access to this view. The heavy wires are the supports of the awning used during the warm seasons for al fresco dining. A young waiter agreed to pose in the doorway. This was the only time I used a figure simulating the position of one of Piranesi's. It is interesting to compare the difference in scale between the photo and the etching. The cella wall has been partially restored since Piranesi's day.

7. FORO DI AUGUSTO
Forum of Augustus (F.56; 134 x 263)

THE ETCHING

This etching, as also Nos. 11, 16 and 26, belongs to Piranesi's first published views of Rome in 1748, under the title *Antichità Romane de'Tempi della Repubblica* (Roman Antiquities from the Time of the Republic). These etchings are quite small (approximately 5 inches by 12) compared to the later views (about 18 inches by 30). This first series was etched with a freshness and a freedom appropriate for the smaller format. They are almost like preliminary studies for the more detailed and elaborate large plates. The Forum of Augustus was dominated by the Temple of Mars Ultor (Mars the Avenger), built by Augustus after the battle of Philippi, 42 B.C., in which he avenged the death of Julius Caesar, since his murderers, Brutus and Cassius, perished there. Julius' sword, kept in the temple, was an object of special veneration. On the left of the etching are the remains of the temple

° Piranesi's other views of this temple are not included in the present volume.

most visible in the eighteenth century, three large fluted Corinthian columns. The fourth capital crowns a pilaster engaged in the strong retaining wall against which the temple was built. Continuing at a right angle to this, the only surviving portion of a triumphal arch joins the rest of the retaining wall of the forum. The earth cover at this time was fully one-third to one-half the height of the forum. The arch became known in the Middle Ages as the Arco dei Pantani (Arch of the Swamps) because of the backing up of water in this area. It was finally drained in the sixteenth century. In Piranesi's drawing, the size of the arch was exaggerated to fantastic dimensions.

THE PHOTOGRAPH

The excavations of this forum were not begun until 1928. The floor of the temple and of the area in the foreground were found to have a beautiful inlaid marble design of geometric forms. The approach to the temple, with its impressive marble steps, lies on the far left, beyond the edge of this photograph. The former earth cover reached to what is now the street level of modern Rome seen through the arch, which in the photograph, because of the perspective foreshortening, appears to be smaller than it actually is. Its dimensions, however, are far from Piranesi's inflated scale.

8. VEDUTA DELL'ATRIO DEL PORTICO DI OTTAVIA
View of the Atrium of the Portico of Octavia
(F.815, H.58; 396 x 595)

THE ETCHING

The portico, dating from 149 B.C., was remodeled in 23 B.C. by Augustus and dedicated to his sister Octavia. Later restorations were made by Septimius Severus and Caracalla. Originally it was part of a complex of two temples and libraries. The remains now form the atrium of the church of S. Angelo in Pescheria, begun in the eighth century but much restored. A portion of the church is on the right. An ancient street of the old Jewish quarter ended inside the atrium, which later became a fish market; hence the name of the church, "The Holy Angel of the Fish Market." On the extreme left a house cuts into the facade of the atrium. Vestiges of sculpture apparently were still visible on the pediment, and below it an inscription is discernible alluding to the restorations made by Septimius Severus about 200 A.D. after the fire which partially destroyed the Augustus complex. The bottom portion of the arches are walled, enclosing the atrium. At the base of the front wall are tables with stone slabs for the sale of fish.

THE PHOTOGRAPH

People living in this area have made the space around the atrium a place for parking their cars, making it very difficult to photograph the portico. This is still largely a Jewish neighborhood, but the fish market has been gone since the 1870s. The house on the left of the etching has been removed, revealing not only the full pediment, but two fluted Corinthian columns. The faint trace of pediment sculpture in the etching has vanished, along with the outline of a coat-of-arms above the large central arch. The walls at the bottom of the arches went the way of the fish market, but the parked cars prevent one from seeing what lies behind. S. Angelo in Pescheria, if the photo extended that far, would be found behind several trucks and assorted Fiats on the far right.

9. VEDUTA DELLA PIRAMIDE DI CAJO CESTIO
View of the Pyramid of Caius Cestius
(F.322; 398 x 597)

THE ETCHING

From the *Antichità Romane* of 1756. This funerary monument of the praetor (judge) Caius Cestius, erected before his death in 12 B.C., reflected Rome's new interest in Egypt, which it had recently acquired as its newest province. The pyramid was built with the usual strength of Roman materials, brick and mortar on the inside, a facing of large marble blocks. The inscription that Piranesi has placed on the eastern face of the pyramid is actually on the opposite side. Almost three centuries after the erection of the pyramid, the emperor Aurelian began the walls and fortifications around the city to protect it from the threat of invasions by the Goths. The gate on the right and the wall leading to the pyramid are part of these famous walls, much of which still exists. The gate, which gave access to the road to Rome's port of Ostia on the Mediterranean, was called the Porta Ostiensis; it is now called Porta San Paolo. The road, however, had its ancient title of Via Ostiense restored in the 1930s. The gate was reconstructed in the sixth century by the Byzantine general Belisarius. Since then the pyramid, the walls and the gate have been threatened with destruction many times, most recently in World War II by allied bombers, but remarkably they all have survived.

THE PHOTOGRAPH

The trolley wires overhead made a clear view impossible, as they always do. This compromise view was made in order to eliminate a more complex crisscrossing of the wires. The iron fence on the sidewalk surrounding the pyramid guards the excavations which reveal the base of the tomb. The pyramid was cleaned and repaired several years ago and the marble is once more restored to its whiteness. The inscription, of course, is on the opposite side, which faces the small Protestant cemetery which the Romans call "English" since so many Englishmen are buried in it. The graves of Keats and Shelley make the burial ground a goal of literary pilgrims. Rome has thus provided, in its remarkable history, the strange ghostly neighbors of Cestius, Keats and Shelley.

10. VEDUTA DELL'ARCO DI COSTANTINO, E DELL'ANFITEATRO FLAVIO DETTO IL COLOSSEO
View of the Arch of Constantine and the Flavian Amphitheater, Called the Colosseum
(F.805, H.56; 400 x 539)

THE ETCHING

This view was sketched from the Palatine Hill. In the foreground, Piranesi has included some rather imposing ruins, with figures all about, but this is merely a typical invention of his, although some smaller pieces of rubble do indeed lie scattered at the bottom of the hill. The factual scene begins with the Arch of Constantine, the largest, the most recent (315 A.D.) and the best-preserved of all the arches of Rome. To the left of the arch is a rather shapeless and nondescript stump, which was the ruin of a conical fountain called the Meta Sudans, erected by Titus and later remodeled by Constantine. It was removed in 1936. The Colosseum has been the most renowned amphitheater in the world from the time it was begun, about 70 A.D., by Vespasian and completed by his sons Titus and Domitian. Everything about it is colossal

and it is one of the most spectacular examples of ancient Roman architectural engineering. As Piranesi saw it in 1760, it was without its famous buttresses, which were not completed until 1825 (see below). Toward the right he shows the condition of the ruined walls, indicative of only a small part of its destruction. From about the sixth to the ninth centuries, a series of earthquakes caused enormous damage. Originally, the Colosseum was completely encircled by its outer walls. Less than half of these still remain. The entire southwestern side, facing us in the etching, was destroyed, forming a mountain of stone, brick and marble which for centuries furnished material for the building of palaces and churches. The plundering did not stop until well into the eighteenth century, when Piranesi first came to Rome. The miracle of this monument, despoiled and ravaged by the Romans themselves, and leveled by the catastrophic earthquakes, is that it still has the power to astonish.

THE PHOTOGRAPH

In the foreground a large number of trees hide more than half of the Arch of Constantine. A large circle embedded in the street marks the spot of the Meta Sudans. At the beginning of the nineteenth century, the badly damaged walls of the Colosseum were in danger of collapse. Work begun by Pope Pius VII in 1805 continued through a succession of projects by subsequent Popes until the 1850s. The familiar buttressing on the left was provided by Leo XII and completed in 1825. The reconstruction in brick of the portion on the right enables the viewer to separate it from the ancient walls of travertine. Note the scale of the figures and parked cars. In the etching, Piranesi did not have to exaggerate, and in this instance at least, we are not disappointed in the true vastness of the Colosseum.

11. ANFITEATRO FLAVIO DETTO IL COLOSSEO IN ROMA
Flavian Amphitheater, Called the Colosseum, in Rome (F.53; 133 x 273)

THE ETCHING

From the *Antichità Romane de'Tempi della Repubblica* of 1748. This view shows the portion of the outer wall which still retains its complete four-storied structure. In the right background is the Arch of Constantine and on the far right is a portion of the Palatine Hill.

THE PHOTOGRAPH

Modern Rome prevented me from encompassing the entire Colosseum in the camera's eye, while still retaining the Arch of Constantine on the right. I chose to concentrate on that portion of the view which included the arch.

12. VEDUTA DELL'ARCO DI TITO
View of the Arch of Titus [East Facade] (F.755, H.98; 471 x 720)

THE ETCHING

Occupying the right half of Piranesi's view is the ruin of the arch as it existed in 1760. Erected at the eastern end of the Roman Forum after the death of Titus (81 A.D.), the arch commemorates his capture of Jerusalem in 70 A.D. During the Middle Ages, it suffered a strange transformation, becoming part of the private fortress of the noble Roman Frangipani family: specifically, the buttress of a tower, the Turris Cartularia. This unit became a detached portion of

the family's Palatine headquarters and was used by the Popes as a safe receptacle for their state documents. In order to build two floors in the passageway of the arch, large holes were bored in the sculptured panels on each side to accommodate the beams, causing severe damage to the bas-reliefs. All of the free-standing portions in the foreground of the panels, such as heads, arms and legs, were broken off and certain other details were chiseled down to make way for the Frangipani archives. This was characteristic of the indifference shown to the ancient monuments until well into the eighteenth century. The mutilated bas-relief on the right, under the vault, seen more clearly in the photograph, depicts the triumphal return of Titus in a four-horse chariot led by the goddess Roma; Titus is crowned by a winged victory. The dedication panel in the attic is the original, though it has lost the bronze letters that were attached to the incised characters. The triumphal arch was one of the unique contributions of Roman architecture, and exerted considerable influence on Renaissance architects. On the far left of the etching we see Vignola's gate to the Farnese gardens and other monuments made familiar by the etchings of the Campo Vaccino.

THE PHOTOGRAPH

The arch was rebuilt in 1822 by Giuseppe Valadier, an important Roman architect (1762–1839) known for his work on the Piazza del Popolo and the adjacent Pincian Hill. The arch had been so badly injured by the Frangipani fortress that Valadier had to have it taken down and reerected, the missing parts being added in travertine. The restored arch retains all of the original material, including much of the marble on the right pier as well as the small figures of the sacrificial procession on the lintel above it. The large stones of the foundation were exposed by the excavations. The earth cover at this higher eastern end of the Forum was comparatively insignificant compared to the western end. In the etching, by an exaggeration of Piranesi's perspective, we can see part of Maxentius' Basilica through the arch. In the photograph only a small portion is seen on the extreme right. The white columns on the left, behind the restored left pier of the arch, belong to the Temple of Antoninus and Faustina.

13. VEDUTA DELL'ARCO DI TITO
View of the Arch of Titus [West Facade] (F.756, H.55; 397 x 610)

THE ETCHING

The arch, on the left, faces the Forum. One is immediately aware of the far greater damage to this facade compared to the opposite side. The top parts of the columns are gone, as is the entablature above them, as well as the entire attic, which repeated the commemorative inscription that is intact on the other side. Above the arch, however, important details remain. At the top center of the arch is a keystone in the form of a scroll, on which is an apotheosis of Titus, flanked by winged victories on the spandrels. This motif is repeated with minor variations on the east facade. Under the coffered vault is the famous bas-relief showing figures carrying spoils from the Temple of Jerusalem, including the Menorah, the seven-branched candelabrum. The procession moves with gathering momentum from the left, passing under an arch on the right. Immediately to the right of the Arch of Titus in Piranesi's view are tradesmen, and through the roofed wooden doors one sees cords of wood piled high in the back. On the far right is a corner of the wall which enclosed the Farnese Gardens.

THE PHOTOGRAPH

The Valadier restoration completed the arch as it is seen today. The holes made to support the beams for the section of the fortress built by the Frangipani family, are seen more clearly in the photograph than in the etching. All of the details seen by Piranesi on the right of the etching are gone except for the path which leads to the top level of the Palatine Hill. At the bottom of the photograph is seen the antique Roman paving, which continues on the Palatine path, out of sight on the far right.

14. VEDUTA DEL TEMPIO DI GIOVE TONANTE
View of the Temple of Jupiter Tonans
[Temple of Vespasian] (F.819, H.44; 397 x 592)

THE ETCHING

The title "Giove Tonante" had been in use for centuries for the three corner columns of the Temple of Vespasian, built by Vespasian's sons, Titus and Domitian, in the first century A.D. Long before Piranesi's view of 1756, a huge mound of earth had formed at this western end of the Forum. A veritable hill rose sharply from the lower parts of the Forum, covering the three columns almost to their capitals. Above the capitals, on the frieze, are carved symbols of sacrificial rites. Remembering that the Forum in Piranesi's time was still the Campo Vaccino, we are not surprised to see goats and a large cow resting just below the back of the Senate Building of the Campidoglio. The houses in the background were of no particular importance, and were demolished during the excavations.

THE PHOTOGRAPH

The extent of the excavations of the nineteenth century, and what they revealed, is staggering. The three corner columns of the Temple of Vespasian have been dug out right down to the foundations of the temple itself. In the center of the view is a series of small columns with Corinthian capitals supporting an entablature. This is the Porticus Deorum Consentium, dedicated to the twelve Olympian Gods, dating from the fourth century A.D. In 1858 the colonnade was restored by Pope Pius IX, using the ancient material. The wall on the extreme right belongs to the ancient Tabularium (78 B.C.), where the state archives (*tabulae*) were kept. In the Middle Ages this section of the Tabularium was incorporated in the foundations of the Senate Building, which faces the Piazza del Campidoglio. The present Senate Building is a Renaissance structure. An enlargement of a detail of the photo, showing capitals and entablature of the Temple of Vespasian, is given (page xxvi) for a closer comparison with the etching.

15. TROFEO DI OTTAVIANO AUGUSTO
Trophy of Octavian Augustus [actually of Domitian] (F.136; 632 x 388)

THE ETCHING

This etching was first published in *Le Magnificenze di Roma*, ca. 1751. It was generally believed in the eighteenth century that this trophy had been created in honor of Augustus to commemorate his victory at Actium, 30 B.C., over Antony and Cleopatra. Its true history, however, begins with a branch of the Julian Aqueduct that ended in a monumental fountain, the Nymphaeum, the ruins of which stand today in the Piazza Vittorio Emanuele II. This was built in the time of

Alexander Severus in 235 A.D. It has a large niche in the center, while on either side, in arched openings, stood the marble trophies that originally came from one of Domitian's victory monuments. Domitian, son of Vespasian and brother of Titus, was emperor from 81 to 96 A.D. From the time of the Renaissance the trophies were attributed to Caius Marius (ca. 155–86 B.C.). Piranesi does mention, on the etching, that the trophy was popularly known as that of Marius. The trophies were removed to the Piazza del Campidoglio in 1590 by Sixtus V and placed on the balustrade that encloses one side of the square. This trophy is seen on the left side of the approach to the Campidoglio. The sculpture is composed of a three-dimensional collage in which are assembled recognizable elements of ancient Roman combat. Shields, helmets, swords in their decorated sheaths, arrows in their tubular cases and a breastplate with its leather straps are all designed to be seen from the front. Very little detail exists on the back, since it was placed in the arch of the Nymphaeum to be admired as part of the ensemble of the facade. Piranesi has drawn this plate with his impeccable attention to every detail. The importance of this work is seen in its influence on Piranesi's later designs for the Piazza dei Cavalieri di Malta on the Aventine Hill.

THE PHOTOGRAPH

The detailed side of the sculpture now faces the city while the much simpler side is seen from the Piazza del Campidoglio. I think that many visitors to Rome miss seeing this side of the trophy since the front view faces a large lawn on which there are many bushes and trees, making it difficult to detect from the long, uphill approach to the piazza. Furthermore, the ramp to the piazza is flanked by marble balustrades. In order to secure the photograph it was necessary to climb over the balustrade and set the camera, with a long lens, on its tripod in the center of the lawn. When one compares the detail in the etching and in the photograph, it looks as if some portions have been badly eroded, especially the helmet on the base. But it must be remembered that Piranesi may have drawn in these details where very little actually existed.

16. PARTE DEL FORO DI NERVA
Part of the Forum of Nerva (F.46; 136 x 271)

THE ETCHING

From the *Antichità Romane de'Tempi della Repubblica* of 1748. This is the last trace of the remains of the southeast wall of the Forum of Nerva, who was emperor from 96 to 98 A.D. Two fluted Corinthian columns support an elaborate entablature with a sculptured frieze depicting women spinning and weaving and the punishment of Arachne by Minerva (Athena). The statue of Minerva is in high relief at the top, within a framed niche. Windows and doors were placed within the ancient facade, which was built into a house. This formed the corner of an intersection of streets which remained as Piranesi saw it until the excavations of the 1920s.

THE PHOTOGRAPH

Since the excavations the Nerva wall has been restored with brick to prevent further damage. The windows and doors of the old attached house have been filled in and the old streets and houses have been demolished to make way for the broad Via dei Fori Imperiali, which runs alongside the Nerva wall. On the other side of the sidewalk parapet, upon which the man in the foreground is sitting, the completed unearthing reveals the rest of the columns and the antique door between

the columns. The earth level, before the excavations, came up to the height of the modern street level, which is at the bottom of the photograph.

17. COLONNA TRAJANA
The Column of Trajan
(F.798, H.15; 548 x 403)

THE ETCHING

In 113 A.D., to commemorate his victories over the Dacians (in modern Rumania), Trajan erected this column in the midst of his spectacular forum, one of the marvels of the ancient Roman world with its libraries and its main building, the Basilica Ulpia. This last and largest of the forums was built by the famous architect Apollodorus of Damascus. In spite of the plundering of Rome in the sixth century, the Forum of Trajan was still in a good state of preservation in the eighth century, but later it suffered great damage and was gradually covered over with medieval buildings until little of it could be seen. The column, however, always remained a miraculous survivor of the ravages of man and time. The column has a spiral band which winds its way up for a length of over six hundred feet. The bas-reliefs are a record of the campaigns, documenting hundreds of details of activities of various forces of the armies. At the summit once stood a statue of Trajan. Originally there was a stairway in the hollow interior of the column. The overall height, including the base, is one hundred twenty five feet. Trajan's tomb was built into the base, which once contained his ashes in a golden urn. It was broken into and robbed by thieves centuries ago. The statue of Trajan vanished, and in 1588 Sixtus V had the column surmounted by a statue of St. Peter, the work of Tommaso Della Porta and Leonardo Sormani. Piranesi's caption states that Pope Sixtus V was also responsible for the excavations at the base of the column with a stairway leading down from the modern street level. On the right is the church of the Santissimo Nome di Maria, built 1736–1738 after a design by Antonio Dérizet.

THE PHOTOGRAPH

In the excavations of 1928–31, the remains of the Basilica Ulpia were revealed and the broken columns were reerected. The columns now present a severe obstacle to achieving a view that matches Piranesi's etching, but they add to the interest of the photograph. The white marble Column of Trajan is seen behind the central axis of the basilica.

18. VEDUTA DEL PONTE, E DEL MAUSOLEO, FABBRICATI DA ELIO ADRIANO IMP^re.
View of the Bridge and Mausoleum built by the Emperor (Aelius) Hadrian (F.339; 393 x 638)

THE ETCHING

From the *Antichità Romane* of 1756. The mausoleum was built by Hadrian (emperor from 117 to 138 A.D.)—for himself, his family and his successors—on the right bank of the Tiber. The tomb was consecrated to the deceased emperor and his already deified wife Sabina in 139 A.D. In 537 A.D., during an invasion by the Goths, the tomb was besieged and in the course of the battle the defenders threw the marble statues down on their assailants. This hastened the destruction of the tomb's beautiful decorations. Originally on the top was a mound of earth, planted with cypresses, and at the apex, a quadriga (four-horse chariot) with a statue of Hadrian. By the sixth century much of this was destroyed and the tomb had become a quarry for the building of other structures in Byzantine Rome. In the Middle Ages the tomb was converted into a fortress but retained its original circular form. During the Renaissance it served as a refuge for the Popes, connected to the Vatican by an underground tunnel which still exists. It was especially useful during the sack of Rome by the troops of Charles V. During the sixteenth century, the Pope's apartments were richly decorated with frescoes and other works of art. Finally, during the seventeenth and eighteenth centuries, it became a prison and was used as such until 1870. (The third act of Puccini's opera *Tosca* takes place on a terrace of this building.) The tomb is topped by the bronze figure of the Archangel Michael, placed there in gratitude by the Romans after the passing of the serious plague of 589–590, during which Gregory the Great, shortly before his election to the papacy, led a penitential procession through the streets; as he approached the bridge before Hadrian's Tomb, it is said that he saw the Archangel above the tomb sheathing his sword to indicate that the plague was at an end. The tomb became known as the Castel Sant'-Angelo, the Castle of the Holy Angel. The bronze angel was done in 1753 by Pietro Von Werschaffelt. The bridge leading directly to the tomb was built by Hadrian in connection with the building of his mausoleum and was completed in 136 A.D. It kept its original form until the last years of the nineteenth century, when the course of the Tiber was altered and new embankments were built. The ends of the original bridge with its small arches over the old embankments were demolished and were replaced by larger arches. The three arches in the center are the ancient originals. The sculptures on the bridge are replacements of the antique ones. The new marble angels were designed by Bernini and the work was carried out by his students in 1669.

THE PHOTOGRAPH

As the Castel Sant'Angelo is one of the most accessible monuments in Rome, Piranesi's viewpoint presented no problem. Piranesi drew the the drum of the tomb in a cramped fashion; the photograph proves the shape to be much wider on the left side. It seems as though Piranesi drew the upper structure from the street level and the bridge from the river level. In the photograph the circular form is seen from the lower level and therefore seems much squatter. One will note the loss of the Baroque clock which is seen in the top center of the etching. Gone also are the four torsos at the top rim; only the pedestals remain. Directly below the loggia is the coat-of-arms of Pope Alexander VI carved in relief. Piranesi makes it seem larger by extending the height of the figures on each side of the cartouche. The large retaining wall on the left side of the etching no longer exists, nor does the other wall marked M facing the viewer. The ancient rubble (T) and the piles (S) jutting out of the river, creating interest in the foreground of the etching, may have existed but were more likely inventions of the artist. Note the two small arches of the bridge in the etching as they appeared before their destruction in 1892. The large arch seen in the photograph is the modern replacement. The river sees very little activity now and the reflections are hardly disturbed by the natural flow of the current. The photograph was taken at the water's edge along the quay below the street level.

19. VEDUTA DEL TEMPIO DI ANTONINO E FAUSTINA IN CAMPO VACCINO
View of the Temple of Antoninus and Faustina in the Cow Pasture [Roman Forum]
(F.802, H.49; 401 x 538)

THE ETCHING

Ten monolithic columns comprise the portico of the temple built by Antoninus (emperor from 138 to 161 A.D.) and dedicated on the entablature to his deceased wife Faustina in 141 A.D. After his death, it was dedicated by the Senate to his memory as well. By the seventeenth century, the Baroque church of S. Lorenzo in Miranda was built within it, incorporating the remains of the side walls of the ancient temple. Until the excavations, begun in the nineteenth century, this view remained unchanged.

THE PHOTOGRAPH

The photograph was taken from the site of the atrium of the House of the Vestal Virgins. The perspective of the temple seen from this point closely coincides with that of Piranesi's view. Unfortunately, the antique brick walls, uncovered by the excavations, now obscure the lower portion of the temple. Marble statues of two of the vestal virgins are at the left and right of the photograph. These sculptures, as well as a number of others, all of vestal virgins, were unearthed at the site.

20. COLONNA ANTONINA
Column of (Marcus Aurelius) Antoninus
(F.799, H.52; 543 x 400)

THE ETCHING

The column was built by Marcus Aurelius' son Commodus after his father's death in 180 A.D. He used as a model the Column of Trajan, including the spiraling strip of bas-reliefs depicting the victories of Aurelius over the Germans and Sarmatians. The sculptured relief is crowded with thousands of figures engaged in various military maneuvers. At the top of the column a statue of St. Paul replaced the one of Marcus Aurelius in 1589. The original base did not survive but the new base was created from antique marble. Then as now, the column occupied the center of a square in the heart of Rome, named after the column, the Piazza Colonna, which is on the west side of the Via del Corso.

THE PHOTOGRAPH

In order to omit the ugly parking lot in the piazza I took the photograph over the densely parked cars. The sixteenth-century Palazzo Chigi, bottom left, is now occupied by the offices of the Prime Minister.

21. ARCO DI SETTIMIO SEVERO
Arch of Septimius Severus
(F.809, H.54; 373 x 588)

THE ETCHING

This is the northwest corner of the Roman Forum, dominated by the arch in the center, almost half buried. The arch was built in 203 A.D. to commemorate the successful conclusion of the wars against the Parthians. Scenes from these campaigns decorate both sides as bas-reliefs above the two smaller openings. Originally, a six-horse chariot with statues of Septimius Severus and his sons Caracalla and Geta occupied the top of the arch. The Column of Phocas is to the left, and in the background on the extreme left the sixteenth-century Senate Building with its medieval corner rises on the Capitoline Hill. To the right of the arch is seen the Baroque church of S. Martino ai Monti, remodeled by the architect Pietro da Cortona about 1640. On the far right we see a portion of the ancient Curia or senate house.

THE PHOTOGRAPH

The excavations now place the eighteenth-century ground level high above the ancient floor level of the Forum. The high point above the Forum became the modern street level of Rome. Immediately behind the Column of Phocas is the modern stairway to the Piazza del Campidoglio. Above this one can see a portion of the church of Aracoeli, and topping that and almost extending to the center is the white marble monument to Victor Emmanuel, containing the tomb of Italy's unknown soldier. To the extreme right, along the edge of the photograph, is one of the brick pedestals, its marble facing gone, that once supported a statue atop its column, as in the case of the Phocas column. Capitals and other parts of columns lie strewn about the floor of the excavated Forum. The temples and basilicas to which they belonged are totally destroyed.

22. VEDUTA DEL TEMPIO DETTO DELLA CONCORDIA
View of the Temple Called Temple of Concord [Temple of Saturn] (F.829, H.109; 462 x 693)

THE ETCHING

From the left a street of nondescript houses leads into the foreground and passes out of view at the extreme right, behind a corner of the Arch of Septimius Severus. From this point there is a hill, filled with goats, leading to the temple then attributed to Concord, but now known as the Temple of Saturn. The eight monolithic granite columns constituted the portico of the temple. Along the architrave is an inscription which reveals that the temple was restored by the Roman Senate after a fire in the fourth century A.D. By the eighteenth century, houses and shops were built into the bases of the columns. A domestic touch is provided by a line of wash between the second and third columns from the right. The capitals are a late Roman variation on the Ionic with a decorative border of the egg and dart motif running between the volutes.

THE PHOTOGRAPH

The excavations have placed me at a point that is far below Piranesi's. At the extreme right in the etching, the left-hand column of the Severus arch is still covered to almost half its length. In the photograph the material on the right constitutes not only the carved pedestal of the column, but the base of the pedestal and part of the foundations of the arch itself. The column is out of sight above the pedestal. The hill of earth is gone, as is the street of houses. The portico of the temple is now clear to its foundations. Iron bands around some of the columns help to preserve them.

23. ALTRA VEDUTA DEGLI AVANZI DEL PRONAO DEL TEMPIO DELLA CONCORDIA
Another View of the Remains of the Portico of the Temple of Concord [Saturn]
(F.830, H.110; 462 x 701)

THE ETCHING

The eight-columned portico is here seen to be joined by a stable on the right. Carriages are seen in the stable through two open wooden doors. To the left of the portico is the Arch of Septimius Severus with an earth cover almost to the top of its smaller openings. In the left background is S. Martino ai Monti, with its handsome dome and facade by Pietro da Cortona (see No. 21).

THE PHOTOGRAPH

Comparing the etching and the photograph, one notes Piranesi's readjustment of the intervals of space between the three chief monuments. He preferred to separate each one so that they stand independent of each other. It was not possible to do this in the photograph and still maintain the basic perspective quality of the scene. The excavations of the Temple of Saturn have cleared away its mound of earth and the foundations of the pair of portico columns on the left are now seen as part of the sidewalk of the Via del Foro Romano. The present level of the street is a few feet lower at the base of the church of S. Martino, and considerably lower in the foreground, as compared to the dirt path of the eighteenth century. On the far left we see the completely exposed columns of the Temple of Vespasian.

24. VEDUTA DEGLI AVANZI DEL TABLINO DELLA CASA AUREA DI NERONE
[First] View of the Remains of the Tablinum of Nero's Golden House [Basilica of Maxentius]
(F.813, H.45; 412 x 545)

THE ETCHING

Until well into the nineteenth century this was known as the Temple of Peace, supposedly built by Vespasian. In Piranesi's day it was thought to be the remains of Nero's Golden House. It was, however, a vast basilica, begun by Maxentius during his brief reign, 306 to 312 A.D. Since Piranesi refers to it as Nero's home, he must have concluded that what remained were three giant rooms, which opened onto an atrium. Hence we have the use of the term *tablinum* (alcove off an atrium). Actually, the three enormous bays constituted the north aisle of the basilica. The fragments in the foreground are remains of the south aisle. The wall on the far left, in the background, was part of the western apse of the basilica. The nave, over 260 feet long and 115 feet high, is completely gone, probably ruined by the ninth-century earthquake. It became, along with the rest of the Forum, a huge quarry for building materials. Until the seventeenth century, a fluted marble column, with its Corinthian capital and decorated entablature, remained against the pier between the first and second bays. Piranesi correctly stated in his caption that it was removed by Pope Paul V and erected in the Piazza di S. Maria Maggiore, where it is seen today, surmounted by a statue of the Virgin and Child. The Basilica of Maxentius was completed by Constantine. In the fifteenth century, parts of a colossal statue of Constantine were found at the west end of the nave; they are now seen in the courtyard of the Palazzo dei Conservatori on the Campidoglio.

THE PHOTOGRAPH

Excavations have revealed more of the brick piers of the south aisle, as well as the lower portion of the north aisle. The photograph was taken from a portion of the east wall connected to the brick remains in the right foreground. This magnificent building was stripped clean of its decoration. Hardly a shred of marble is to be seen anywhere, yet the bare bones still overwhelm one. This was the legacy of power left by the Roman builders.

25. VEDUTA DEGLI AVANZI DEL TABLINO DELLA CASA AUREA DI NERONE
[Second] View of the Remains of the Tablinum of Nero's Golden House [Basilica of Maxentius]
(F.751, H.114; 478 x 700)

THE ETCHING

Standing close by the western end of the first bay, Piranesi concentrates on its coffered vaulting soaring overhead, providing a view of majesty and grandeur. The remaining two bays diminish rapidly in size owing to Piranesi's forced perspective.

THE PHOTOGRAPH

The excavations have added 12 feet to the height of the basilica.

26. ARCO DI CONSTANTINO IN ROMA
Arch of Constantine in Rome (F.50; 131 x 265)

THE ETCHING

From the *Antichità Romane de'Tempi della Repubblica* of 1748. In this view the arch is seen through an opening in the Colosseum. This type of opening, however, does not really exist in the amphitheater, as all its arches are more nearly semicircular. Piranesi has flattened and widened the gap into something that existed only in his imagination.

THE PHOTOGRAPH

Some of the arches on the ground level of the Colosseum have been bricked in, completely shutting off the passageway. It was necessary to go to the second level, where the view through an arch is possible but from a higher point. This changes the perspective, but not too seriously. Since the details of the arch are more clearly seen on the photograph it is appropriate to mention some things about them here. The arch was erected in honor of Constantine to commemorate his victory over Maxentius in 312 A.D. It was completed three years later. The sculpture and reliefs decorating the arch were taken from monuments of the times of Trajan, Hadrian and Marcus Aurelius. The only sculptures from the time of Constantine were the friezes above the side openings and on the short ends of the arch, the reliefs at the base of the columns, the two medallions of the ends and the reliefs of the spandrels. The contrast of the quality of the work of the first and fourth centuries is startling. The elegance of the former has given way to the coarseness of the latter. It is interesting to note that Constantine deemed it necessary to "borrow" the earlier sculpture for his arch. Above the arch, seen on the top of the Palatine Hill, is the convent church of S. Bonaventura.

27. VEDUTA DEL ROMANO CAMPIDOGLIO CON SCALINATA CHE VA ALLA CHIESA D'ARACELI
View of the Capitol in Rome with the Stairway to the Church of Aracoeli
(F.807, H.38; 401 x 545)

THE ETCHING

This view embraces one of the most splendid of Rome's many remarkable areas. It offers a staggering display of architectural masterpieces adorned with many important examples of ancient Roman sculpture, the greatest of which is the superb bronze equestrian statue of Marcus Aurelius. On the left, the one hundred and twenty-two marble steps climb to the highest point of the Capitoline Hill, to the church. The steps were taken in 1348 from the ruins of a building that has been identified as the Temple of Serapis built by Caracalla, another indication of the powerful attraction Egyptian religion had on the ancient Romans. From the earliest years of ancient Rome this spot was occupied by a succession of important temples, the last of which was the Temple of Juno Moneta. Rome's early mint was housed here and the word "money" comes from Juno's epithet of Moneta. The present church, S. Maria in Aracoeli, or Saint Mary at the Altar of Heaven, dates from the thirteenth century, replacing an earlier one of the sixth century. The legends of ancient Rome blend into those of the early Christians, for it was believed that Augustus, when asked to be deified by the Roman senators, asked the Sibyl for advice. She prophesied that a king would come from Heaven to judge the world. The legend continues that Augustus saw a vision of the Virgin in Heaven standing on an altar, holding a male child in her arms. The vision took place in Augustus' chamber in the temple where the church now stands. The facade was to have been decorated with mosaics but the raw brick wall has remained as it was. Note the clock with its ornate frame that Piranesi has drawn toward the top of the facade. The plain exterior of the church is deceiving because the interior is lavishly decorated and contains many works of art. Returning to the left foreground of the etching, one should note on the right of the steps a mutilated draped sculpture similar to hundreds that ancient Rome produced. Just below this is a fountain in the form of a lioness whose twin is on the other side of the ramp that leads up to the Piazza del Campidoglio. The lionesses are Egyptian originals which from 1880 to 1955 were kept in the museum on the right of the piazza and replaced outdoors by copies. The ramp, the piazza and the palatial facades were carried out in accordance with Michelangelo's designs. The effect is majestic and beautiful. On either side at the top of the staircase are the elegant giants, the ancient Roman Dioscuri, Castor and Pollux, and their horses. The Dioscuri were said to have been found in the great Theater of Pompey in the area called in ancient times the Campus Martius; today this would be the area near the church of S. Andrea della Valle, on the Corso Vittorio Emanuele. When they were moved to the Capitol in 1567, they were in need of restoration, which was carried out by Giovanni Berti (who also made the bases) and completed in 1583. On the top balustrade on either side of the Dioscuri are the trophies (see No. 15). On either side of the trophies are figures of Constantine and his son Constantine II, from the Baths of Constantine, 315 A.D., removed to the Piazza del Campidoglio in 1653. The baths, which stood on the Quirinal Hill, have been totally destroyed. Another sculpture from the baths, one of the river gods, is visible in the etching to the left of the right trophy. It is at the base of the double staircase to the Palazzo Senatorio. Finally, at either end of the balustrade are antique milestones, in the form of columns, taken from the Appian Way. In the center of the piazza is the equestrian bronze of Marcus Aurelius, miraculously saved from destruction by the mistaken notion of the early Christians that it represented Constantine. This statue is seen under the right arm of the Dioscurus on the right. It was brought to the piazza in 1538 by the wishes of Pope Paul III. Michelangelo is thought to have designed the elegantly proportioned base. To the left is the Palazzo Nuovo, which now houses the Museo Capitolino, and on the right is the Palazzo dei Conservatori.

THE PHOTOGRAPH

Shortly after Piranesi created this view, about 1757, the clock was removed from the facade of the church and placed in the bell tower of the Palazzo Senatorio. The antique figure at the bottom of the steps of the church is gone, and in its place is a marble ball on a vase-like pedestal. The iron railing seen just below this and continuing down to the left protects the approach to a vine-covered path that was installed when the triangular garden was landscaped with bushes and trees. A bronze statue of the tribune Cola di Rienzi, on a pedestal faced with fragments of antique marble, has been placed in the garden. The legend tells that his assassination by the Romans took place on this spot in 1354. Aside from the modern lampposts and the swift traffic on the paved street below, the Campidoglio remains as Piranesi drew it.

28. VEDUTA DEL CAMPIDOGLIO DI FIANCO
View of the Capitol from the Side
(F.747, H.39; 402 x 686)

THE ETCHING

This is another of Piranesi's great etchings that combine fact with fancy. The immediate foreground is filled with a group of figures bending, crouching, gesticulating in the dramatic setting of a pile of antique fragments. Referring to the preceding view, this activity would have taken place in the upper left hand corner of the triangular garden, where it would clearly have been impossible. On the far left is a corner of the Capitoline Museum, and behind this is a portion of the Senators' Palace. In the center of the square is the Marcus Aurelius equestrian statue, and dominating the background is the Conservators' Palace. On the balustrade are sculptures discussed in the previous view, but with exaggerations of scale and perspective that are effective and convincing.

THE PHOTOGRAPH

My position was based on the perspective of the balustrade in the etching. The statue of Constantine looks nearly as tall as the trophy, and the interval between them is far greater than Piranesi allows. The relationship of the Dioscuri is less effective as seen in the photograph because the far group of sculptures is almost hidden. Piranesi "corrects" the deficiencies of the perspective by pulling forward all of the sculptures on the right of the balustrade. The artist's liberties in the etching are a triumph of art over fact.

29. VEDUTA DELLA BASILICA DI S. LORENZO FUOR DELLE MURA

View of the Basilica of St. Lawrence Outside the Walls (F.730, H.12; 376 x 662)

THE ETCHING

The Patriarchal Basilica of S. Lorenzo (St. Lawrence) Outside the Walls, one of the seven churches ritually visited by pilgrims to Rome, is a kind of fusion of two ancient churches, S. Lorenzo of the fourth century and the Church of the Virgin Mary of the eighth century. In the twelfth century a campanile and portico were added. The columns of the portico are taken from ancient Roman buildings, as was the custom in the Middle Ages. Successive restorations to S. Lorenzo were effected in later centuries. On July 19, 1943, it was heavily bombed by the Allies since a Nazi supply depot was close by in the railroad yards. It was carefully restored and reopened in 1949. Some precious decorations were destroyed beyond repair, including a ninth-century fresco on the facade protected by the portico. In the etching there is a Corinthian column on an inscribed pedestal, probably dedicated by Sixtus V, who as Pope toward the end of the sixteenth century spent vast amounts of money on the city, rebuilding and decorating, including this piazza in front of the basilica. The column is flanked by two large decorative posts on which there are sculptured designs typical of motifs used in the monuments built by Sixtus V. Decorations were also added to the upper story of the basilica, with the Pope's insignia above the center window. The piazza is enclosed by a ring of posts to prevent carriages from entering.

THE PHOTOGRAPH

The large tree on the right hides the top story of the Romanesque campanile. The sixteenth-century designs on the upper story of the basilica are gone, as are the decorations in the piazza. There is a new column, not visible in this photograph, on the far left, far different from the one seen in the etching. The new column is topped by a modern sculpture of Saint Lawrence holding his symbol of martyrdom. A number of the low posts are still evident on the right side of the piazza. The portico, in spite of the 1943 bombing, is still intact with its antique columns.

30. SPACCATO INTERNO DELLA BASILICA DI S. PAOLO FUORI DELLE MURA

Cross Section of the Interior of the Basilica of St. Paul Outside the Walls (F.792, H.7; 410 x 608)

THE ETCHING

Piranesi has cut through the facade in order to reveal this unusual aspect of the interior. He has made it easy to see not only the central wide nave, but also the four rows of columns that create a total of five aisles. This plan was typical of the ancient Roman basilica at the time when Constantine began the construction of St. Paul's on the spot where the Apostle suffered his martyrdom. Constantine's fourth-century St. Peter's was very similar; it preceded the building of St. Paul's and was much larger in every dimension. In this 1748 view we see the timbered ceiling, similar to that in the earliest Christian Basilica of St. Peter's. The evenly spaced columns of the nave create a dramatic perspective that converges upon the altar. The central nave terminates in a triumphal arch upon which are the fifth-century mosaics representing Christ giving His blessing, surrounded by angels and the twenty-four elders of the Apocalypse, while above them appear symbols of the Evangelists. In the half-dome of the apse are mosaics of a much later period, done in the first quarter of the thirteenth century under the sponsorship of Pope Honorius III. The Gothic tabernacle at the altar, designed by Arnolfo di Cambio, was erected in 1285. Above the four porphyry columns with gilded capitals appear statues of Sts. Peter, Paul, Luke and Benedict. Piranesi states in his caption that the eighty columns of the naves were taken from Hadrian's tomb. Some may have come from Hadrian's tomb but it is more likely that the shafts of the columns, though all antique Roman, came from various sources. The capitals, however, were in the main created specifically for this basilica. One early nineteenth-century source states that twenty-four of the beautiful fluted columns, almost forty feet in height, were from Hadrian's tomb, and that they were of pavonazzetto marble (peacock colors) cut from a single block, with bases and capitals of marble from the Greek island of Paros, whose quarries produced the superb white marble used by sculptors and architects since the sixth century B.C. Instead of the usual horizontal entablature, the columns support small arches in the manner that had been introduced in the Palace of Diocletian at Spalato (Split, Yugoslavia). The spandrels of the arches are covered with stucco tendrils. Above the arches are medallions containing in relief a chronological series of portraits of the Popes beginning with St. Peter. Above these are two tiers of murals painted about 1300 by Cavallini, although Piranesi draws them in a Baroque manner. The murals are separated by stucco colonnettes. At the top, next to the roof, are the clerestory windows. Piranesi also states that the floor of the nave was composed of broken pieces of marble removed from the ruins of antique buildings.

THE PHOTOGRAPH

In 1823, seventy-five years after Piranesi made this etching, a disastrous fire destroyed the entire nave and the facade. The ancient marble could not withstand the intense heat of the flaming timbers of the roof and the acid fumes further corroded the stone until most of the basilica lay in hopeless ruin. Fortunately, the mosaics of the triumphal arch were spared and the tabernacle as well as part of the apse were similarly saved. The basilica was rebuilt as we see it in the photograph. The new, lower, coffered ceiling suggests an ancient Roman basilica more than before. The portraits of the Popes are now done in mosaic. The windows are flanked by pilasters with Corinthian capitals and nineteenth-century paintings alternate with the windows. The new architectural design of the apse is, I think, an improvement and the mosaic above has been completely restored. The eighty columns of the naves are now polished monoliths of granite and the inlaid marble floor is typical of the geometric patterns of antique Roman design. Thus St. Paul's Outside the Walls was handsomely rebuilt and reopened in 1854. It is not the authentic ancient Christian basilica it was before the fire of 1823, but, like the old St. Peter's, it was crumbling from its vast old age and in need of major repairs. It was described in 1820 as having worm-eaten rafters and being a "hideous old church."

31. VEDUTA DEL CASTELLO DELL'-ACQUA FELICE
View of the Fountain of the Felice Aqueduct
(F.735, H.20; 402 x 683)

THE ETCHING

This is the first of the *Castelli*, or large architectural fountains, built in Rome. Designed by Domenico Fontana, the court architect of Sixtus V, it was completed in 1587. The entire monument is basically in the form of an ancient Roman triumphal arch, but Fontana's design, with its top-heavy attic, is badly proportioned. The huge marble slab containing the dedicatory inscription dominates the entire facade and succeeds only in glorifying the name of the Pope. Above this is the sculptured coat-of-arms of the Peretti family. (Before he became Pope, the name of Sixtus V was Felice Peretti. Acqua Felice signifies "the aqueduct sponsored by Felice.") Two obelisks, topped by a ball, complete the Baroque pediment. In the lower half are three arches forming recesses flanked by four engaged columns with a narrow entablature. The recesses contain figures from the Old Testament. The heavy figure of Moses, by Prospero da Brescia and Leonardo Sormani, occupies the center. The recess on the left contains the figure of Aaron in a bas-relief with other figures; the artist was Giovanni Battista Della Porta. The right recess has another bas-relief with the figure of Joshua; its sculptor was Flaminio Vacca. Four lions lying on their pedestals complete the fountain; these are copies of the ancient Egyptian originals which are in the Vatican collections. The actual display of the water from the fountains is scarcely noticeable since the ponderous sculpture overwhelms it. Across the street and to the left is the church of S. Maria della Vittoria, which contains the famous marble group *The Ecstasy of Santa Teresa* by Bernini. The facade of the church was designed by Giovanni Battista Soria in 1626; the interior, by Carlo Maderno, was finished in 1620. In the etching Piranesi has moved the church far to the left of its actual site so that he can show it in its entirety. He cleverly arranges the perspective of the street to convince the eye of the accuracy of the view.

THE PHOTOGRAPH

The true relationship of the church to the fountain is at once apparent. The posts along the widewalk in front of the fountain have been replaced by a marble balustrade and the balls atop the obelisks have been removed. The balcony to the right of the fountain is still intact but the free-standing eagle is now engaged in a wall. Piranesi's eagle is much more alive than it should be but he has endowed it with a vigor which is lacking in the actual sculpture. The imposing gate to a palace garden on the far right is gone and replaced by a hotel.

32. VEDUTA DELLA GRAN PIAZZA E BASILICA DI S. PIETRO
View of the Great Square and Basilica of St. Peter (F.787, H.101; 455 x 701)

THE ETCHING

This is one of the spectacular views that Piranesi etched of St. Peter's Square. It encompasses the entire setting, accurately establishing every detail of the facade and dome, the obelisk and fountains, the Vatican buildings and Bernini's colonnade. It is, of course, another of his 180° views, so that the propylaea or monumental entrances are seen on the left and right of the etching. As usual, his point of view is well above the ground level. St. Peter's is not only the Christian world's principal church but it is the largest by far. This site was in ancient times that of Nero's circus, the scene of numerous Christian martyrdoms. The first church of St. Peter was built by Constantine in the fourth century, shortly after his conversion to Christianity. It was huge, with five aisles and transept, but in keeping with the new Christian spirit, it was austere in design with a simple wood roof covered in tile. The church was built over the sarcophagus of St. Peter. For over a thousand years, the Basilica was the scene of a rich tapestry of history. Charlemagne, along with many other emperors and popes, was crowned in elaborate ceremonies of majestic solemnity. By the fifteenth century, however, the Basilica was in need of large-scale repairs. It had so far disintegrated that Pope Nicholas V decided that an entirely new structure was necessary. In 1452 actual work was begun on a design by Bernardo Rossellino completed in 1445. Little was done, however, in the next fifty years. Finally, after the accession of Pope Julius II in 1503, Bramante was selected as architect, his plans for a church in the form of a symmetrical Greek cross with a dome over the center having been approved. Bramante died in 1514 and Raphael, along with other architects, was placed in charge of the construction. Little was accomplished for they also died soon after. Peruzzi followed in 1520 and Sangallo the Younger after him in 1538. By this time several changes in the plans were recommended. Pope Paul III, in 1546, appointed Michelangelo as architect, and he returned to Bramante's original scheme. Construction proceeded to the top of the drum of his great dome before his death in 1564. Giacomo della Porta and Domenico Fontana completed the vast dome by 1590. The Egyptian obelisk, meanwhile, had been erected in the square in 1586 by Domenico Fontana, who had it moved from the piazza in front of the round church of S. Andrea, south of St. Peter's. Originally, Caligula had brought the obelisk from Heliopolis in Egypt and had it placed in the circus upon which St. Peter's is situated. Carlo Maderno transformed the interior plan from a Greek to a Latin cross, adding the long nave in 1605. In addition, Maderno designed the narthex and the facade. The completed church was dedicated in 1626 by Pope Urban VIII. Carlo Maderno had also built an early Baroque fountain in front of the Vatican Palace. Bernini changed the position of this fountain and duplicated it with his own version. These were placed on the south and north sides of the obelisk when Bernini was working on the colonnade enclosing the piazza. He was responsible for the design of the discharge of the water from the fountains. In his superb full Baroque manner, Bernini combined a cluster of small jets with a large one set in the center. This creates a tall crown of water that is topped by the central jet, which projects its stream high above the entire ensemble. The vast quadruple colonnade was completed by Bernini in 1667. Thus the history of the construction of the "new" St. Peter's and its piazza covers a period of two hundred and twenty-two years.

THE PHOTOGRAPH

Because of the problems of modern traffic and the fact that the street approaching the piazza is on a somewhat lower level, I had to move to a position that would place me as high as possible. As a result of this, the fountains are just outside the scope of the lens. My view, being earthbound, causes the obelisk to rise above the dome. The horse-drawn carriages in the foreground of Piranesi's eighteenth-century view have been replaced by motor cars but otherwise nothing has altered the basic design completed over three hundred years before my photograph was taken.

33. VEDUTA INTERNA DELLA BASILICA DI S. PIETRO IN VATICANO
View of the Interior of the Basilica of St. Peter in the Vatican (F.788, H.4; 403 x 601)

THE ETCHING

This view of the central nave includes four arches or bays on the left (south) aisle, the barrel vaulting and—in the center of the transept, under the giant dome—the high altar, with the apse behind it. Unlike most churches, the facade of St. Peter's is the eastern end. Piranesi has very strong light pouring into the nave from the north, with horizontal shadows from the piers. This becomes one of Piranesi's more unusual twists. He commands the play of light and shade in the manner of a theatrical director of today who would order powerful spotlights to pour in from the wings on the spectators' right. Carlo Maderno was mostly responsible for the interior design, carrying out the original plans by Michelangelo. The vaults, piers, arches, aisles and chapels are ornamented profusely, every surface treated with a lavish and extravagant decorative scheme. Bas-reliefs and sculpture appear in enormous quantities. In a smaller area this would have a suffocating effect but in this vast basilica it seems almost normal. The canopy (*baldacchino*) over the high altar was designed by Bernini. Seen from this point in the nave, the baldacchino seems almost small, though it is actually ninety-five feet high. It must be remembered that the dome rises to a height of three hundred and ninety feet, while the nave is six hundred and ten feet long. The ancient Romans would have felt very comfortable in this setting not only because the architectural features would have been familiar but the massive scale would have recalled the dimensions of the Baths of Caracalla. Through the baldacchino one can see in the apse another work by Bernini, the Throne of St. Peter, a wildly exuberant sculpture full of the overwhelming energy typical of this remarkable Roman artist. Like the baldacchino, the Throne sculpture is in bronze with enormous quantities of gilt.

THE PHOTOGRAPH

We see somewhat less than Piranesi's view provides in the peripheral areas but in every other respect, except one, nothing has changed. The etching indicates that the floor of the nave is without design. This has since been applied with inlaid colors of marble in geometric patterns. The visitor to St. Peter's is now completely surrounded by decoration on all sides and under foot as well.

34. VEDUTA DEL CASTELLO DELL'ACQUA PAOLA SUL MONTE AUREO
View of the Fountain of the Aqueduct of Pope Paul V on Monte Aureo (F.736, H.21; 399 x 614)

THE ETCHING

The fountain, as seen today, is on a terrace of the Via Garibaldi at the intersection of the Via di Porta San Pancrazio. This area is toward the south end of the Janiculum Hill, no longer called "Monte Aureo." The fountain, designed by Flaminio Ponzio and Giovanni Fontana for Pope Paul V, was erected in 1612. At the top is the Pope's coat-of-arms supported by two angels. The Latin dedication refers to the source of the water at Lake Bracciano and the further supply from Lake Martignano, referred to by its ancient Latin name of Alsietinus. The water pipes of the ancient aqueduct were replaced by new ones. The view to the right of the fountain, as seen in the eighteenth century, includes the small villa called the Casino Farnese and, to the far right in the distance, the dome of St. Peter's. In the middle ground a heavy wall encloses the grounds of the Casino Farnese. A large number of figures, animatedly enjoying the view of the city from the terrace, completes Piranesi's etching.

THE PHOTOGRAPH

Since the turn of the century the parks of the Janiculum Hill have undergone several changes. Roads have been built that cleared away all of the things seen in the etching on the right of the fountain. The terrace has been widened, the low wall in the foreground of the etching removed, permitting the Via Garibaldi to circle around the fountain at the right of the photograph.

35. VEDUTA, NELLA VIA DEL CORSO, DEL PALAZZO DELL'ACCADEMIA
View, on the Via del Corso, of the Palace of the [French] Academy (F.739, H.24; 399 x 618)

THE ETCHING

In 1725 the French Academy in Rome signed a lease to rent the Palazzo Mancini (now known as the Palazzo Salviati), which dominates the etching, from the center to the right foreground. The facade of the palace is typical of Roman Baroque design in the seventeenth century. The French installed an elaborate coat-of-arms of Louis XV above the central portico, between the top two stories. In certain rooms on the second floor, as Piranesi correctly states, casts of statues and bas-reliefs, including casts of the Column of Trajan, were exhibited. On the third floor was the director's apartment and on the fourth, student quarters, divided into small monastic cells and one spacious studio where the students worked communally. The Via del Corso is seen from nearly its source at the Piazza Venezia, continuing in a straight line to its other end at the Piazza del Popolo. Across the street, in the left foreground, is a portion of the Palazzo Doria, where today one can visit the galleries containing a fine collection of paintings along with a number of antique Roman sculptures. Piranesi etched this plate in 1752, not long after he had established himself in Rome. His studio was opposite the French Academy, and there he met the fine French painter Hubert Robert in 1759. The Academy's final history at this site was enacted in the turbulent years of the French Revolution. The palace was pillaged and set on fire by the Neapolitans in 1793. Finally, in 1803, when Napoleon as Consul wished to reinstate the artists there, it was no longer possible as it was felt that the palace, located on the busiest and noisiest artery in Rome, did not lend itself to the tranquility necessary for study. It was then that the Academy acquired the Villa Medici, where it has remained to this day.

THE PHOTOGRAPH

Louis XV's coat-of-arms vanished from the facade a long time ago. Brass plaques on two of the portico columns indicate that this is now the entrance to the Bank of Sicily. The post with the clock installed on the sidewalk (hardly improving the setting) has a sign that advertises the exchange facilities of the bank. Compare the size of the figures on the sidewalk with those in the etching. Again, Piranesi has dwarfed the figures to enhance the scale of the palace. The photograph had to be taken at a moment when the constant heavy traffic had quieted down (a Sunday morning). Patience rewarded me with an unimpeded view of the facade.

36. VEDUTA DI PIAZZA DI SPAGNA
View of the Piazza di Spagna
(F.795, H.18; 399 x 598)

THE ETCHING

The dramatic focal point of the piazza is the monumental stairway leading to the terrace at the top in front of the Church of the Trinità dei Monti. This represents another of Rome's justly famous architectural ensembles full of theatrical splendor. In the center foreground is the Fontana della Barcaccia, in the imaginative form of a boat set in an oval basin. This is one of two fountains supplied by the "Acqua Vergine," the other being the Trevi. This aqueduct carried the water along what is now the Via Condotti, which got its name from the Italian word for conduits or water pipes. The Via Condotti leads into the square from the extreme left of the etching. The Fontana della Barcaccia was designed by Pietro Bernini, father of the superlatively gifted Gian Lorenzo Bernini. In 1495 Pope Alexander VI approved of the foundation of the Church of the Trinità dei Monti, but from the beginning its history has been associated with the French. On the order of the French king Charles VIII, the French ambassador in the late fifteenth century had acquired the land on the Pincian Hill to build a monastery and church for the brothers of the Franciscan Order. The church was to have been built in the late Gothic style after the models of Rheims and Strasbourg. This plan was never fulfilled, though some interior architectural forms are Gothic, as in the transept and in the chapels. The stone for these details was actually shipped from France. The facade, with its two lateral towers, is in the early Baroque spirit of the Counter-Reformation and was finished in 1587. The double staircase of the main entrance was designed by Domenico Fontana, and in 1595 the upper piazza of the Trinità dei Monti was consecrated by Sixtus V. At that time, access to the top level of the hill was by steep paths made by horses and carriages and by pedestrians. In the early eighteenth century, the French began a project to build a staircase and commissioned Francesco De Sanctis to design it. The Romans, however, wished to use Alessandro Specchi. The French plan was preferred and was authorized by Pope Innocent XIII. Work was begun in late 1723 and about two years later it was completed. The director of the French Academy had proposed to decorate the balustrade of the middle terrace with statues of French saints to be sculptured by ex-students of the Academy but the home authorities in Paris rejected this plan. The two identical houses on each side of the steps are part of the original design and form the wings of a magnificent stage. The Spanish Embassy, out of sight to the right of the area in the etching and across the street, kept civil order in the area and, in fact, on the steps itself, where there were several confrontations with the Spanish guards. The French complained of the interference by a foreign power on their property but the Roman authorities ruled that the Spanish Embassy's sphere of jurisdiction included the steps. Soon the name of the hated Spaniards was attached to the lower piazza and even clung to the great stairway itself, which the French had built on their property with their own money. The eighteenth-century houses facing the piazza in the middle ground of the etching all belonged to the French monastery of the Trinità dei Monti. At the beginning of the nineteenth century, these houses were leased to various tenants. The one on the corner of the Via Babuino (at the far left in the etching) and the piazza contained a cafe with billiards, and later an English publishing firm produced an English-language newspaper there called *The Rome Advertiser*. The other houses became hotels and apartments, and the house to the left of the steps was used by the American Legation in Rome from 1863 to 1868. It is now occupied, and has been for years, by Babington's Tea Rooms. The house to the right of the steps became a *pensione*; in a small apartment with windows facing the steps, the English poet Keats lived—and died there in 1821. In 1909, a foundation was begun by some English and Americans to honor the memory of the two great English poets, Keats and Shelley, who are buried in Rome. The house is now the Keats and Shelley Memorial and contains a library of their works, diaries, written accounts of their trips in Italy, and the like.

THE PHOTOGRAPH

As usual, the camera cannot compete with Piranesi's vast panoramic sweep of 180°. Instead it concentrates on the essentials of the square: the Fontana della Barcaccia in the foreground, the monumental staircase popularly known as "The Spanish Steps," the Trinità dei Monti with its twin towers and the obelisk added to the piazza in front of the church in 1789—thirty-nine years after Piranesi had etched this view. At the time this photograph was taken, the French monastery to the left of the church was undergoing repairs, and a large portion of the facade is covered by a straw matting over the scaffolds to protect the workmen.

37. VEDUTA DELLA FACCIATA DELLA BASILICA DI S. CROCE IN GERUSALEMME
View of the Facade of the Basilica of The Holy Cross in Jerusalem (F.729, H.11; 397 x 614)

THE ETCHING

The Baroque facade of the eighteenth century is literally a cover over a history that goes back to the enormous palace of Heliogabalus (emperor 218–222 A.D.). The Amphitheatrum Castrense, which was later to be incorporated as part of the Aurelian Wall, formed part of it. The atrium of the palace was converted by Constantine into the Church of the Holy Cross in 320 A.D. to guard and honor the relics of the Cross brought back from the Holy Land by his mother, St. Helen. The church was rebuilt in 1144 in the Romanesque manner of the time. Finally, in 1743, Pope Benedict XIV had the Rococo facade designed by Domenico Gregorini and Pietro Passalacqua. The campanile remained as it was in the twelfth century. In the immediate foreground are the typical Piranesi touches of antique rubble and a group of figures stooped by unknown deformities, leaning on their long staffs. At the bottom of the far right is a more unusual figure—a man, completely nude, seated among the pieces of rubble.

THE PHOTOGRAPH

Some minor details have changed the facade on the right. The old door with its sturdy and handsome little Romanesque portico, has been removed and replaced by a nondescript door. The fenestration on the upper floors above this has been altered, throwing off balance the simple but rhythmic pattern of the old facade. A second, smaller door has been built to the left of the larger one. A clock has been installed in the campanile, detracting from the purity of the twelfth-century design. On the extreme right a large tree trunk blocks the sight of the lower wall which was part of the monastery. The main central facade has remained intact.

38. VEDUTA IN PROSPETTIVA DELLA GRAN FONTANA DELL'ACQUA VERGINE DETTA DI TREVI
View in Perspective of the Great Fountain of the Aqueduct of the Virgin, Called the Fontana di Trevi (F.734, H.104; 472 x 710)

THE ETCHING

Piranesi apparently sketched this view from the top story of one of the houses opposite the fountain. In his typical, very wide-angled view, he depicts the entire setting. The architect of the fountain was Nicola (or Nicolò) Salvi, as Piranesi states on the etching. Salvi began the construction in 1732, but it was not yet completed at his death in 1751. It was finished in 1762 by Bracci, who also sculptured the ocean group with its marine horses. The sculpture is dominated by the figure of Neptune, who stands in a kind of chariot made of a giant shell, which occupies the central niche. Several other eighteenth-century artists completed the rest of the sculptures on the facade. The entire ensemble constitutes the largest and most splendid of Rome's architectural fountains. It was built against the Palazzo Poli, the family residence of Innocent XIII. It was this Pope who initiated the decoration of this side wall of his palace, which stood close to the distributing tank of the Acqua Vergine.

THE PHOTOGRAPH

Since it was not possible for me to photograph the entire structure from the center, it was necessary to move to the right of the piazza, on the steps of the church of Ss. Vicenzo e Anastasio. From this point I was able to take in the whole facade of the Trevi.

39. VEDUTA DELLA VASTA FONTANA DI TREVI ANTICAMENTE DETTA L'ACQUA VERGINE
View of the Vast Fontana di Trevi, Formerly Called the Aqueduct of the Virgin (F.797, H.19; 395 x 550)

THE ETCHING

This is seen sharply from the left side, sending the far end of the fountain into deep perspective. This is another of Piranesi's 180° views, ranging from the far left side of the fountain to the extreme right side of the piazza, with its houses facing the fountain. The church mentioned in the preceding note is here seen in the right background. This church was popularly called "the Organ" because of the many columns, like organ pipes, on its Baroque facade.

THE PHOTOGRAPH

In spite of the use of my wide-angle lens, the photograph as compared to the etching looks like a small detail of the setting. I could have stepped back a few yards, but I could not reduce the people in front of the camera to Lilliputians, as Piranesi conveniently did in his view. The figures with which I had to contend would have constituted major obstructions to the camera's view. Hence I was obliged to forfeit the wider view for the unobstructed one.

40. VEDUTA DI PIAZZA NAVONA SOPRA LE ROVINE DEL CIRCO AGONALE
View of the Piazza Navona above the Ruins of the Games Stadium (F.733, H.108; 466 x 705)

THE ETCHING

The Piazza Navona (corruption of the Greek *agon*, "contest") occupies the site of a stadium built by Domitian in 96 A.D. and restored by Alexander Severus in 228 A.D. It was used primarily for athletic games and gladiatorial matches. The piazza has faithfully preserved the outline of the stadium while the buildings facing it complete the outer contour. The foundations of these buildings were supported in part by the remains of the ancient stadium. The foreground of the etching is almost completely occupied by the large fountain executed by Giovanni Antonio Mari (1655) based on a sketch by Bernini and called "The Fountain of the Moor" after the features of the central figure, whose back we see. Four mermen blowing double shell-like horns from which streams of water flow, and large fantastic heads supported by small sea monsters, complete the composition of this characteristically Baroque design. On the left is the Palazzo Pamphili, the great palace built by Innocent X for himself and his family, which was designed by Girolamo Rainaldi (completed 1650). Innocent X was the major factor in the development of the Piazza Navona as we see it in Piranesi's etching. After Rainaldi had begun the church of S. Agnese in Agone, to the right of the palace, the Pope assigned the rebuilding of it to Borromini, who was responsible for its Baroque facade and dome, with its concave and convex lines, facing the piazza. The Pope then wished to erect an obelisk which he saw lying near the Via Appia, where it had been placed in the circus of Maxentius early in the fourth century. Prior to that it was in the Temple of Isis built by Vespasian's sons, Titus and Domitian. (It was not until 1822, when Champollion deciphered the obelisk's inscription, that it was established to be not Egyptian but Roman work with the names of Titus and Domitian incised in the Egyptian hieroglyphs.) The Pope ordered his architect Borromini to design a monumental fountain to support the obelisk, but the design did not satisfy him. Bernini, through a ruse in cooperation with the Pope's sister-in-law Olimpia, was able to place a small model of his design for the fountain in the Pope's palace. Olimpia conducted the Pope to the room where the model was exhibited. The Pope admired it and commissioned Bernini to start work on it at once. It represents an artificial rock on which are seated giant figures representing the Gods of four rivers, the Ganges, Río de la Plata, Nile and Danube, all executed with Bernini's typical passionate energy. At the top of the obelisk is a dove, calmly perched, a symbol from the Pamphili coat-of-arms. A third fountain, seen in the etching at the far end of the piazza, was a comparatively simple one, but with a large basin designed by the early Baroque architect Giacomo Della Porta (1574). This basin is quite similar to the one in the foreground.

THE PHOTOGRAPH

The photograph was taken late in November, when the Romans had already begun the annual building of temporary wooden stalls that would eventually completely enclose the piazza with their temptations for Christmas shoppers. The only important addition to the piazza is unfortunately hidden by the central Bernini fountain. This was the sculpture of Neptune and other marine figures executed by Antonio Della Bitta and Gregorio Zappalà in 1873 and placed in Della

Porta's basin (now called the Fontana del Nettuno) at the north end of the piazza. The sculpture, while not memorable, does complete the Baroque ensemble of the entire piazza—one of Rome's remarkable settings.

41. VEDUTA DELLA PIAZZA DEL POPOLO
View of the Piazza del Popolo
(F.794, H.14; 402 x 543)

THE ETCHING

Dominating the center foreground is an ancient Egyptian obelisk. Augustus removed this from Heliopolis and placed it in the Circus Maximus. By the order of Sixtus V, it was installed in its present position in 1589. It is now called the Flaminian obelisk since it faces to the north the famous Via Flaminia. Twin Baroque churches occupy the middle ground where three important streets converge. The churches, S. Maria in Montesanto on the left and S. Maria dei Miracoli on the right, were begun by Carlo Rainaldi and completed by Carlo Fontana and Bernini in the seventeenth century. The Via Babuino leads into the piazza from the left, the Via del Corso from the center, and the Via Ripetta from the right. In the eighteenth century the streets were unpaved and in Piranesi's etching the deep muddy tracks made by the carriages are distinctly apparent.

THE PHOTOGRAPH

The Piazza del Popolo was redesigned by Giuseppe Valadier from 1816 to 1820. He added at the base of the obelisk a fountain of four lions, spouting water into basins below them. Statues of the four seasons, placed at the far corners of the square, were also installed. Two of these are visible in the photograph.

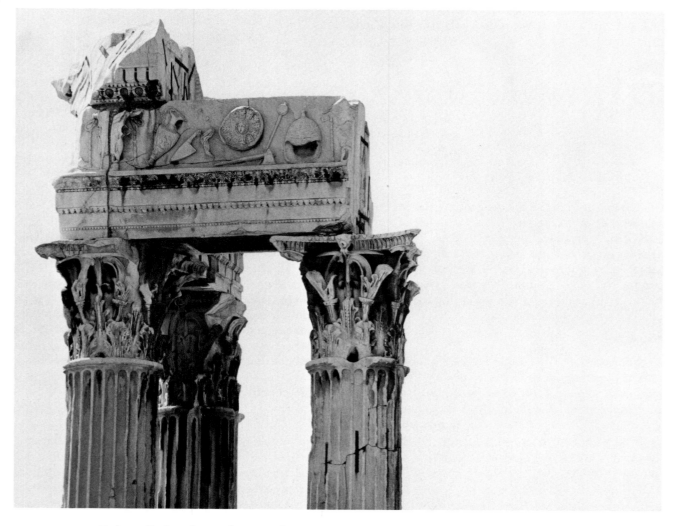

Enlarged detail of photograph showing the capitals and entablature of the Temple of Vespasian. See Notes to View 14, page xvi.

VIEWS OF ROME

THEN AND NOW

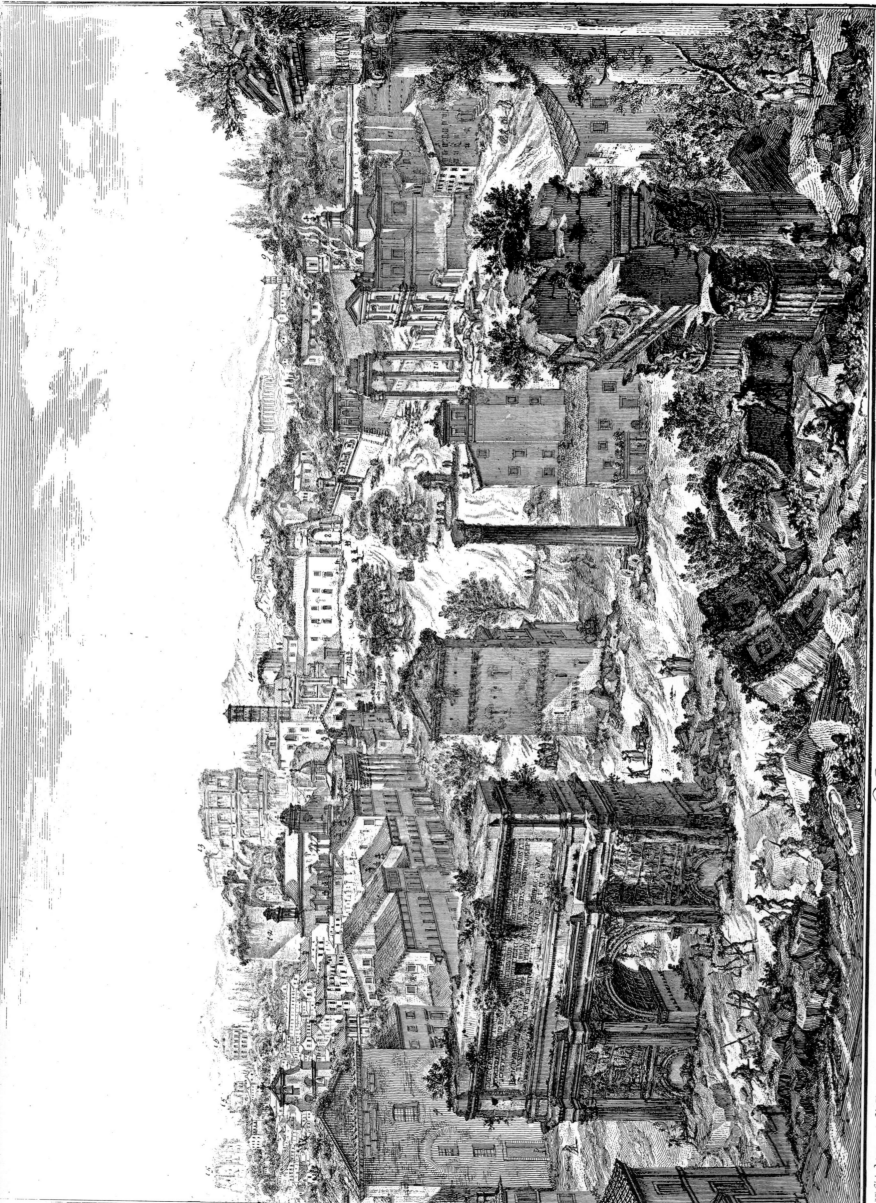

Veduta di Campo Vaccino

1. Veduta del Tempio di Giove Tonante
2. Veduta del Tempio della Concordia
3. Arco di Settimio Severo
4. Adrittio Erario oggi S. Adriano

5. Tempio d'Antonino, e Faustina
6. Tempio di Romolo, e Remo, oral. Cosmo, e Dami.
7. S. Francesca Romana
8. Arco di Tito

9. Veduta del Palazzo de' Cesari nel Palatino
10. Sestione del Tempio di Giove Statore
11. Mucroglioni dei Rostri
12. Avanzi del Tablino della Casa aurea

13. Colosseo
14. Avanzo di due Triclinj della Detta Casa aurea
15. Veduta delle Terme di Tito
78

Presso l'autore a Strada Felice vicino alla Trinità de' monti

Piranesi del. Scalp.

1 *[First] View of the Cow Pasture [Roman Forum]*

Veduta di Campo Vaccino

1. Colonna del Tempio stato di Giove Statore.
2. Chiesa di Santa Maria Liberatrice piantata nel sito dove anticamente era il...

Tempio di Vesta.
3. Vestigi del palazzo de Cesari sul Palatino.
4. Orti Farnesiani.

5. Arco di Tito.
6. Chiesa di S.a Francesca Romana.
7. Colosseo.

8. Avanzi del Tablino della Casa Aurea di Nerone volgarmente detto il Tempio della Pace.

9. Tempio di Romolo e Remo in og: gi Chiesa di SS. Cosmo e Damiano.
10. Tempio di Antonino e Faustina.

11. Tazza antica di granito di un sol pezzo situata nel luogo dove una volta era il lago Curzio. Cambr. Piranesi in...

2 Veduta di Campo Vaccino

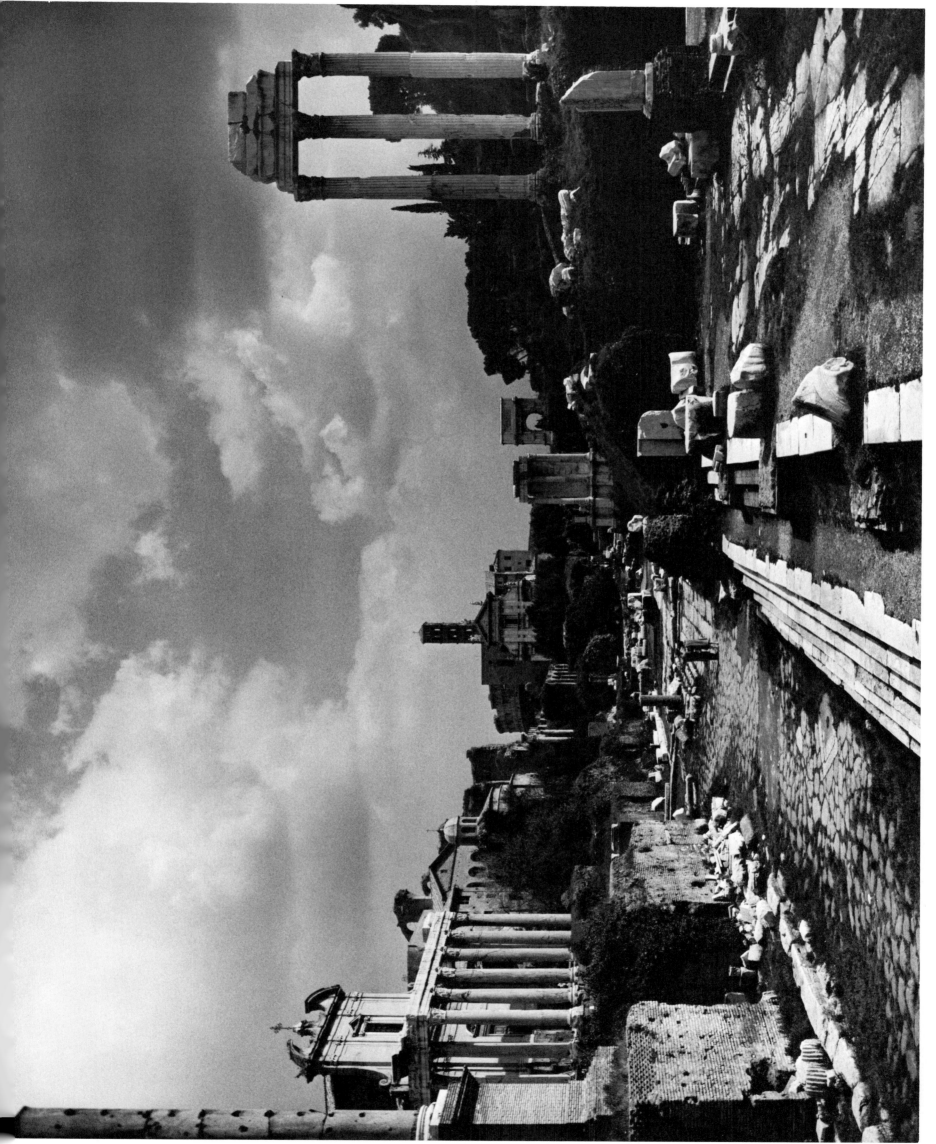

2 [Second] View of the Cow Pasture [Roman Forum]

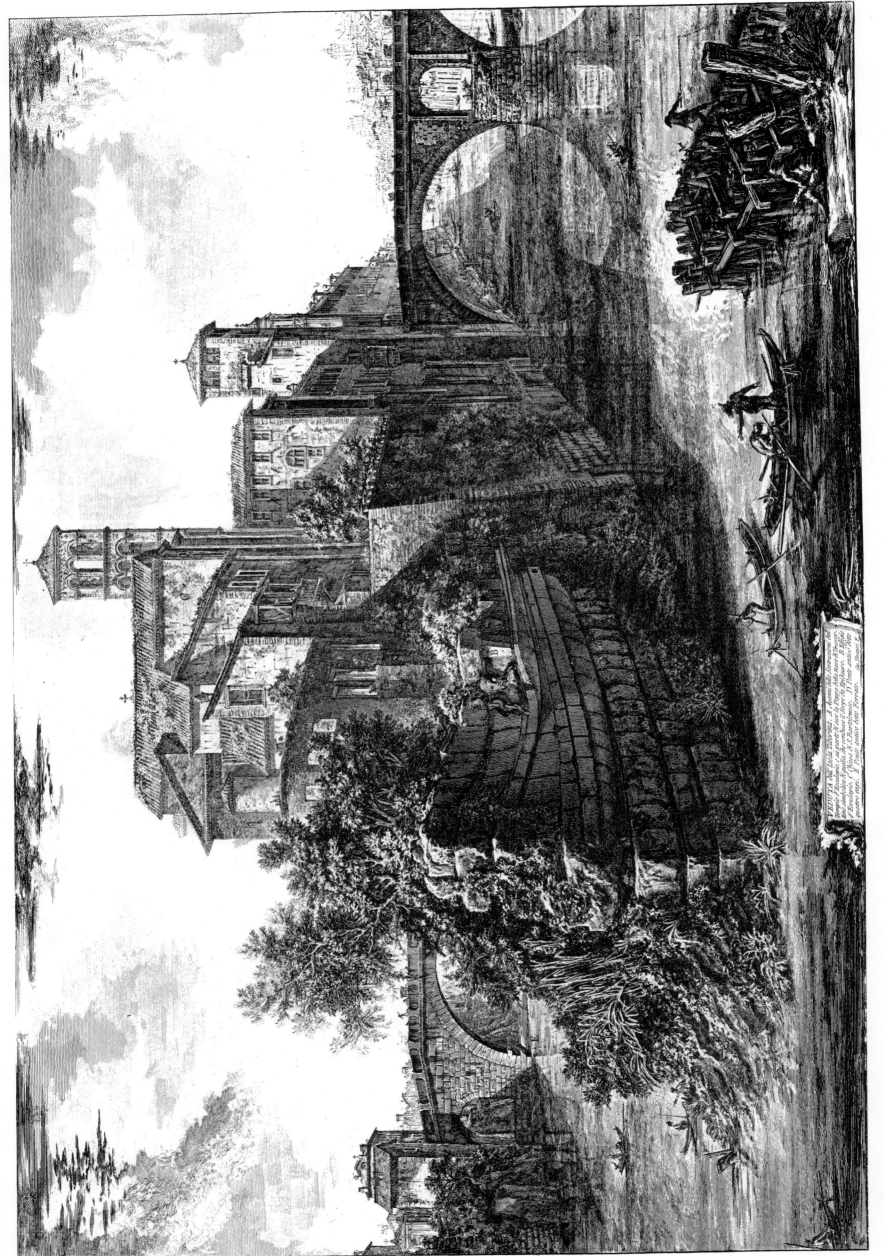

3 *Veduta dell'Isola Tiberina*

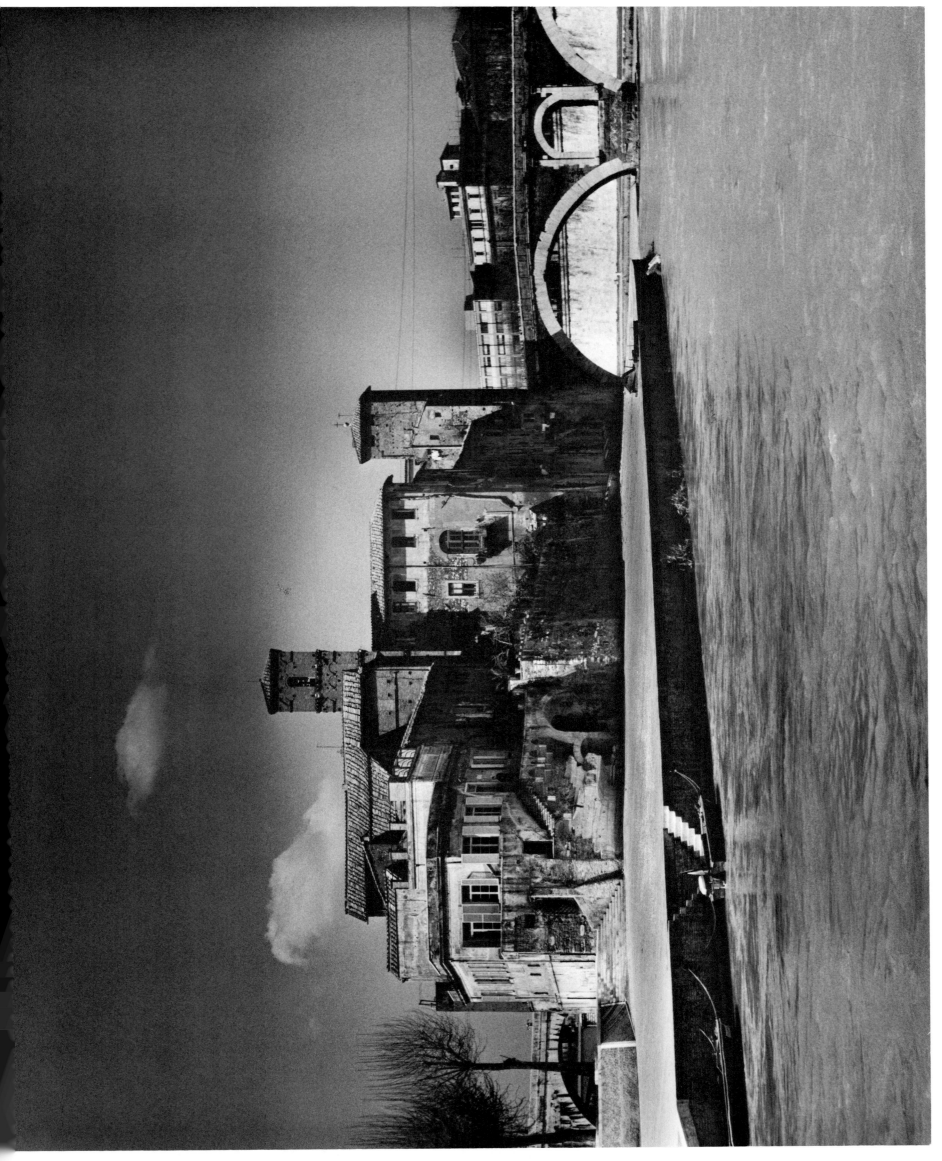

3 *View of the Isola Tiberina (Tiber Island)*

4 Veduta del Ponte Fabrizio

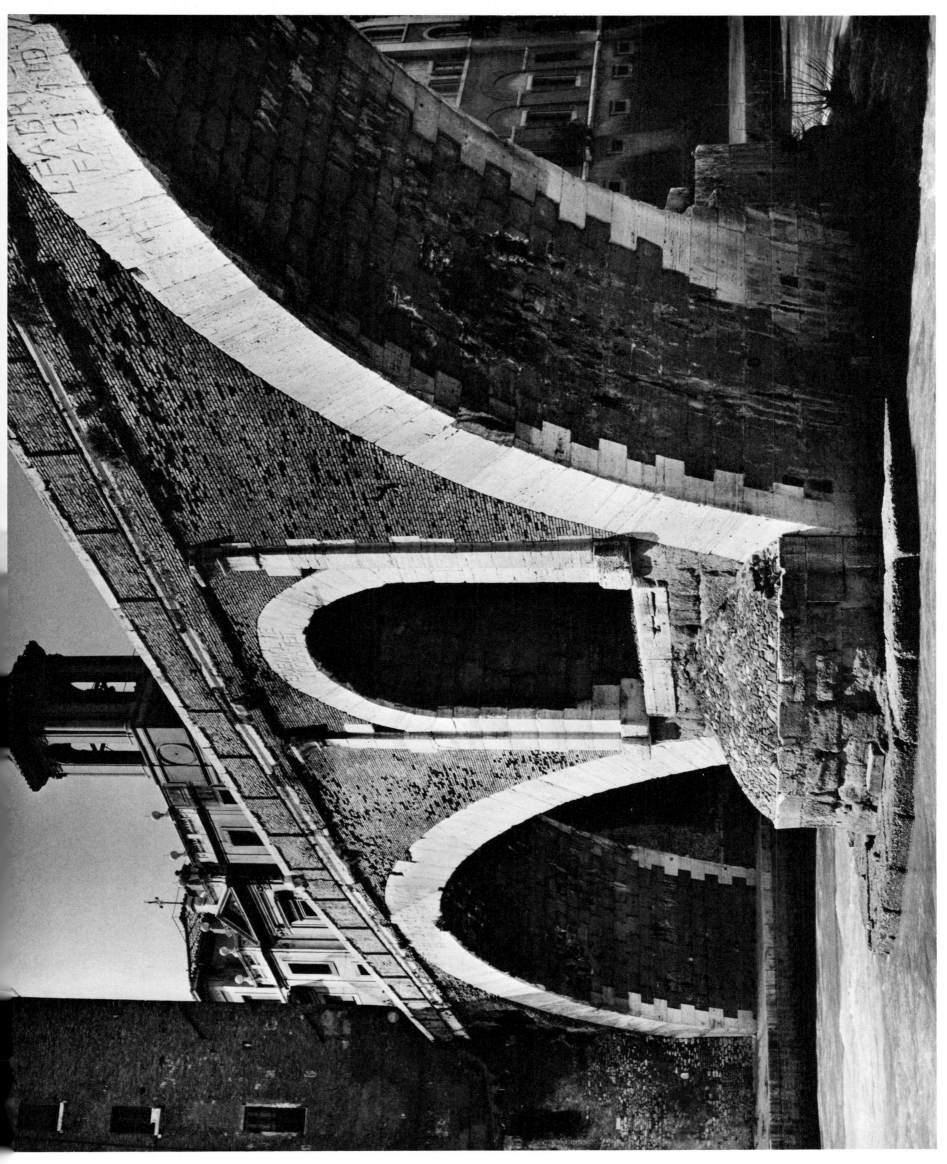

4 *View of the Ponte Fabricio (Fabrician Bridge)*

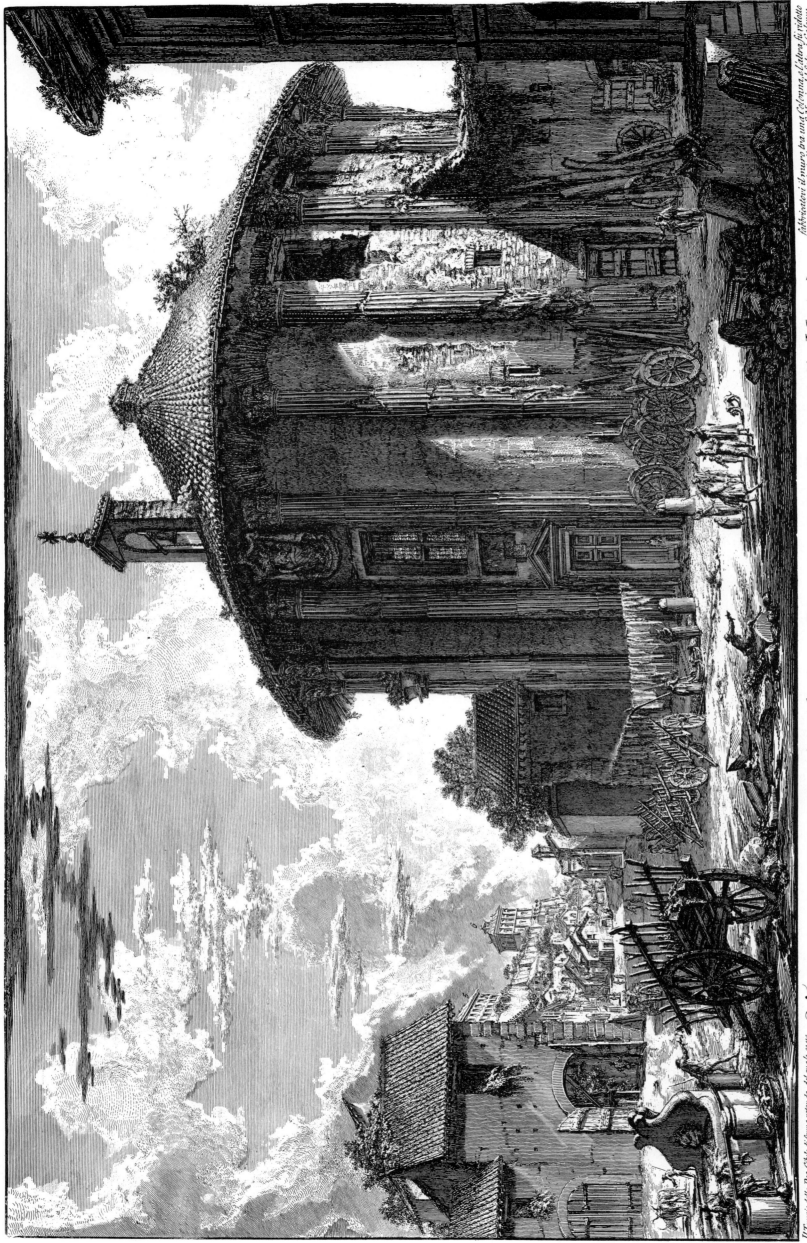

Veduta del Tempio di Cibele a Piazza della Bocca della Verità

Fabbricatori il muro tra una Colonna, e l'altra fu ridotto
ad uso di Chiesa, dedicata a S. Maria del Sole. 4 Colonne
di Chiesa, dedicata a S. Maria. 4 Colonne
del Portico principale, coloro Capitelli. 2 Muro moderno. 3
Il Tempio. 4 Avanzi delle strutture, ed altri a quelli se-
condano, de quali si Portale col frutto della Pina, una trab-
parecchi del Tempio di Pinno. 5 Metafore di S. Alessio. 6 Il Pri-
parecchi del Tempio di Pinno. 5 Metafore di S. Alessio. 6 Il Pri-
vestri di Malta

Presso l'autore a Strada Felice vicino alla Trinità de'monti

Il Tempio della Dea Cibele di forma rotunda, del quale se ne
vede ancori l'avanza in circondato a tun nobilissimo Por-
tico, formato da muro, ed altre pianelle, coloro Capitelli,
ed uso di Chiesa, ed altro a quelli se-
Dietri della Dei, à cui era svolgendo il Tempio. Piareno
Casetti del So Pontica; i marmi del Frutica à Architetto, e

5 Veduta del Tempio di Cibele a Piazza della Bocca della Verità

5 *View of the Temple of Cybele in the Piazza della Bocca della Verità [Temple of Vesta]*

ALTRA VEDVTA DEL TEMPIO DELLA SIBILLA IN TIVOLI
1 Cella del Tempio. 2 Vestigij del pronaotale 2, della gutta. 3 Muro della celda di opera incerta.
4 Empicican, d'ia riempitura del muro della cela. 5 Colonna tra sono dessere vedono.

6 Altra Veduta del Tempio della Sibilla in Tivoli

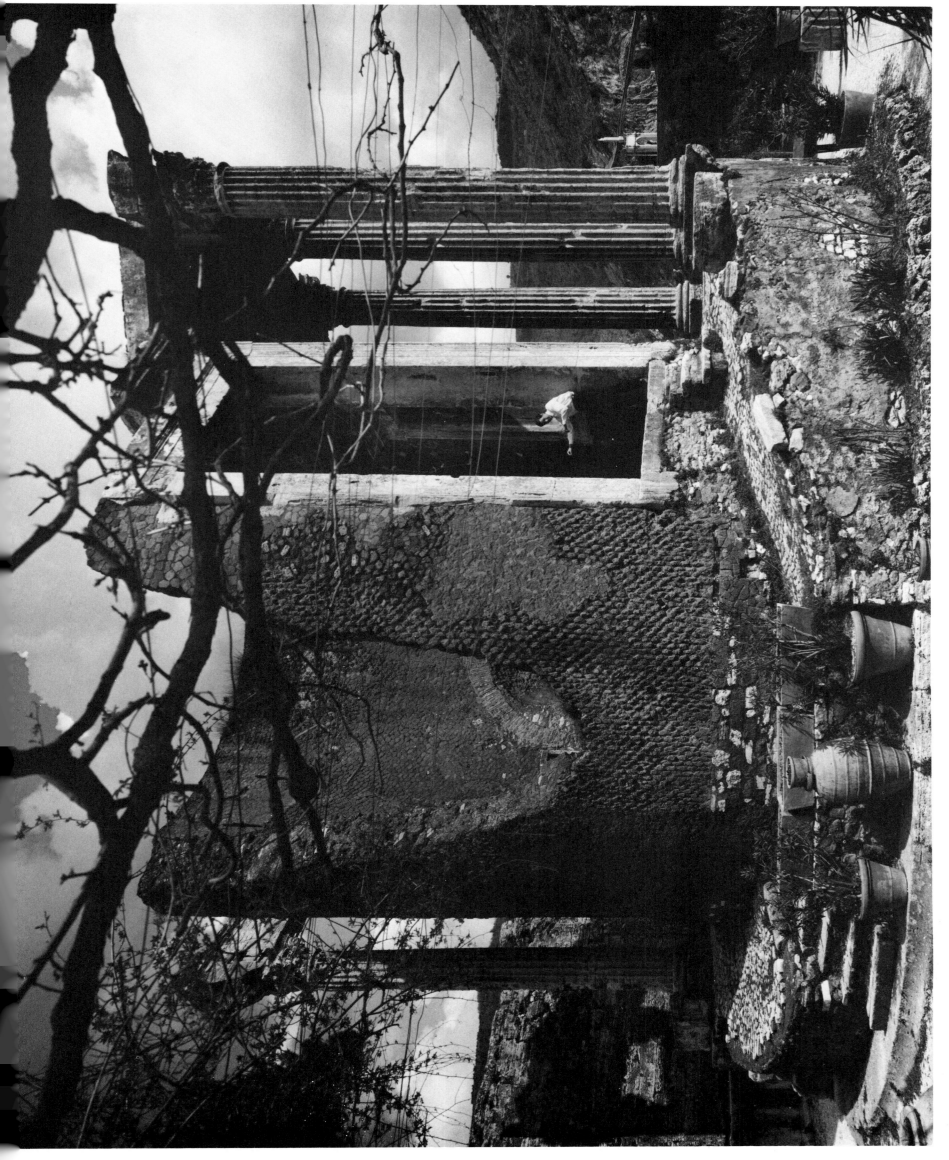

6 *Another View of the Temple of the Sibyl in Tivoli*

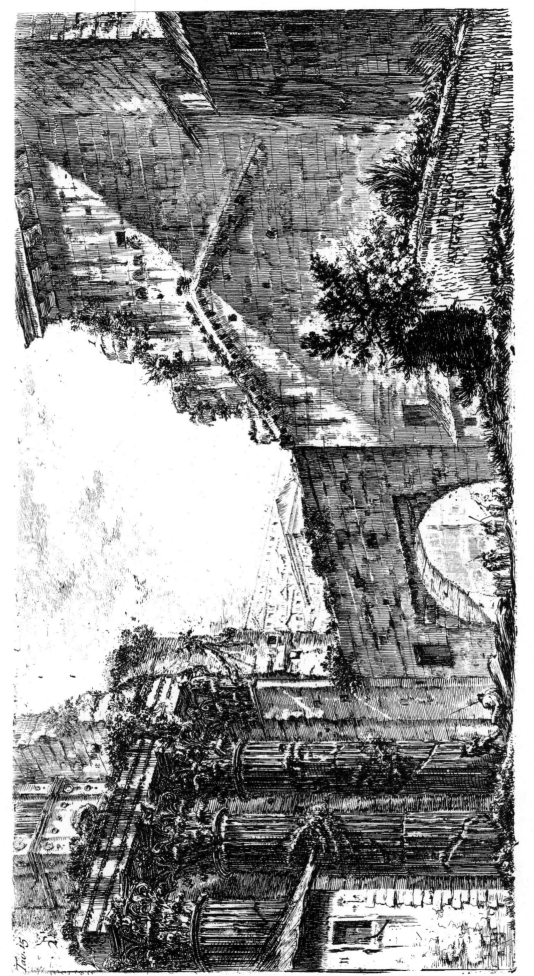

7 *Foro di Augusto*

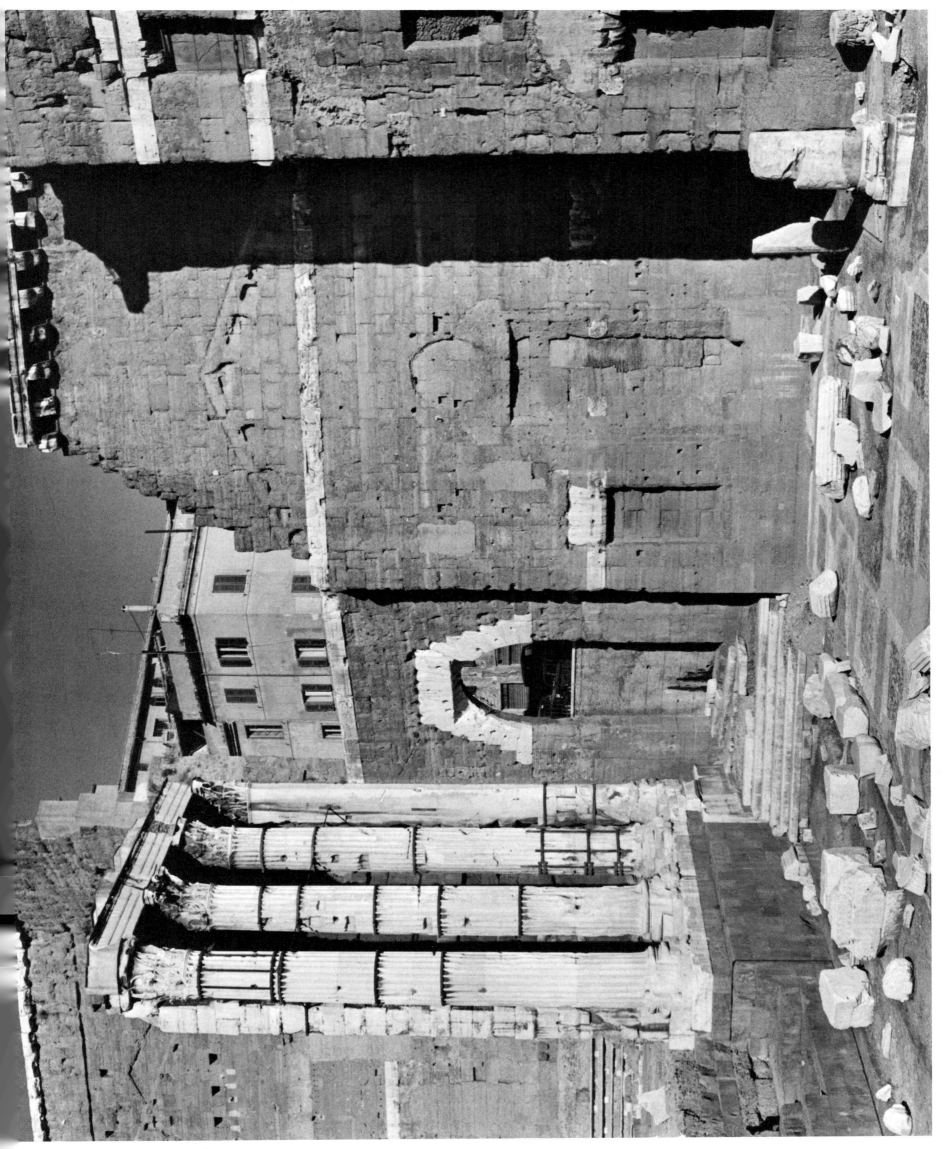

7 *Forum of Augustus*

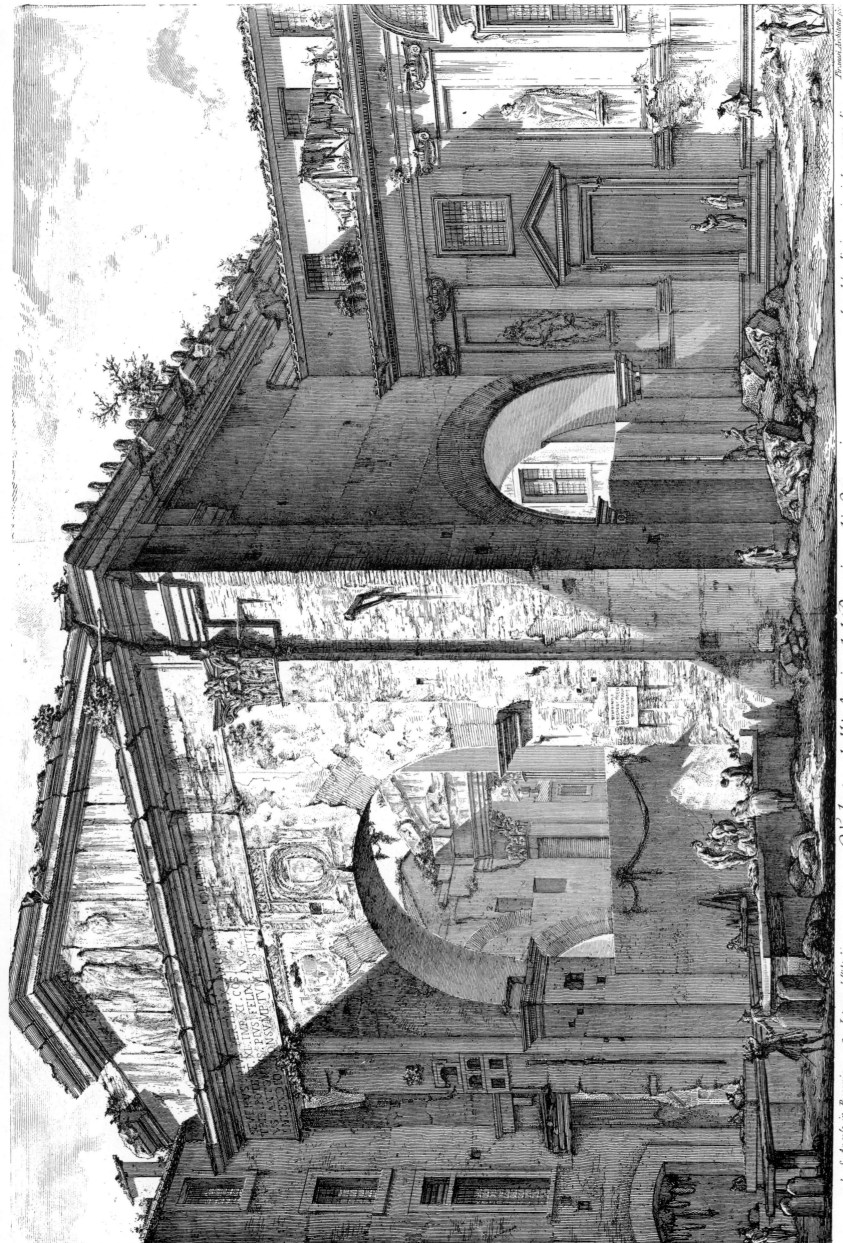

Veduta dell'Atrio del Portico di Ottavia.

1. S. Angelo in Pescaria. 2. Interno dell'Atrio cadaun de'quali si scorge in piede un pezzo di marmo Firmon Architet.
3. Tavolini di marmo, che copriano l'Atrio. intagliato di un'Aquila in basso rilievo. 4. Titure moderne.

Presso l'Autore a Strada Felice vicino alla Trinità de'monti

8 Veduta dell'Atrio del Portico di Ottavia

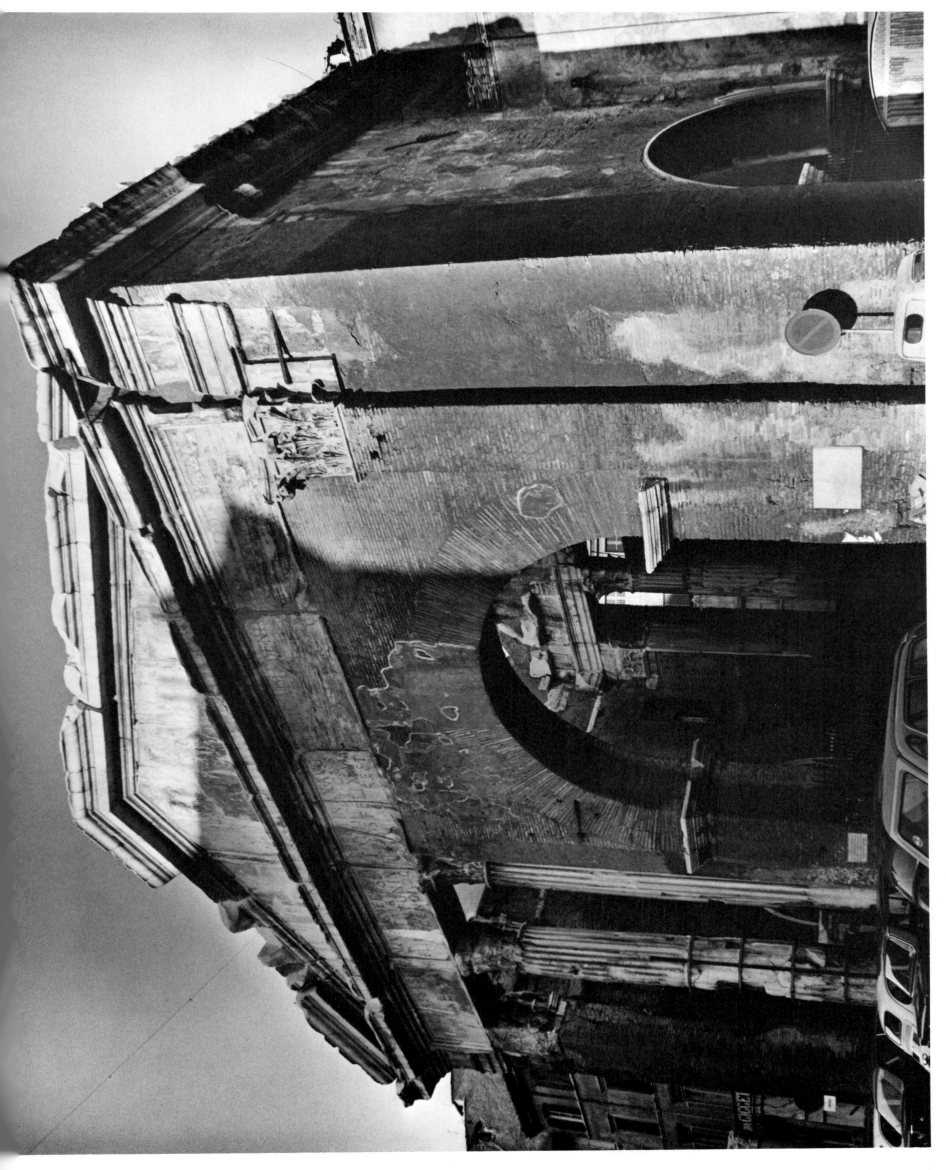

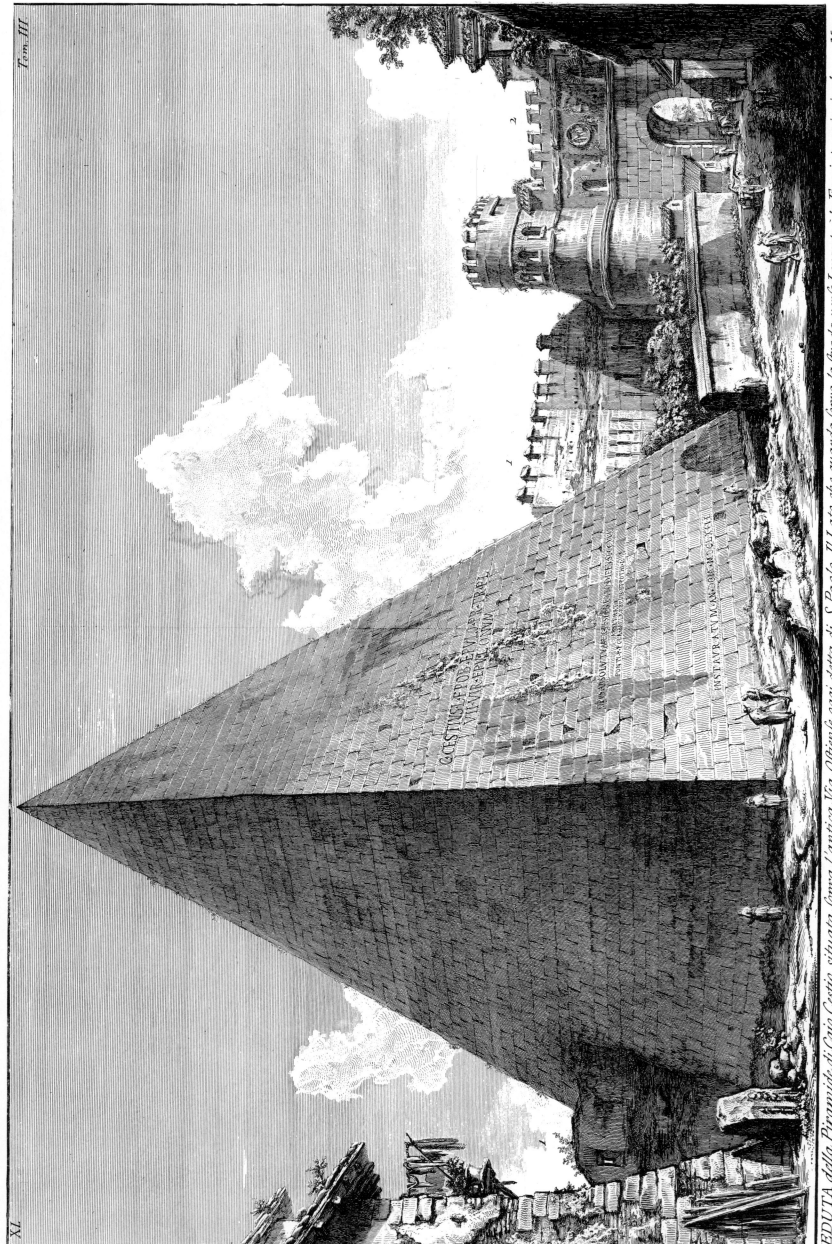

VEDUTA della Piramide di Cajo Cestio, situata sopra l'antica Via Ostiense, oggi detta di S.Paolo. Il Lato, che guarda sopra la strada verso Levante, è la Facciata principale. 1 Mura di Roma, le quali sono congiunte ai lati della Piramide. Furono esse dilatate sino a questo Sepolcro dall'Imperatore Aureliano; e poscia quivi ristabilite ne' tempi posteriori. 2 Porta Ostiense detta oggi di S. Paolo.

Piranesi Archit. dis. dim.

9 *Veduta della piramide di Cajo Cestio*

9 *View of the Pyramid of Caius Cestius*

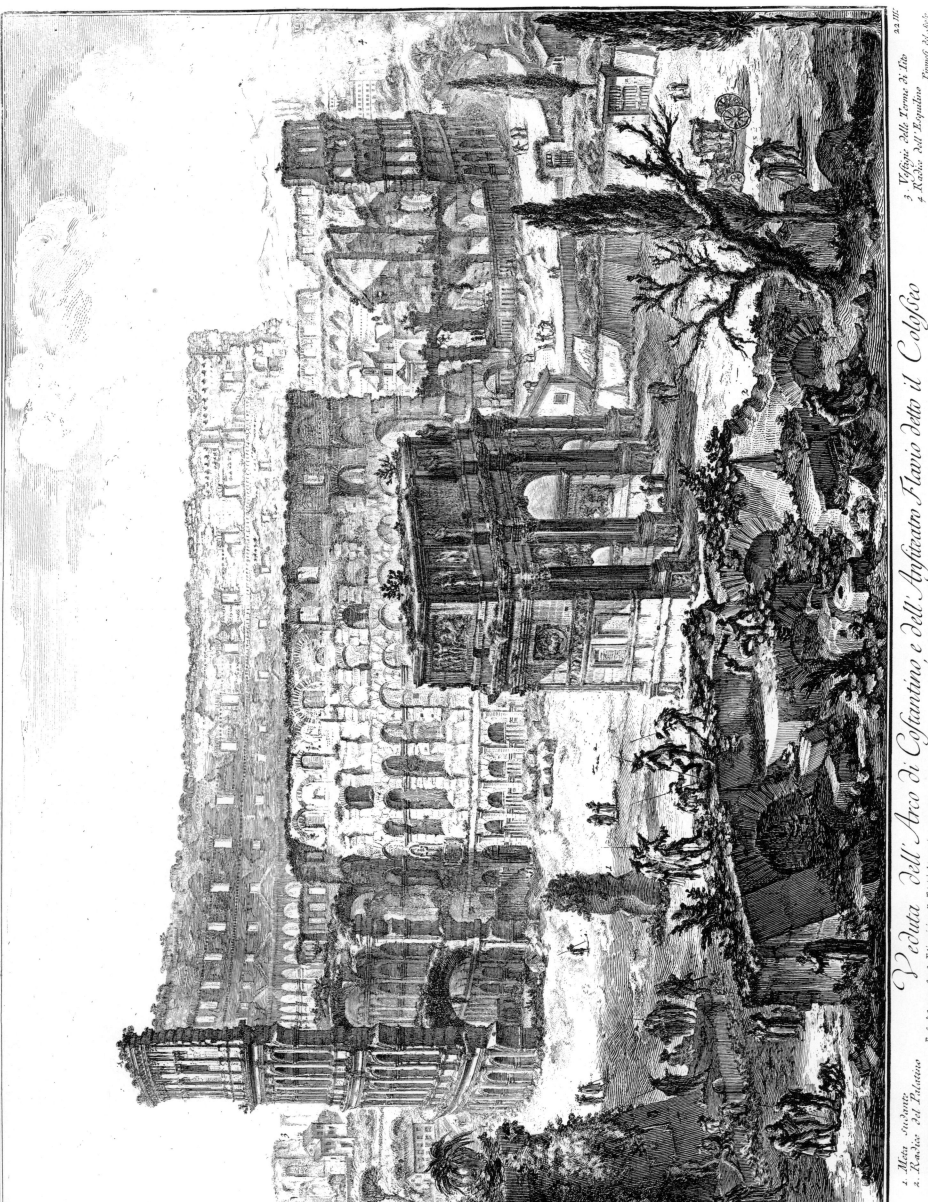

Veduta dell'Arco di Costantino, e dell'Anfiteatro Flavio detto il Colosseo

1. Meta sudante. 3. Vestigie delle Terme di Tito.
2. Radici del Palatino. 4. Radice dell'Esquilino.

Presso l'Autore a Strada Felice vicino alla Trinità de' monti Piranesi del. scolp.

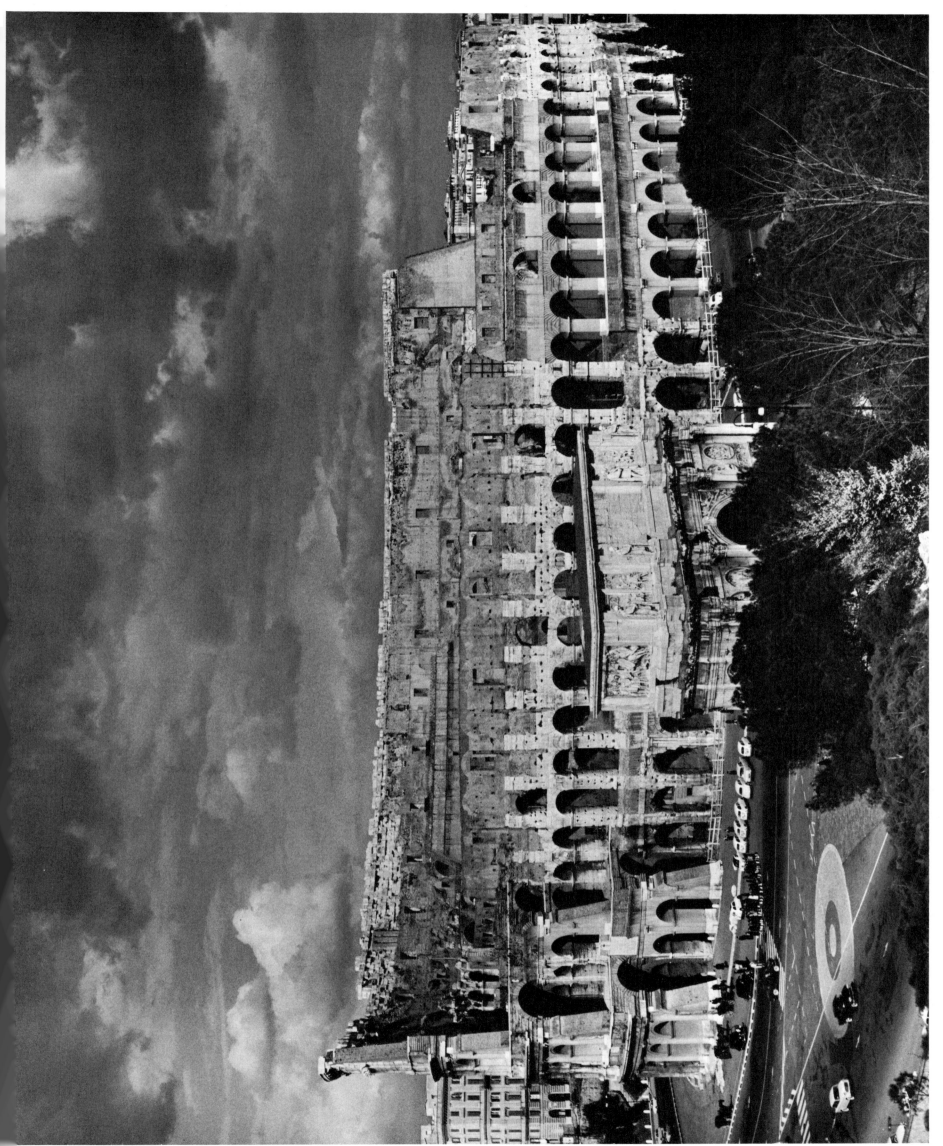

10 *View of the Arch of Constantine and the Flavian Amphitheater, Called the Colosseum*

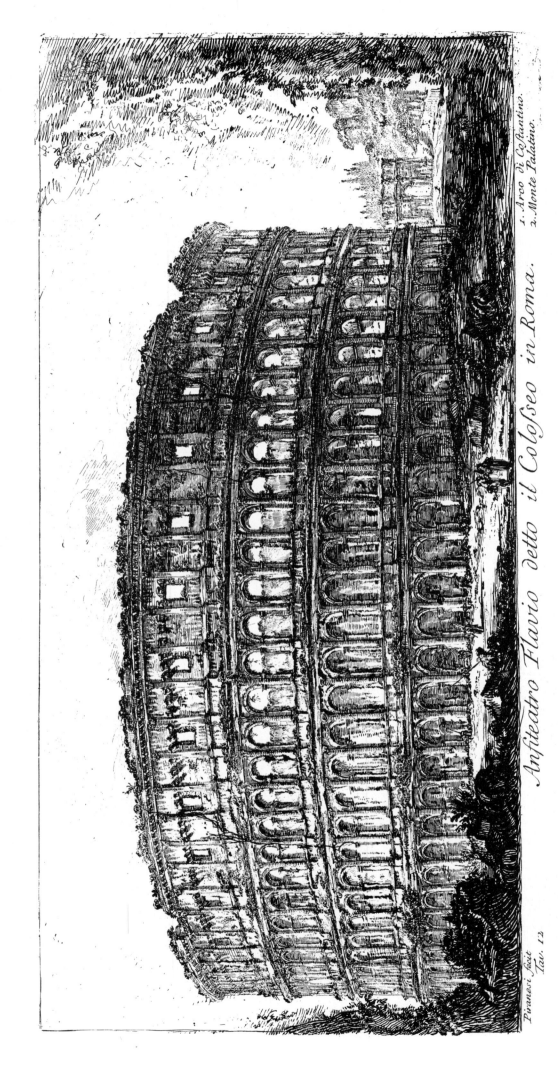

Piranesi facit.
Tav. 12

Anfiteatro Flavio detto il Colosseo in Roma.

1. Arco di Costantino.
2. Monte Palatino.

11 Anfiteatro Flavio detto il Colosseo in Roma

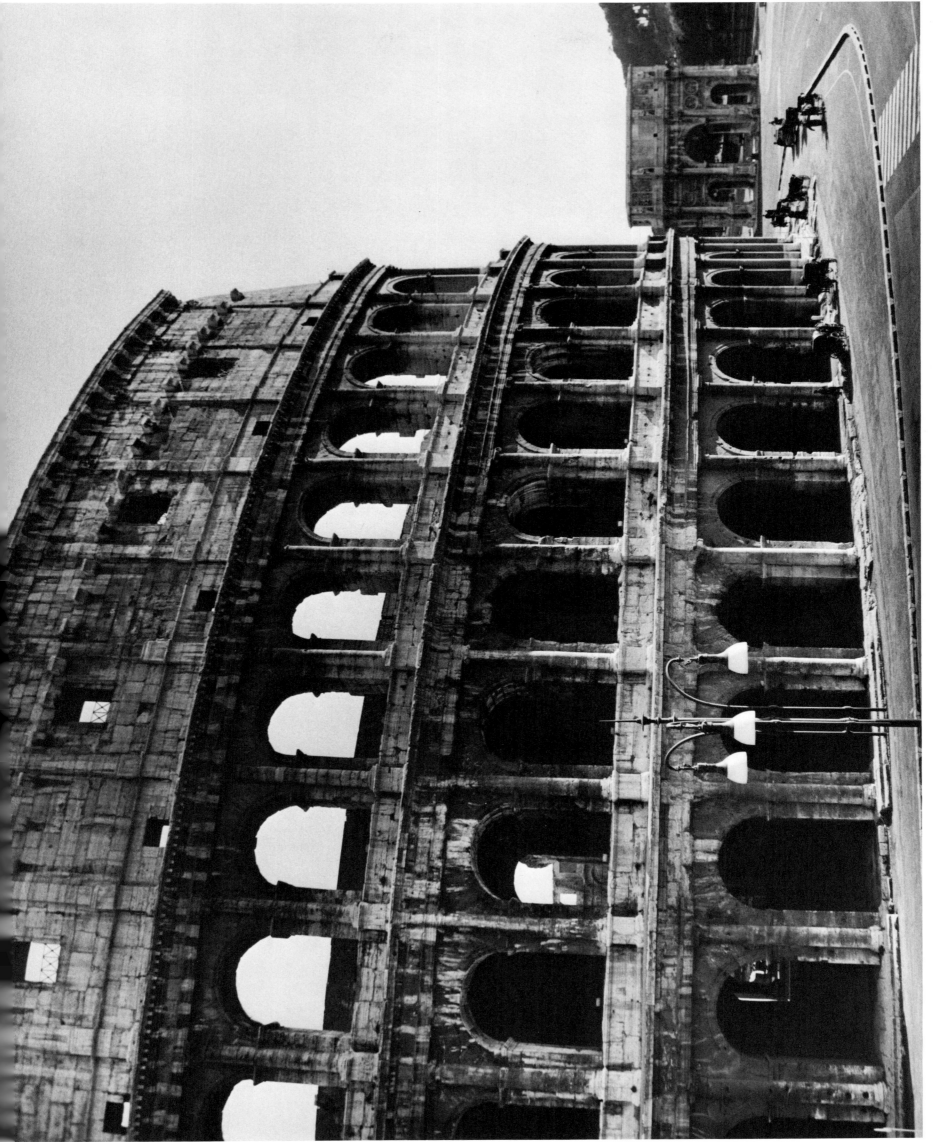

11 *Flavian Amphitheater, Called the Colosseum, in Rome*

SENATVS
POPVLVSQVE ROMANVS
DIVO TITO DIVI VESPASIANI F
VESPASIANO AVGVSTO

Veduta dell'Arco di Tito
1. Villa Farnese. 2. Luogo detto il Tempio detto di
Giove Statore. 3. Monte Capitolino. 4. Ruine
del Tempio detto della Pace. 5...

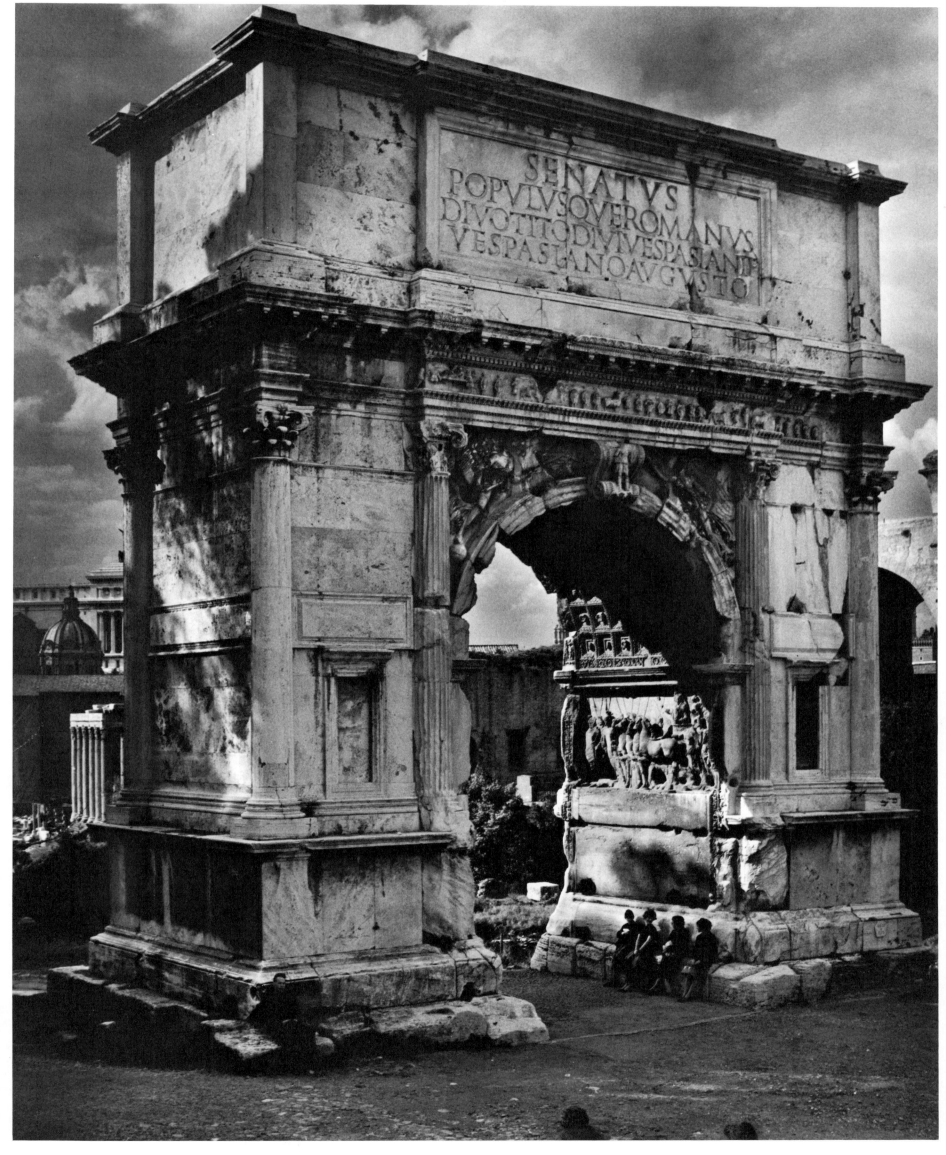

12 *View of the Arch of Titus [East Facade]*

Veduta dell'Arco di Tito

Tito fu eretto a questo Imperadore dopo la di lui morte in memoria della distruzione di
Gerosolima, e'inoghi parte de' suoi ornamenti. A Bassirilievi indi-
canti il di lui trionfo, adornato colle spoglie del Tempio di Salomone. B Apoteosi dello

stesso Cesare, espressa in un Aquila che lo solleva al Cielo. C. Orti Farnesiani.
D. Chiesa di S. Sebastiano. E. Polveriere. F. Rovine della Casa Augustana sul Palatino.
G. Strada che conduce a S. Bonaventura.
Gio. Batta Piranesi Architetto diseg. e incise

Presso l'autore a Strada Felice vicino alla Trinità de'Monti

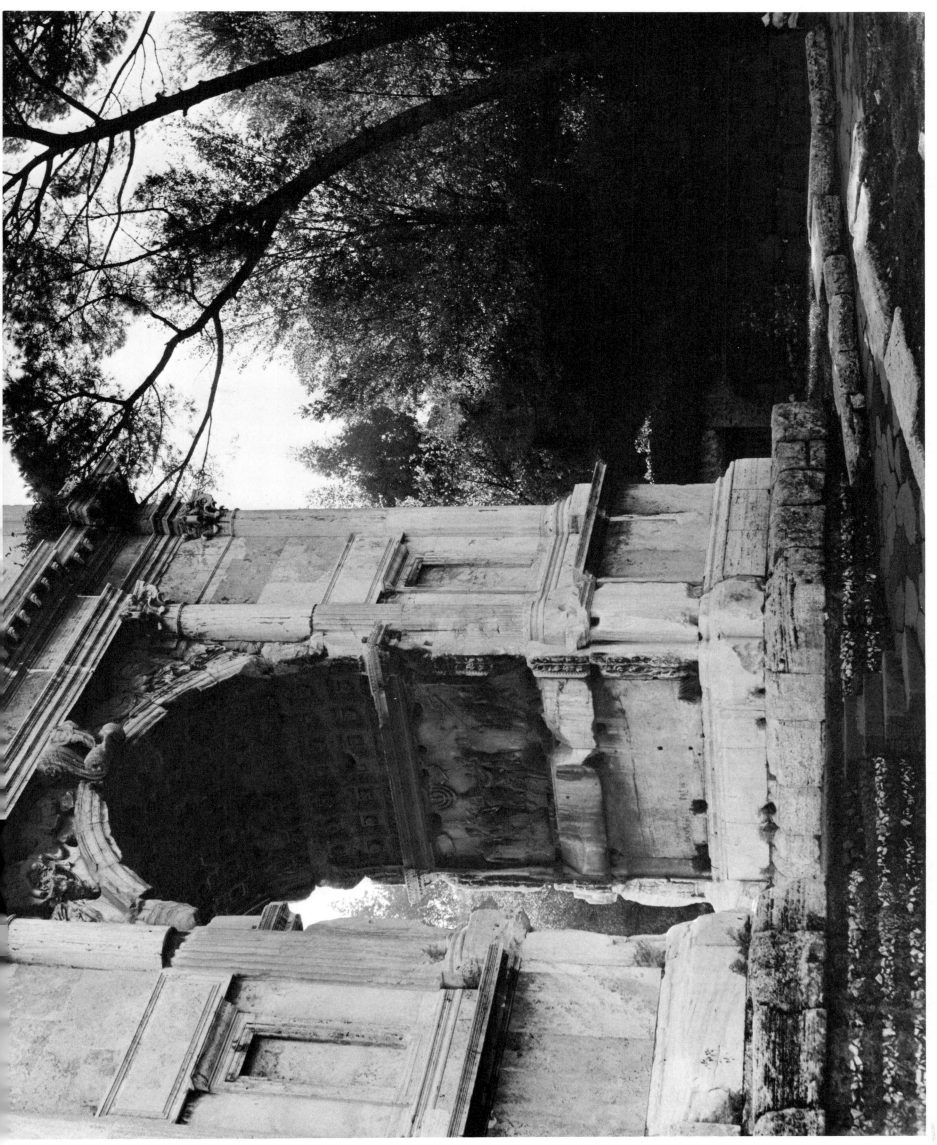

13 *View of the Arch of Titus [West Facade]*

Veduta del Tempio di Giove Tonante

14　View of the Temple of Jupiter Tonans [Temple of Vespasian]

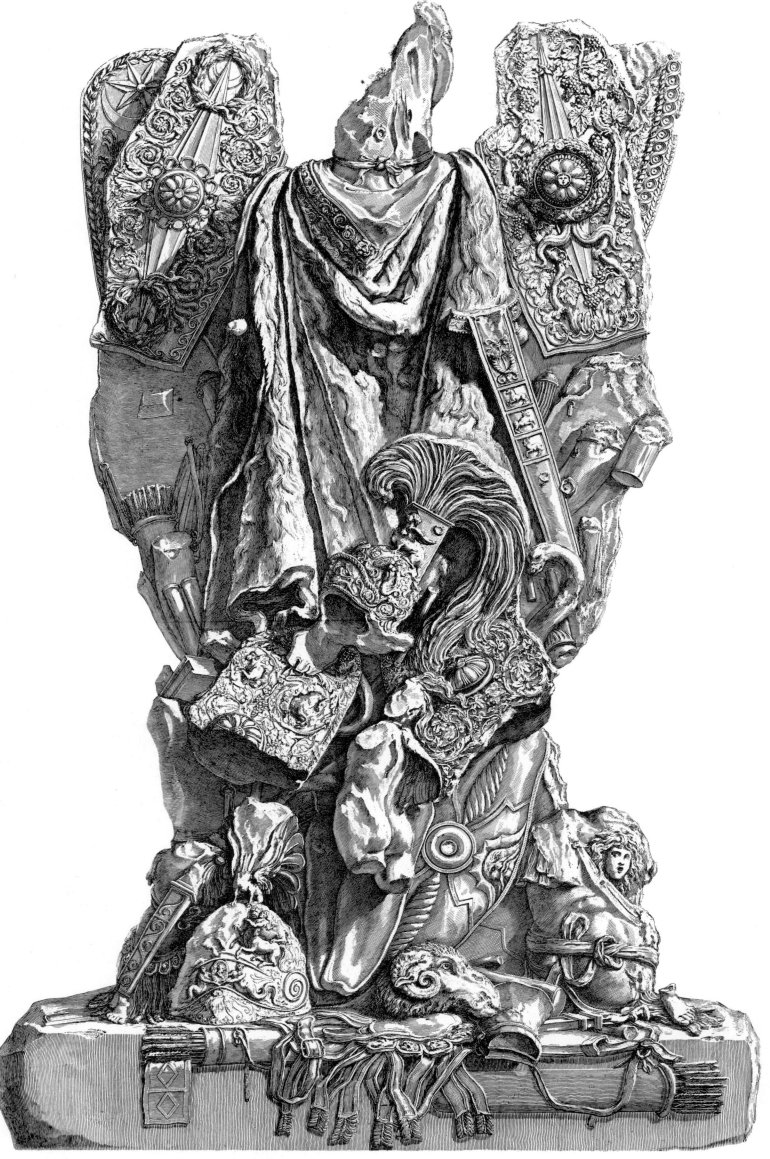

TROFEO DI OTTAVIANO AUGUSTO inalzato per la Vittoria ad Actium, e Conquista dell'Egitto, col mezzo della qual Vittoria assicurossi il possesso dell'Imperio del Mondo. Questo Trofeo, come pure l'altro (ambi esistenti in Campidoglio) di marmo, di gran mole, di nobilissimo lavoro, furone volgarm.te chiamati di Mario, da taluni di Domiziano, e da molti attribuiti a Trajano per la simiglianza, che asseriscono ritrovarsi tra questi ed i Trofei espressi in alcune medaglie dello stesso: come ancora per la maniera di scultura, la quale dicono assimigliarsi a quella della di lui Colonna. Quanto alle due prime opinioni re- stano facilmente escluse dal leggersi in Plutarco: che i Trofei di Mario rilucevano nell'oro: sicche per conseguenza erano di metallo dorato e non di marmo. In Svetonio: che tutte le Statue, Trofei, Bassirilevi, e quanto fu eretto in onore di Domiziano, tosto dopo la morte di lui, fu fatto gittare a terra per ordine del Senato. La terza quantunque forse la più ricevuta, tanto però è lontana dal vero, quanto è mal fondata so- pra una inconsiderata simiglianza, come in fatti lo può agevolmente conoscere ogni uno, qualunque volta si le medaglie, e la colonna, che i presenti Trofei con attenta osservazione si ponga ad esaminare. Poiche scopresi una notabile differenza, non dico per il lavoro, essendo tutti e tre di eccellente maniera, ma per la varietà del componimento, diverso ancora da quello de' trofei nelle medaglie espressi, e per la for- ma differente dell'Armi, che in ciadaun di questi insigni monumenti scolpite si veggono. Osservisi il gran Piedestallo della Colonna, in cui numeransi tra que' trofei più di cinquanta elmi intagliati de' quali ne pure un solo si trova, che sia simile ad alcuno di questi, che qui fedelmente ho procurato di rappresentare. Osservinsi le Scimitarre e torte e lunghe, le Armature, gli Scudi, gli ornamenti, che si scorgeranno affatto dissimili da tutto ciò, che in questi nostri Trofei si ravvisa. Dal che me fò lecito asserire, che le Spoglie de' presenti Trofei essendo diverse da quelle e delle medaglie e della Colonna dinotino altre nazioni diverse da quelle, che sono state debellate da Trajano, a cui perciò non doversi attribuire i Trofei presenti, ma bensi ad Ottaviano Augusto, come sotto l'altro Trofeo sarà dimostrato. Piranesi Architetto dis.ed inc.

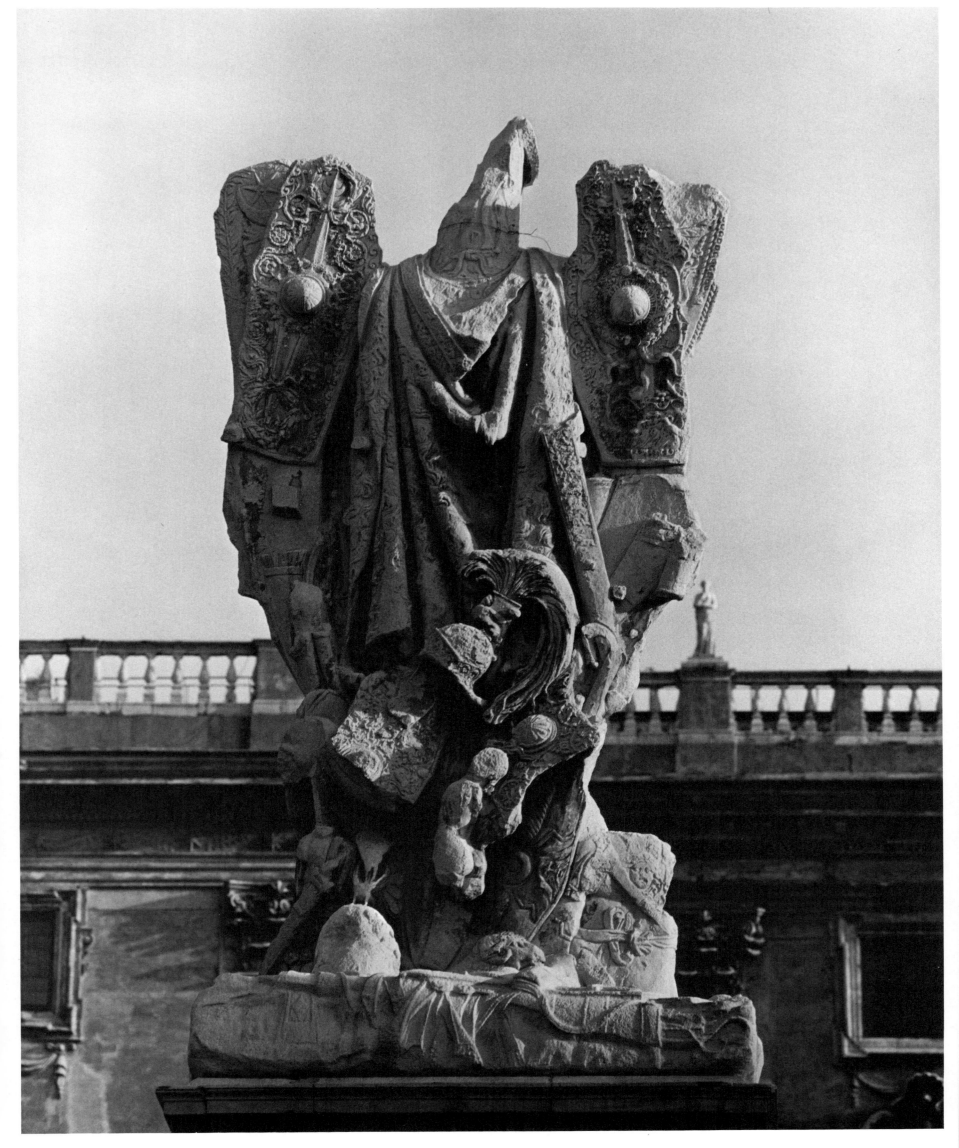

15 *Trophy of Octavian Augustus [actually of Domitian]*

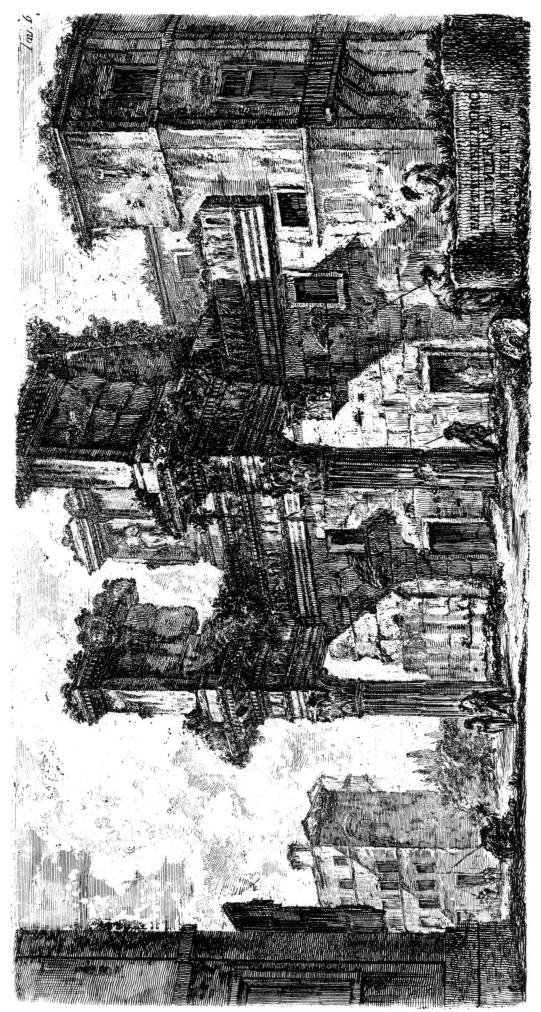

16 *Parte del Foro di Nerva*

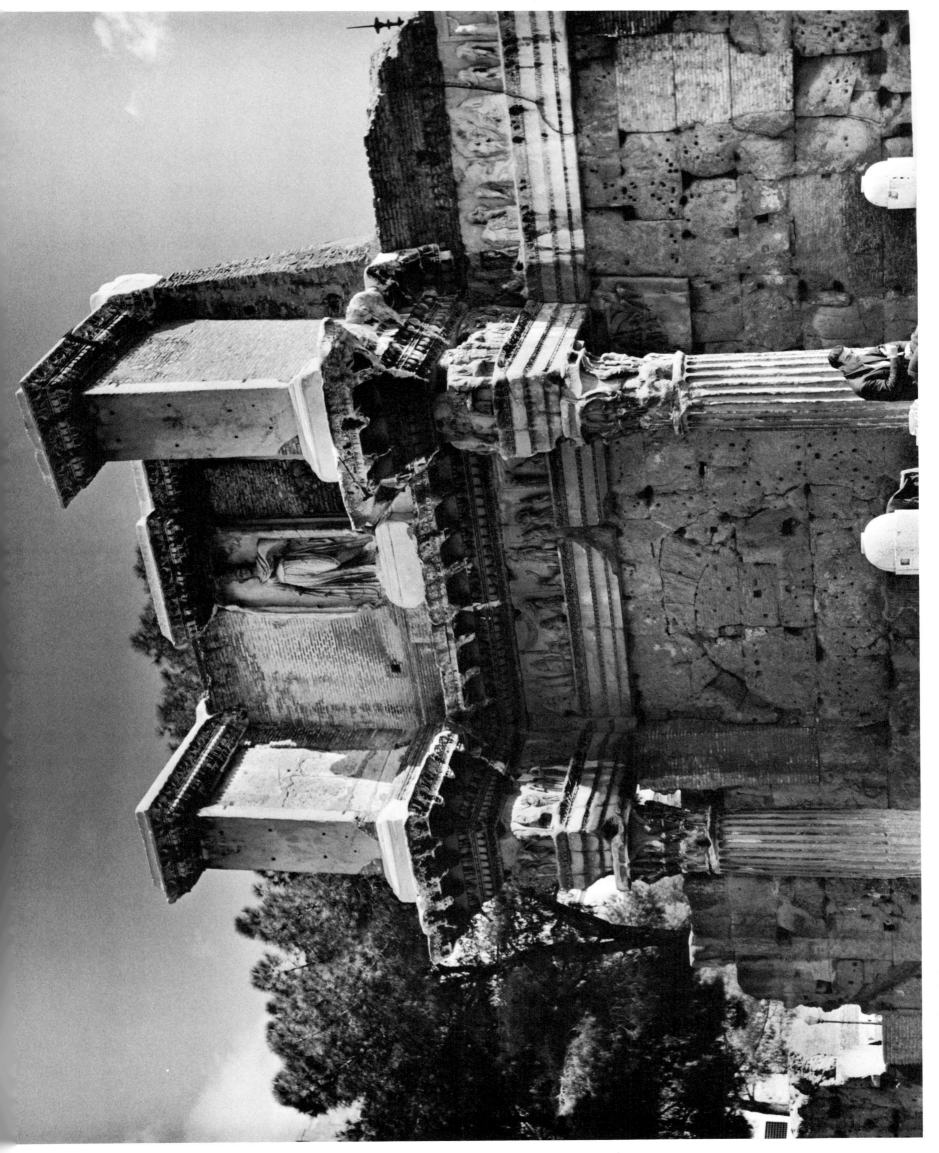

16 *Part of the Forum of Nerva*

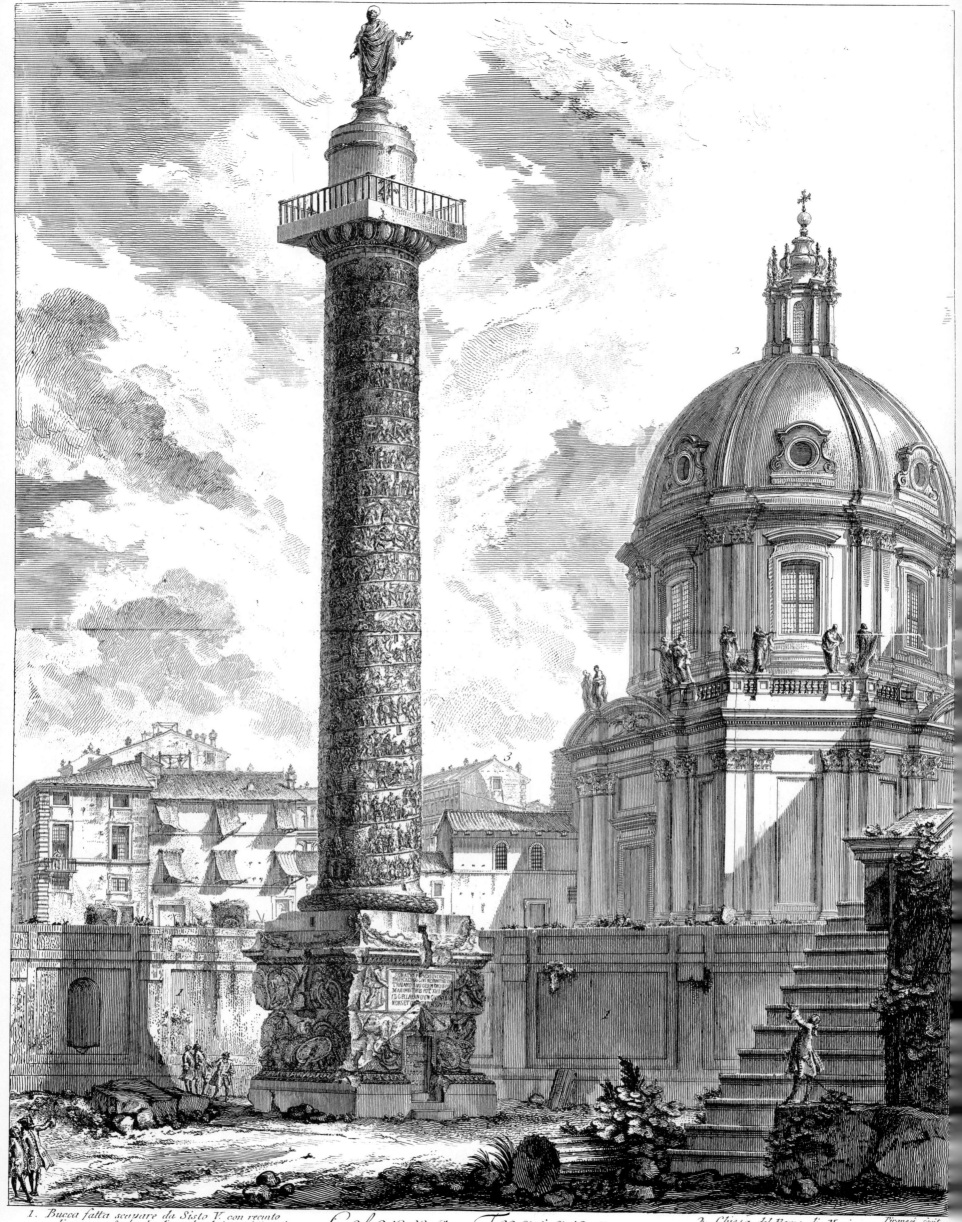

1. *Bucca fatta scavare da Sisto V. con recinto di muro, e Scala, che discende al piano della Colonna.* Colonna Trajana 2. *Chiesa del Nome di Maria.* Piranesi fecit
3. *Palazzo Bonelli*
Presso l'Autore a Strada Felice nel Palazzo Tomati vicino alla Trinità de' monti

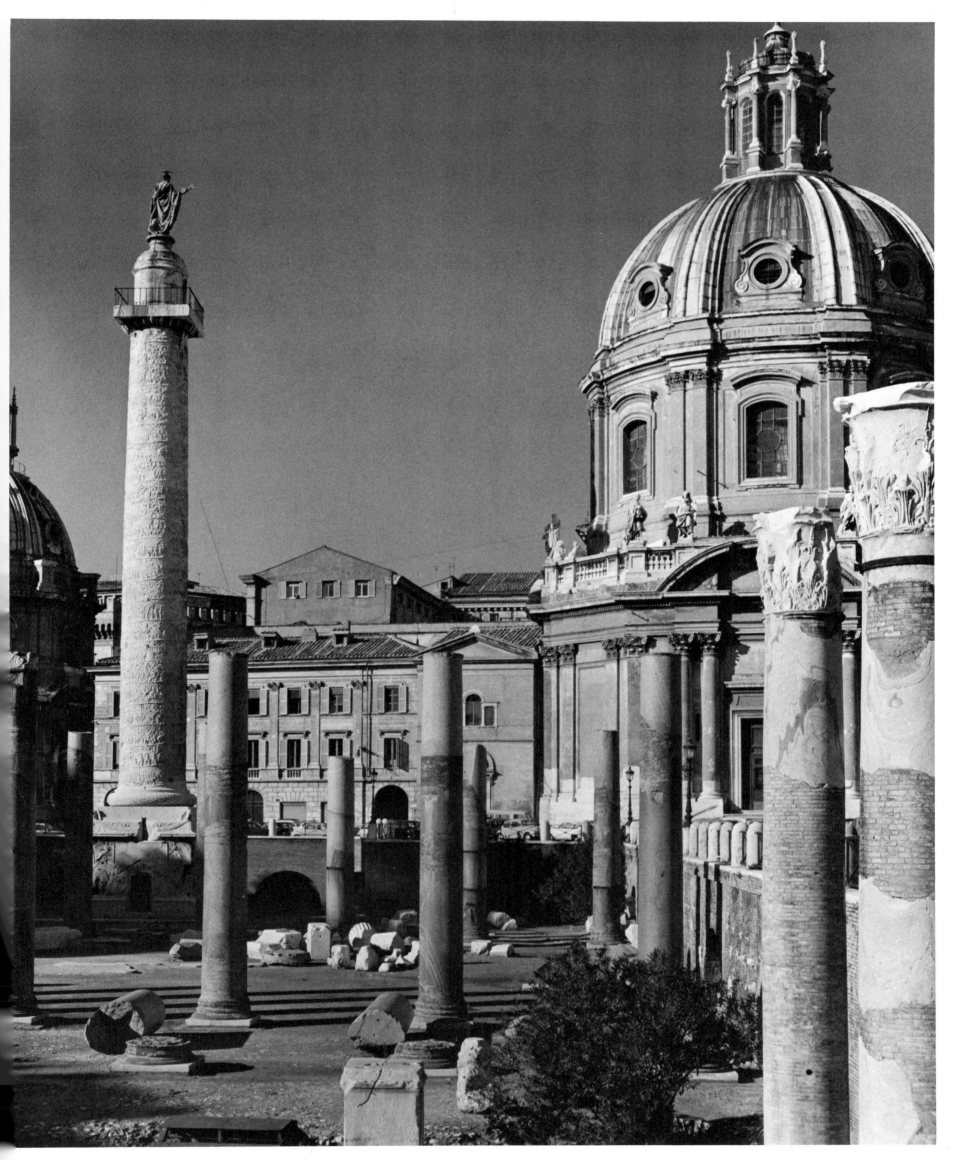

7 *The Column of Trajan*

Piranesi Archit. dis. e inc.

VEDUTA del Ponte, e del Mausoleo, fabbricati da Elio Adriano Imp.re A Speroni, o Controforti semicircolari del Ponte nella parte dietro ai corpi dell'acqua. B Pile quadrate. C Avanzi di Muralli di materni fatti da moderni per riparo. D Arena portata dal Fiume in tempo dell'escrescenza, dalla quale sono quasi riempiti li due Archi E. E Arco maestro, fabbricato sopra l'Arco antico. G Speroni contra la corrente. H Chiusa antica del Maviseo, la quale fiancheggia parte dell'Arco. K Corpo di Guardia reale, per cui entrasi nel Castello. L Una delle quattordici Pietre, le quali si legano i Canini dalle moderne Reggini. M Recinto di Mura, e Baluardi, fabbricati da sommi Pontefici in diversi tempi. N Magio antico, oggi chiamato il Magio. O Copertura di mattoni sopra il Magio. P Arme di Alessandro VI. Q Parte dell'Abitazione del Castellano. R Angelo di metallo posto in centro del Magio. S Palizzate per condurre l'acqua ai Mulini. T Rovine antiche. V Il Palo più basso dell'Acqua per ordinario nel Mare d'Argylia d'ogni Anno.

18 Veduta del Ponte, e del Mausoleo, fabbricati da Elio Adriano Imp.r.

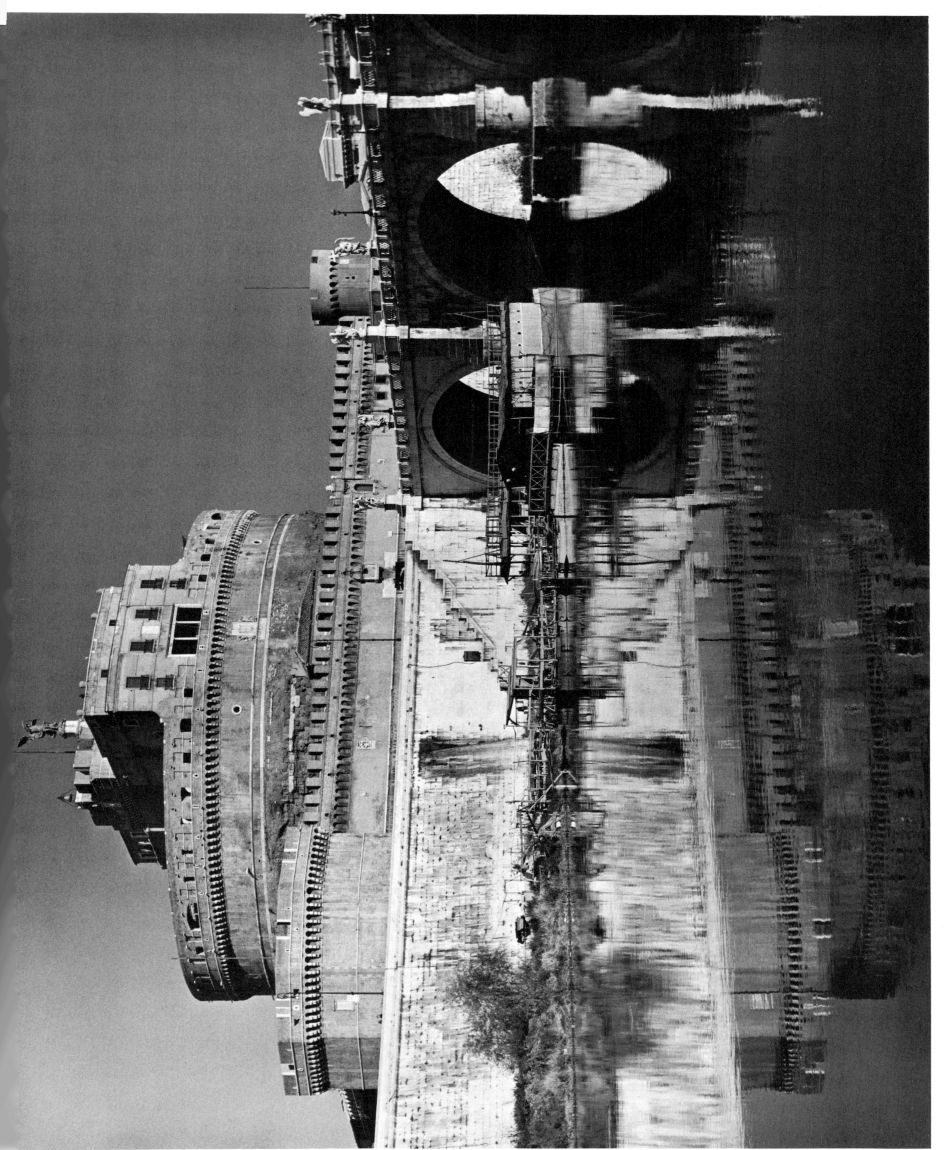

18 *View of the Bridge and Mausoleum Built by the Emperor (Aelius) Hadrian*

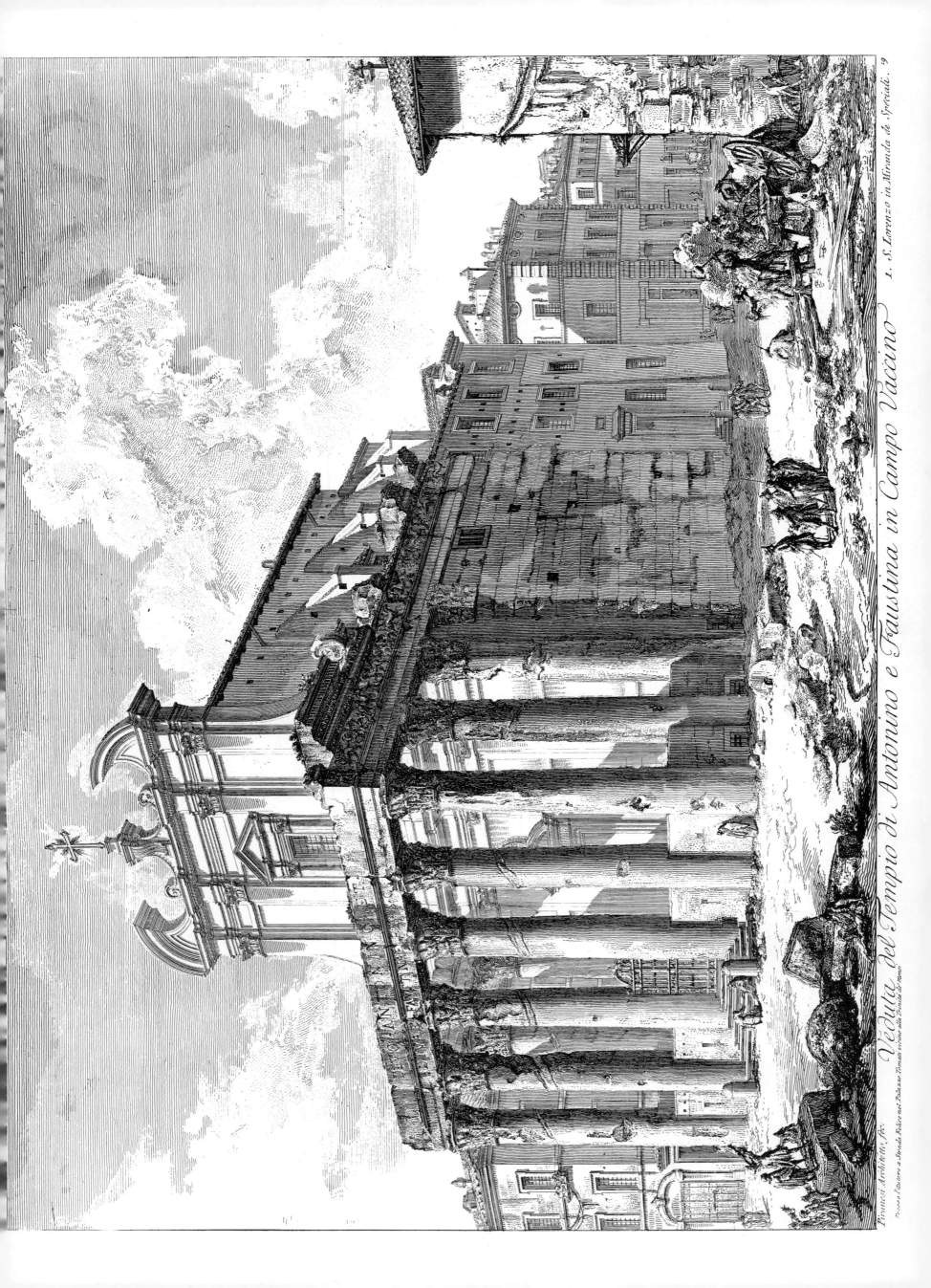

Piranesi Architetto, fec.

Veduta del Tempio di Antonino e Faustina in Campo Vaccino

1. *S. Lorenzo in Miranda de' Speziali.*
9

Presso l'Autore a Strada Felice nel Palazzo Tomati vicino alla Trinità de' monti

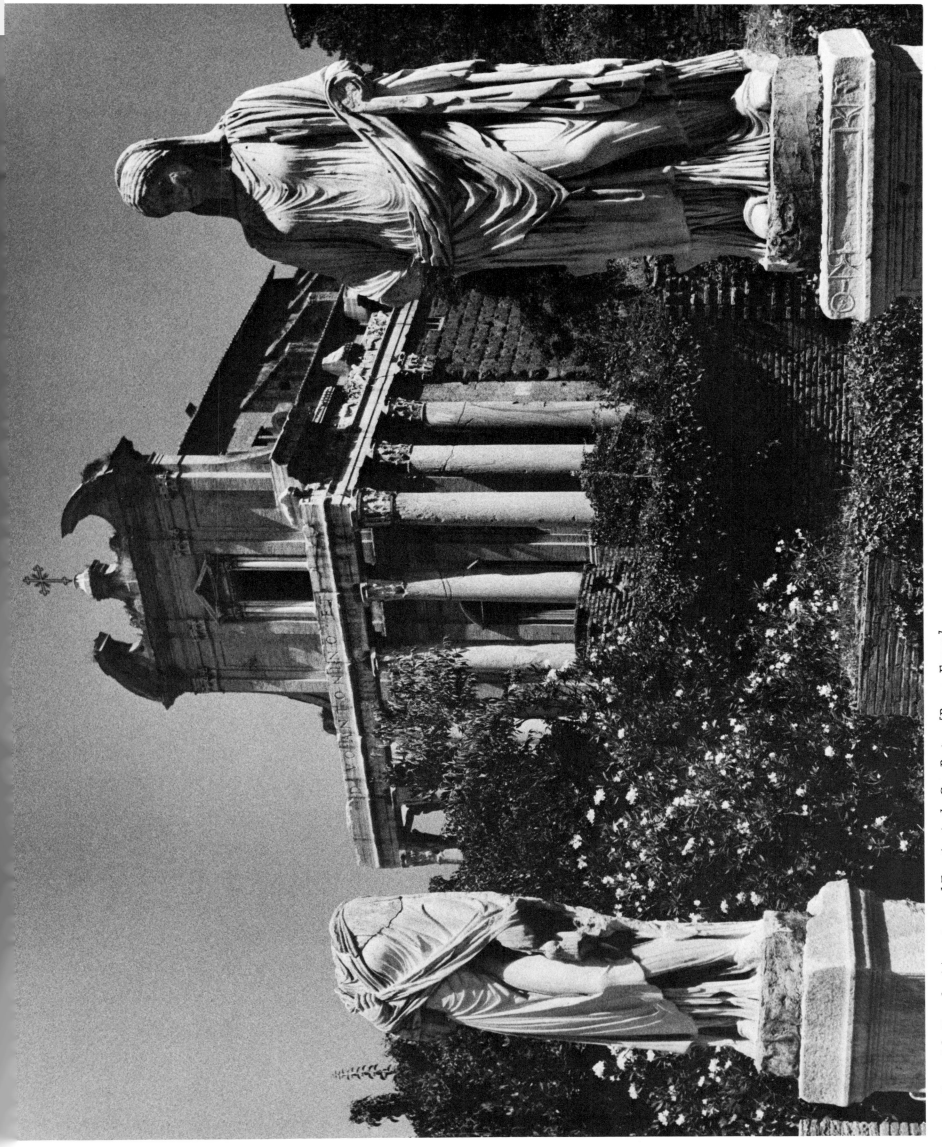

19 *View of the Temple of Antoninus and Faustina in the Cow Pasture [Roman Forum]*

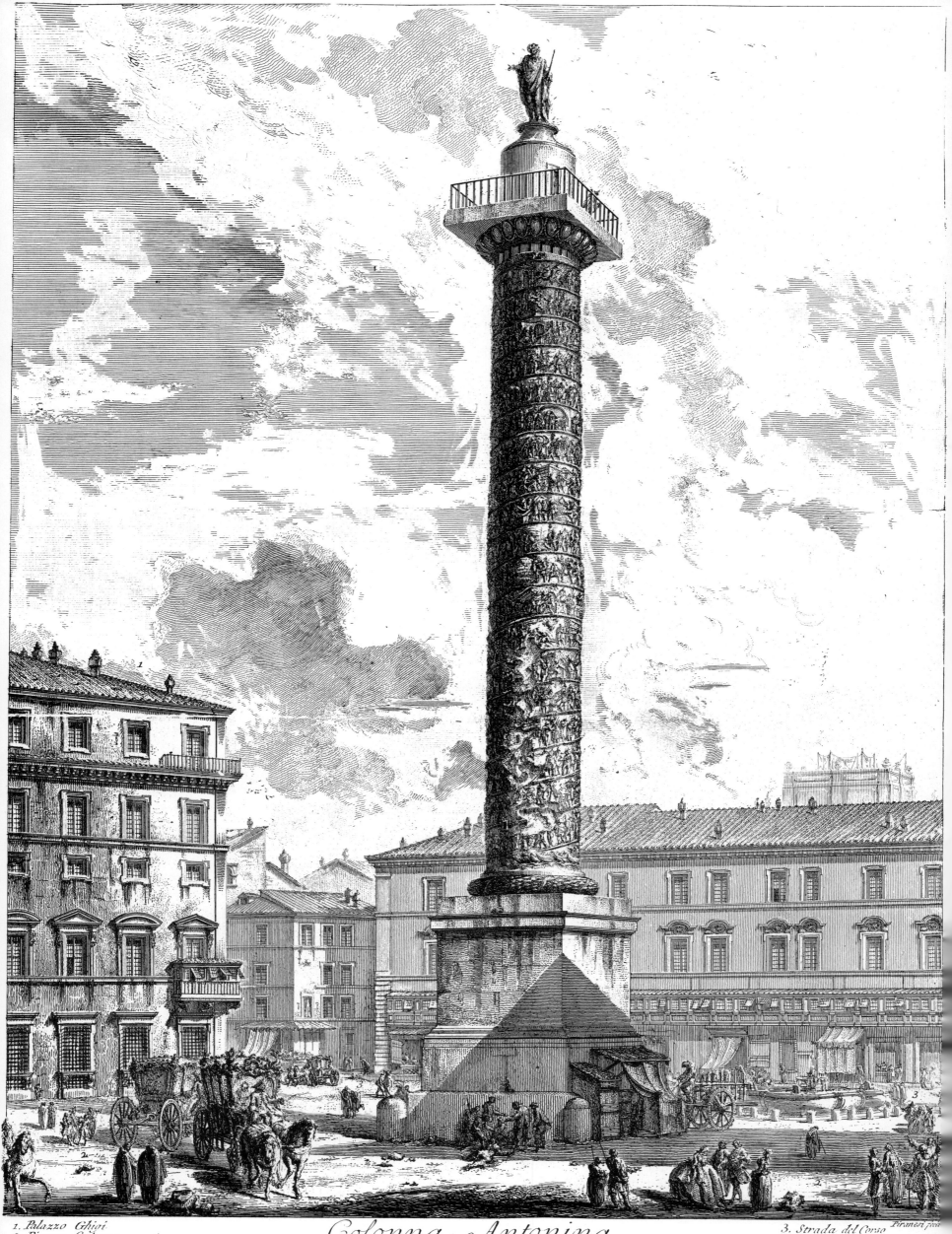

1. Palazzo Ghigi
2. Piazza Colonna 4.

Colonna Antonina

3. Strada del Corso

Piranesi fec.

Pres. de l'Autore a Strada Felice nel Palazzo Tomati vicino alla Trinità de'monti.

32.

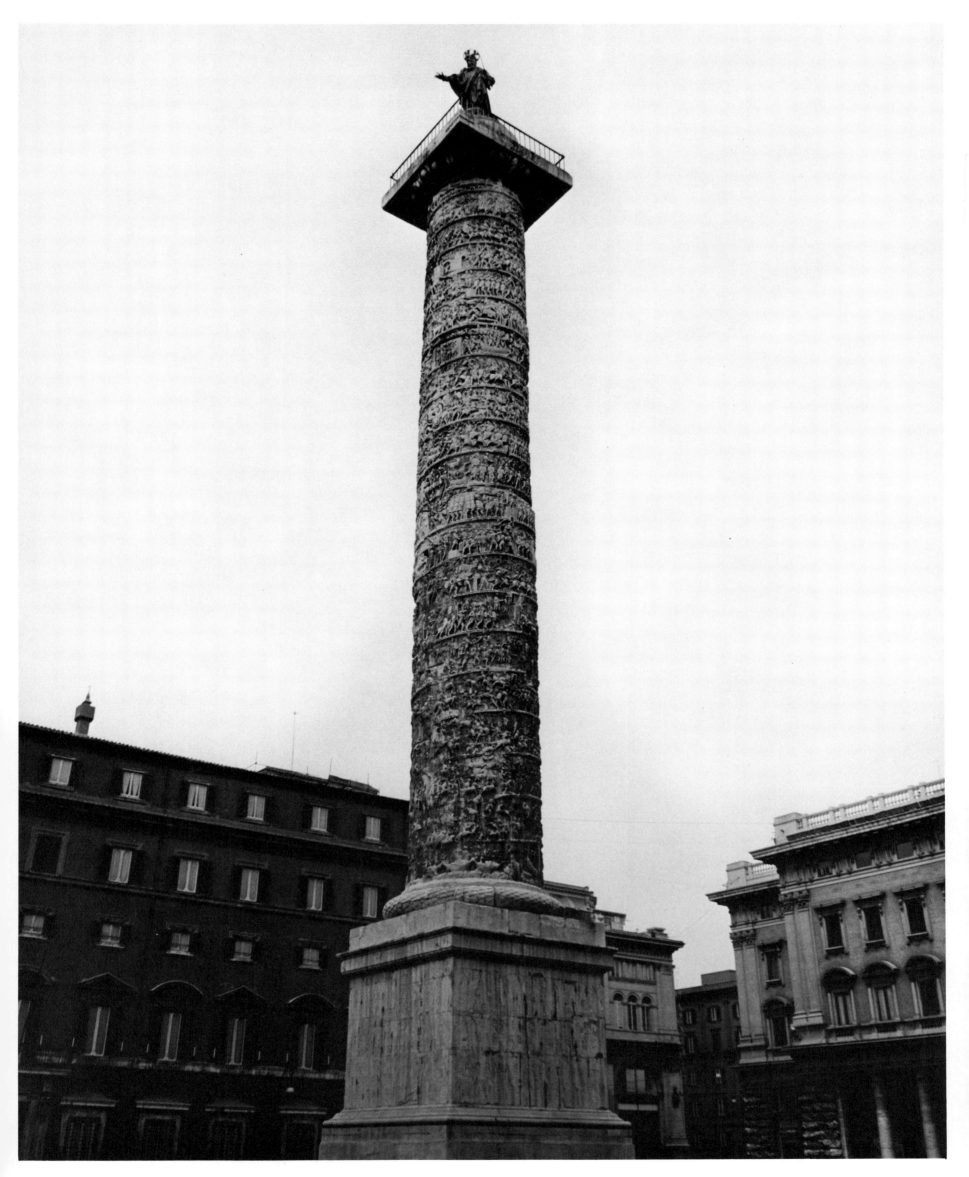

20　*Column of (Marcus Aurelius) Antoninus*

Arco di Settimio Severo.

1. Erario antico, o come altri, Tempio di Saturno, oggi S. Adriano. 2. S. Martina. 6. Chiesa dell'Aracæli fabricata sopra i fondamenti del Tempio di Giove Capitolino. architetta da Pietro da Cortona. Chiesi dell'Accademia del Disegno, detta di S. Luca. 3. Lan- 7. Colonna rimasta in piedi creduta del Ponte, che fece fare l'Imperatore Caligola, per passare tica Carcere, mantenuta, oggi chiese poste, S. Pietro, e Paolo; Sempij, questo ci' la scritta dal Palatino al Campidoglio. Poco rimase a Strada Felice nel palazzo Tomati vicino alla Fontanamozzi. Un Chiesa di S. Giuseppe. 4. Salita che porta al Campidoglio. 5. Abitazione del Senatore Romano. Nelmezzo di questo passava l'antica Via sacra che portava i Trionfi in Campid.

Arco di Settimio Severo

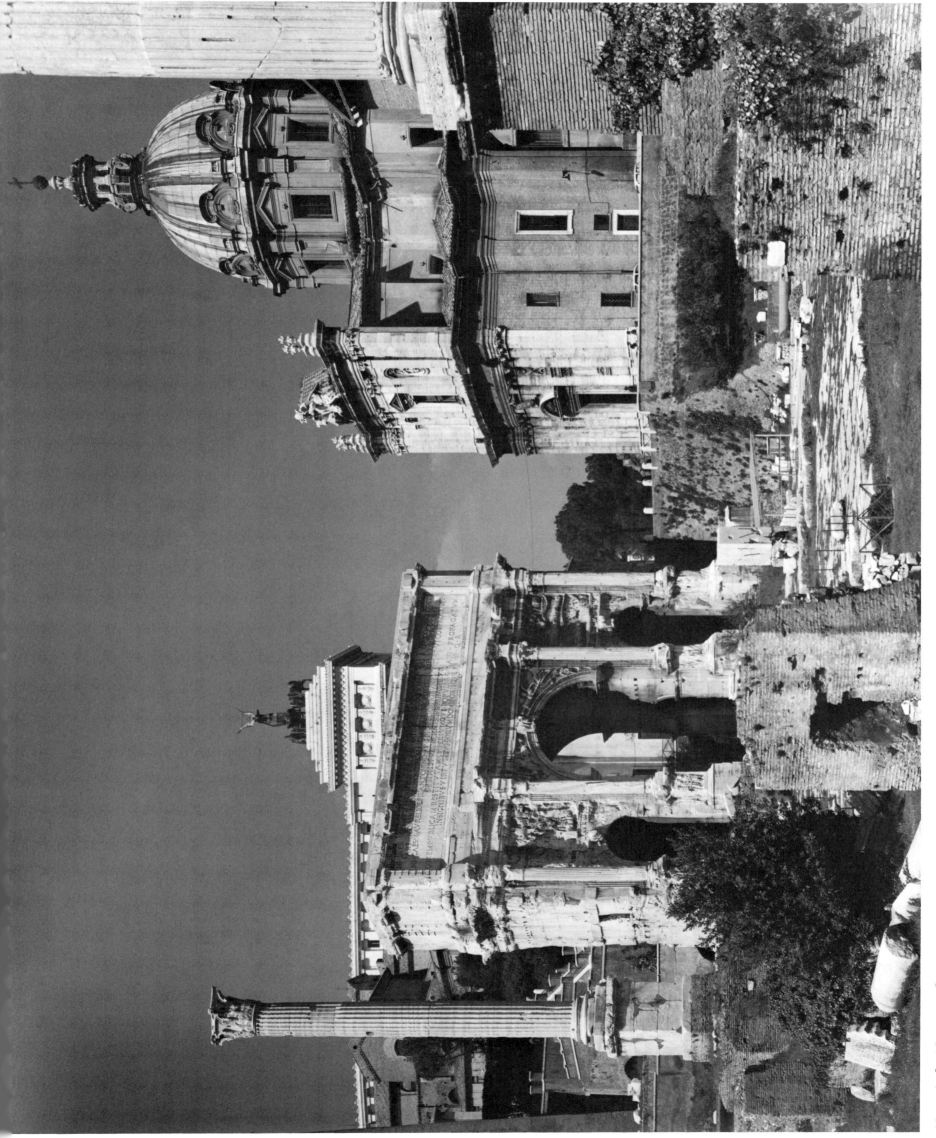

21　*Arch of Septimius Severus*

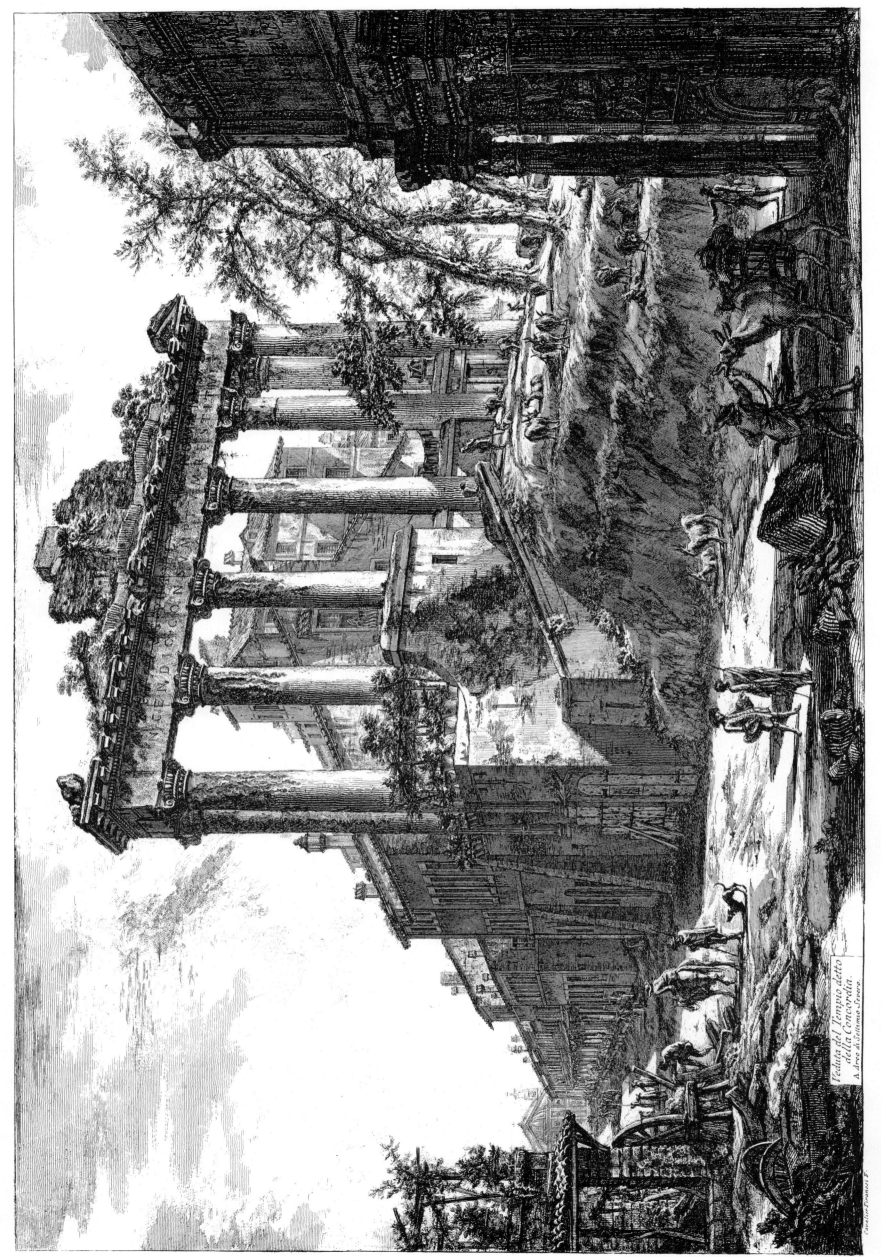

*Veduta del Tempio detto
della Concordia.*
A. Arco di Settimio Severo

22 Veduta del Tempio detto della Concordia

22 *View of the Temple Called Temple of Concord [Temple of Saturn]*

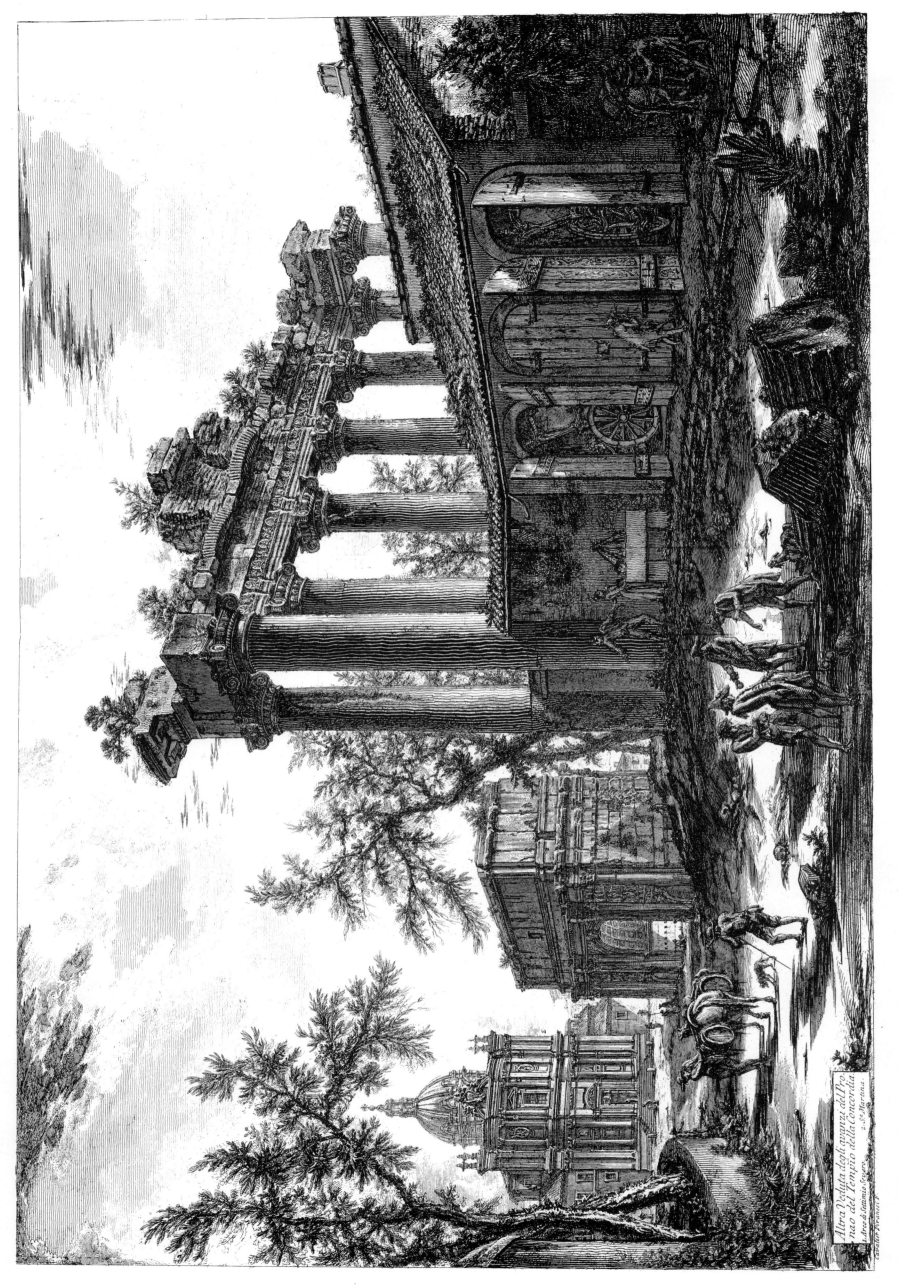

Altra Veduta degli avanzi del Pronao del Tempio della Concordia

23

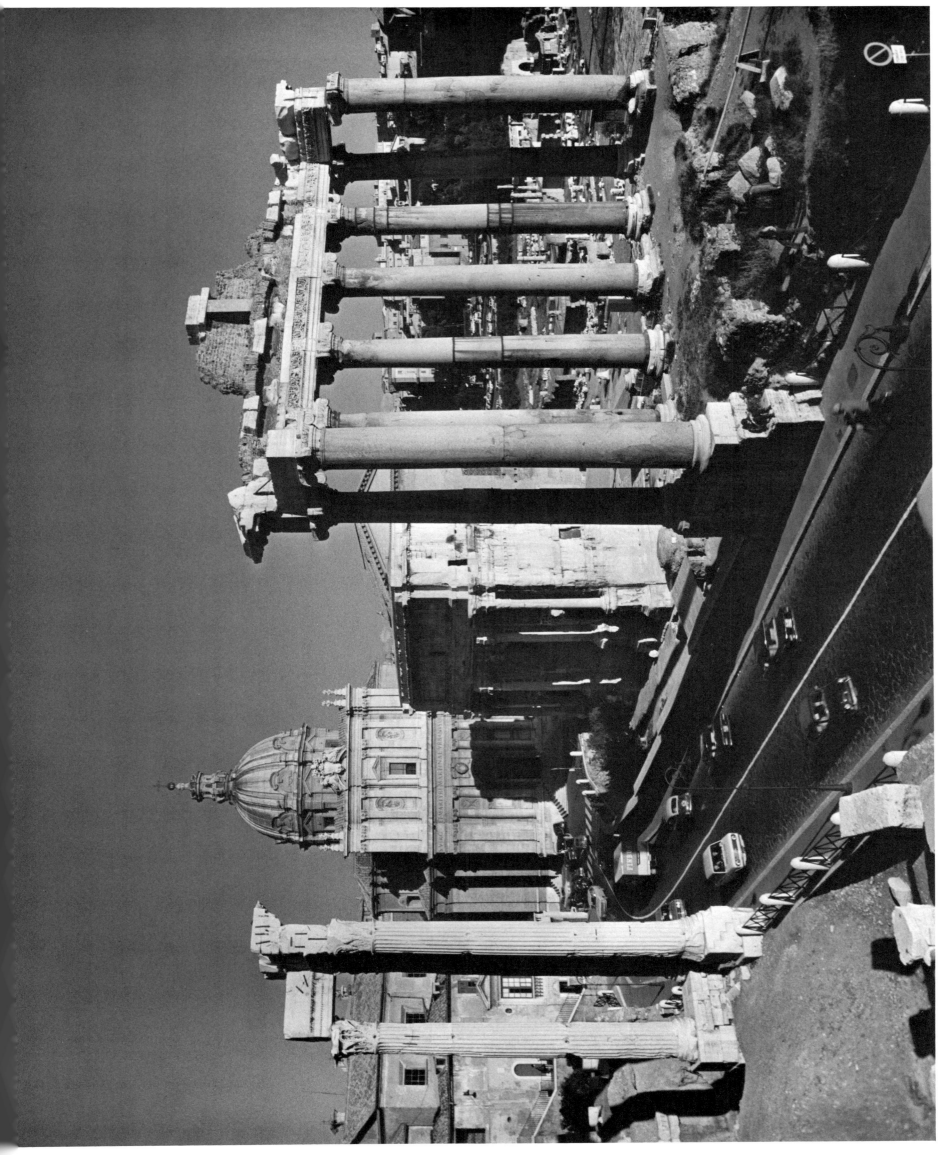

23 *Another View of the Remains of the Portico of the Temple of Concord* [Saturn]

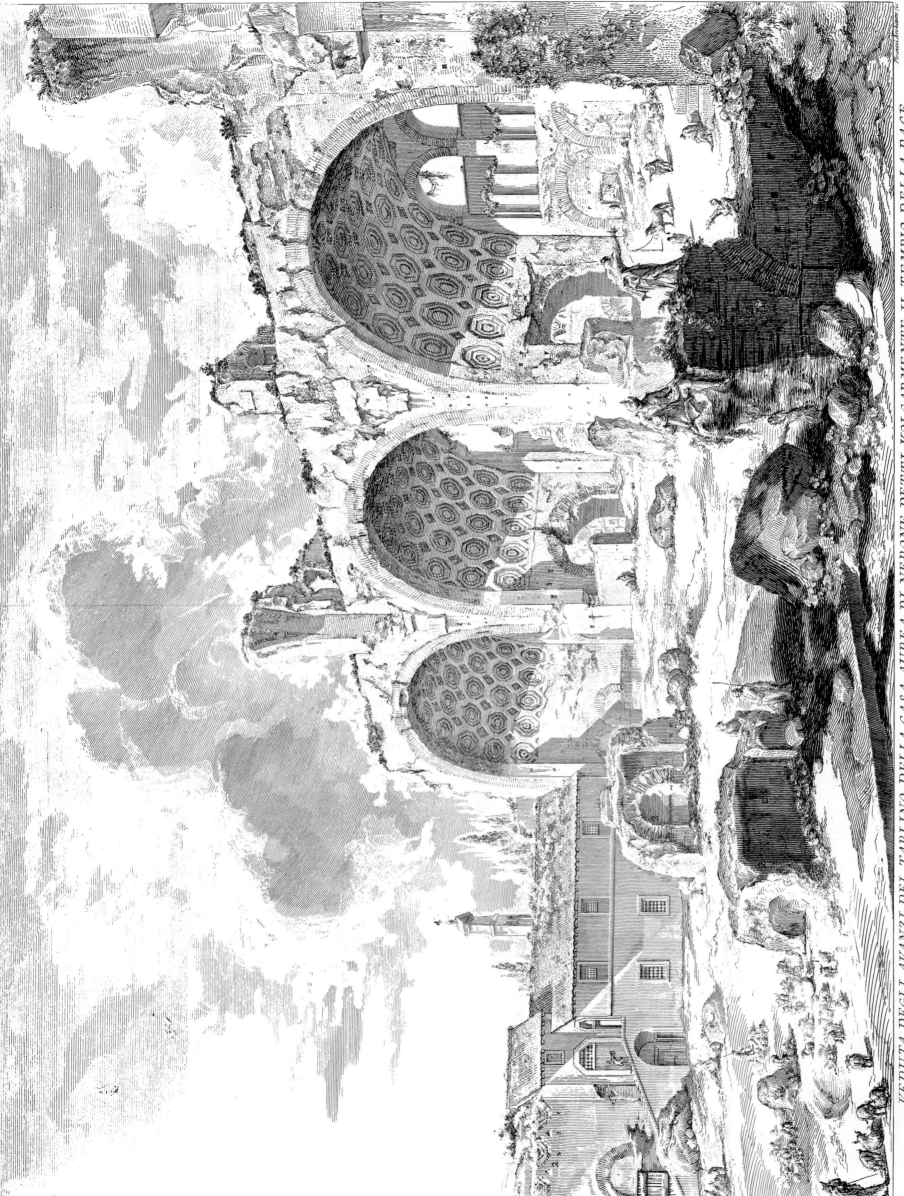

VEDUTA DEGLI AVANZI DEL TABLINO DELLA CASA AUREA DI NERONE, DETTI VOLGARMENTE IL TEMPIO DELLA PACE

1. Di qui fu trasportata da Paolo V la gran Colonna che si vede innalzata nella Piazza di S. Maria Maggiore. 2. Muri, e piloni che reggevano la parte opposta del Tablino. 3. Nicchie per le Statue degli uomini illustri.

Presso l'autore a Strada Felice vicino alla Trinità de' monti

24 [First] View of the Remains of the Tablinum of Nero's Golden House [Basilica of Maxentius]

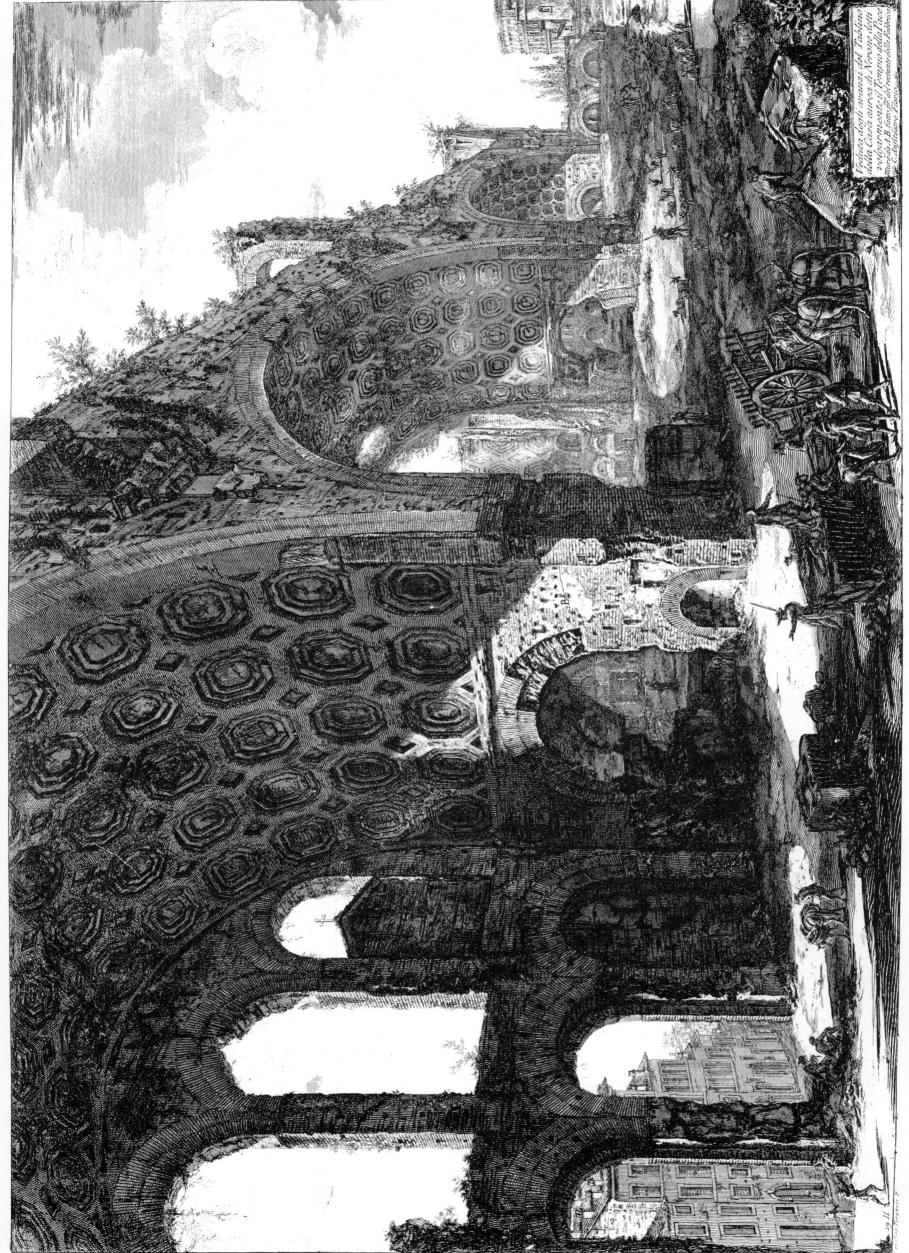

25 *Veduta degli avanzi del Tablino della Casa aurea di Nerone*

[Second] View of the Remains of the Tablinum of Nero's Golden House [Basilica of Maxentius]

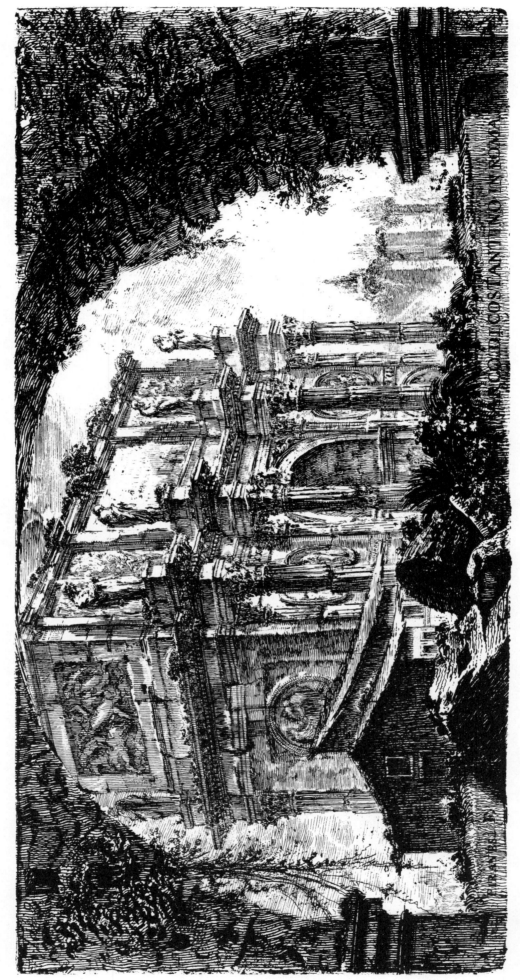

Arco di Costantino in Roma

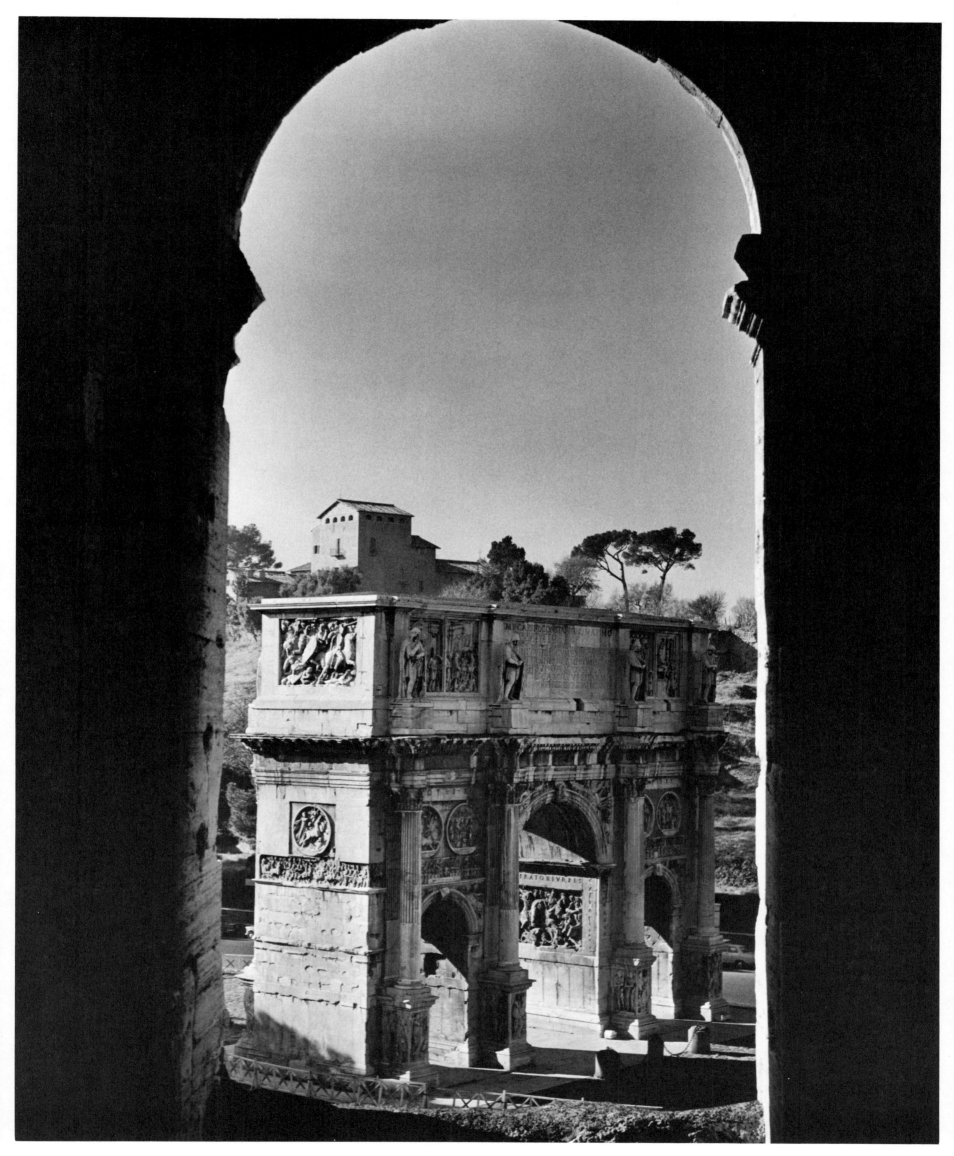

26 *Arch of Constantine in Rome*

Veduta del Romano Campidoglio con Scalinata che và alla Chiesa d'Araceli

1. Abitazione del Senator Romano
2. Museo, ove si conservano le Statue antiche
3. Palazzo de' Conservatori
4. Statua equestre di Marco Aurelio di metallo Corintio

5. Statue Colossali antiche di Castore, e Polluce
6. Trofei d'Augusto, volgarmente detti di Mario.
7. Colonna milliaria aurea
8. Leoncini di marmo Egizio

Architettura di Michelangelo Bonaroti Fontana e Scala Felice nel Palazzo Franchi erano alla Trinità de' m..

Franchi Del. Sculp. 185.III

27 *View of the Capitol in Rome with the Staircay to the Church of Aracoeli*

Veduta del Campidoglio di fianco

28

28 *View of the Capitol from the Side*

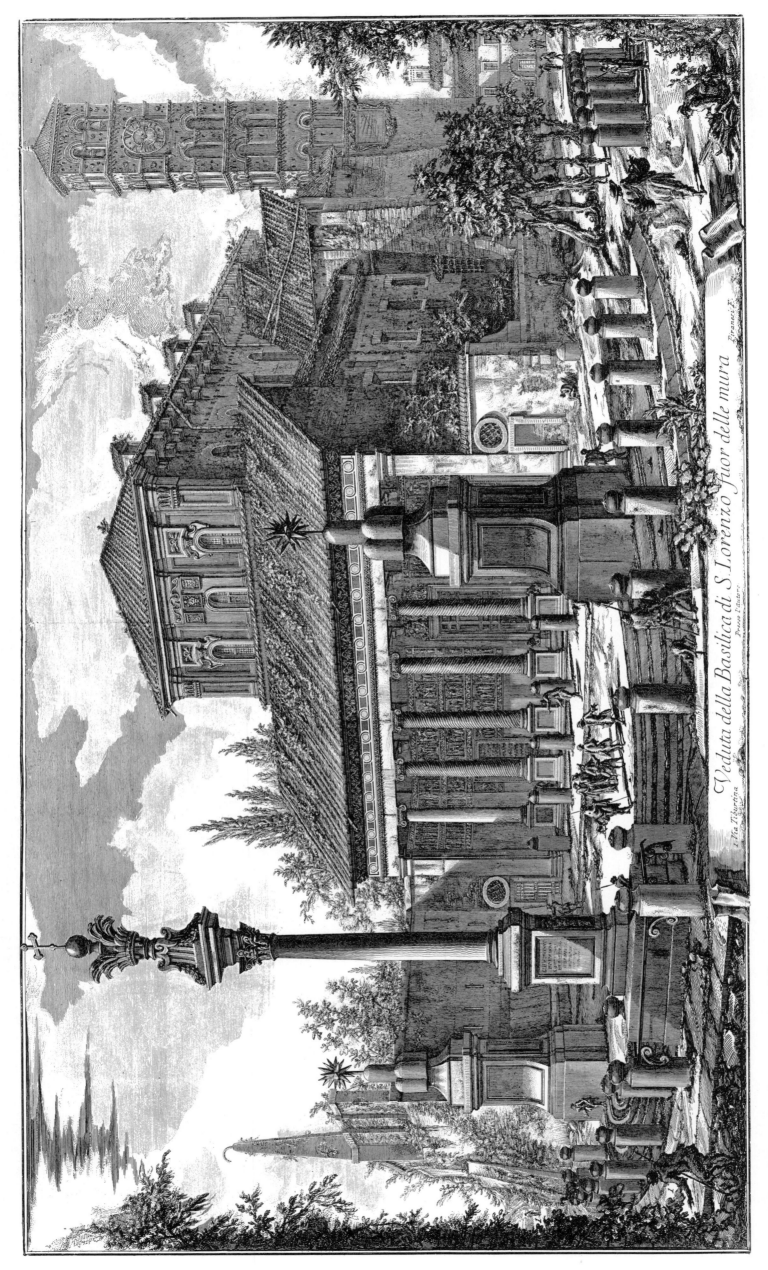

Veduta della Basilica di S. Lorenzo fuor delle mura

29 *View of the Basilica of St. Laurence Outside the Walls*

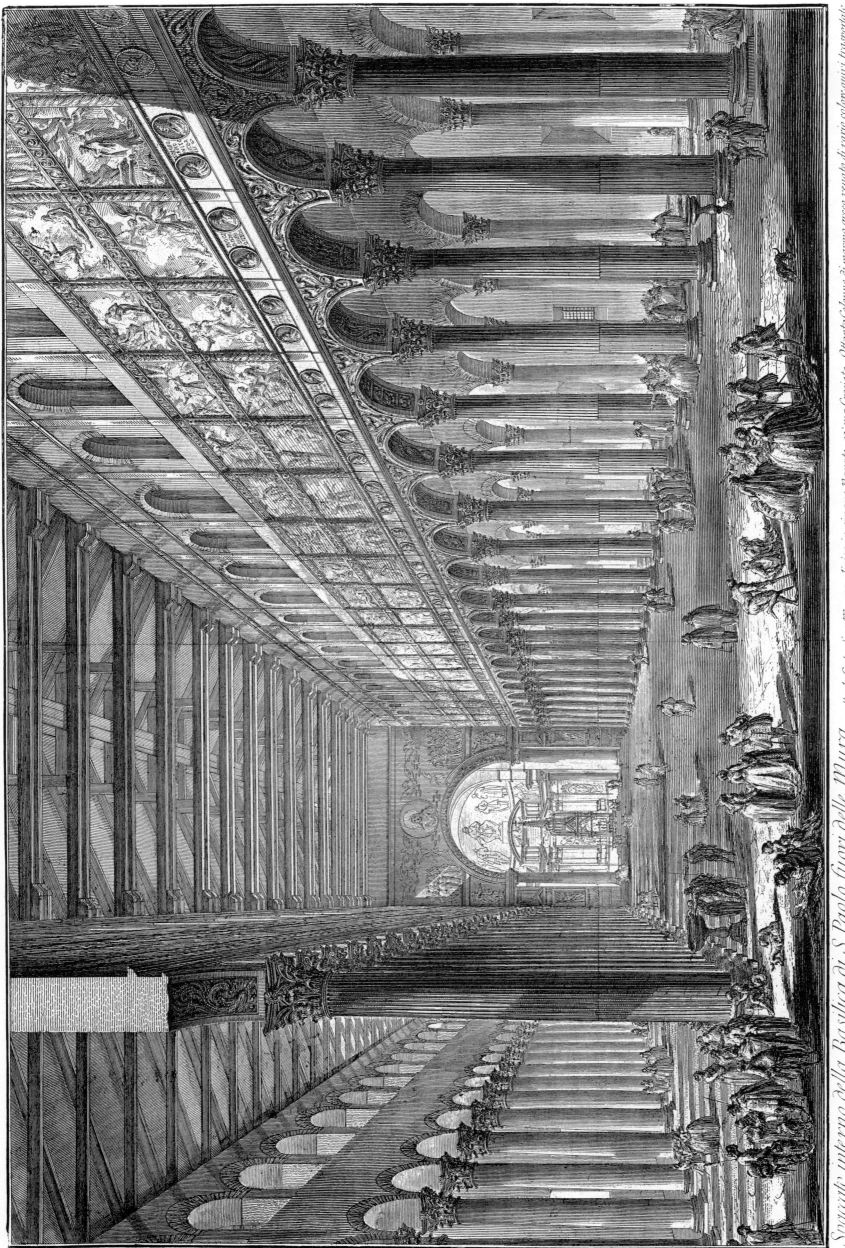

Spaccato interno della Basilica di S. Paolo fuori delle Mura

30 *Cross Section of the Interior of the Basilica of St. Paul Outside the Walls*

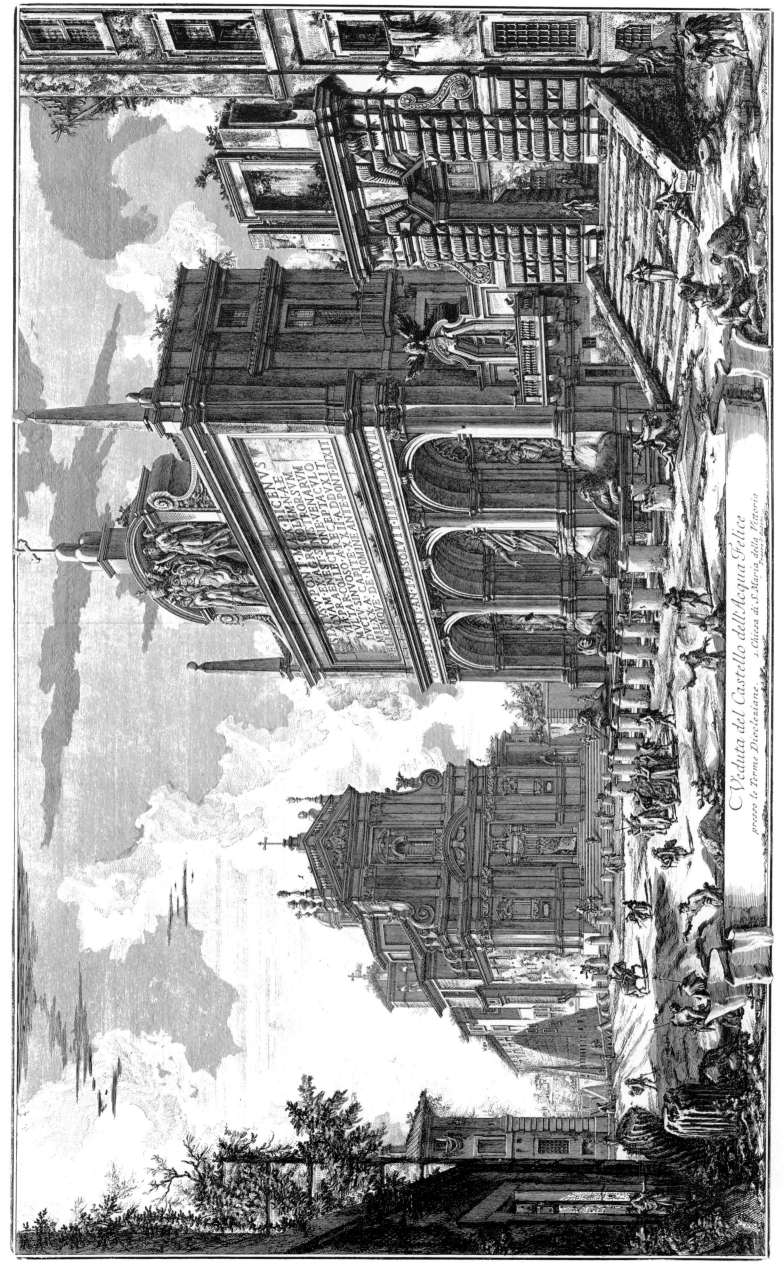

Veduta del Castello dell'Acqua Felice
presso le Terme Diocleziane. 1 Chiesa di S.Maria della Vittoria

31 *View of the Fountain of the Felice Aqueduct*

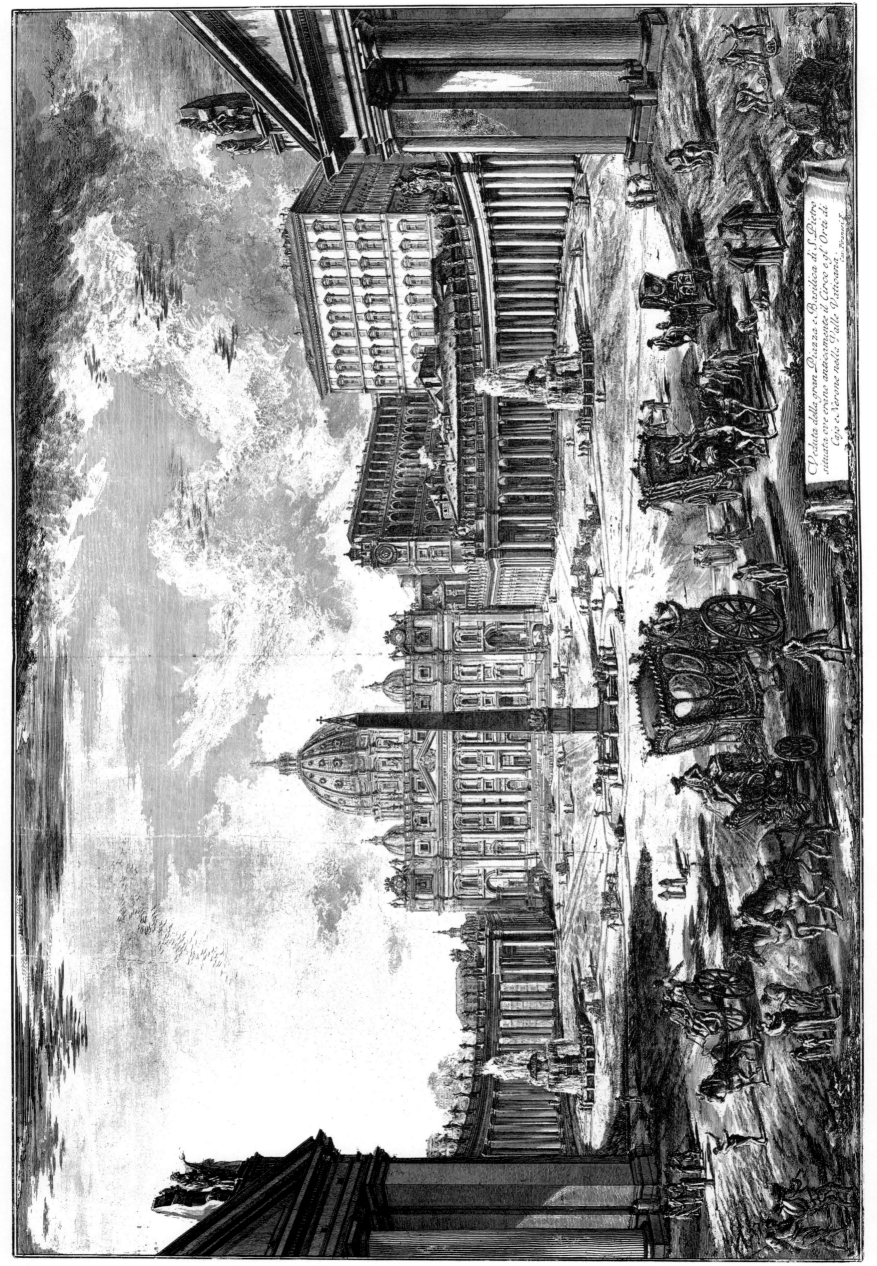

Veduta della gran Piazza e Basilica di S. Pietro

32 *View of the Great Square and Basilica of St. Peter*

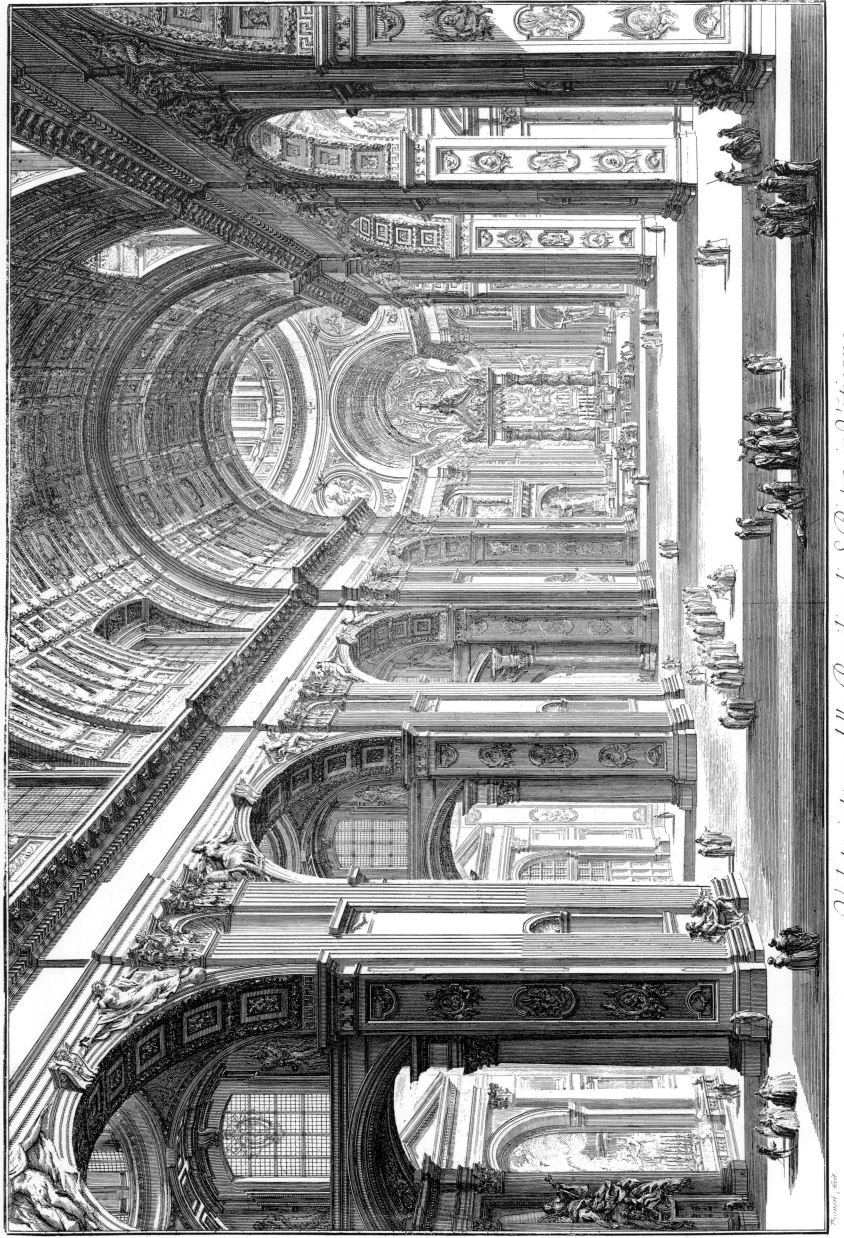

Veduta interna della Basilica di S. Pietro in Vaticano

Preffo l'autore a Strada Felice nel Palazzo Tomati vicino alla Trinità dei monti

33 Veduta interna della Basilica di S. Pietro in Vaticano

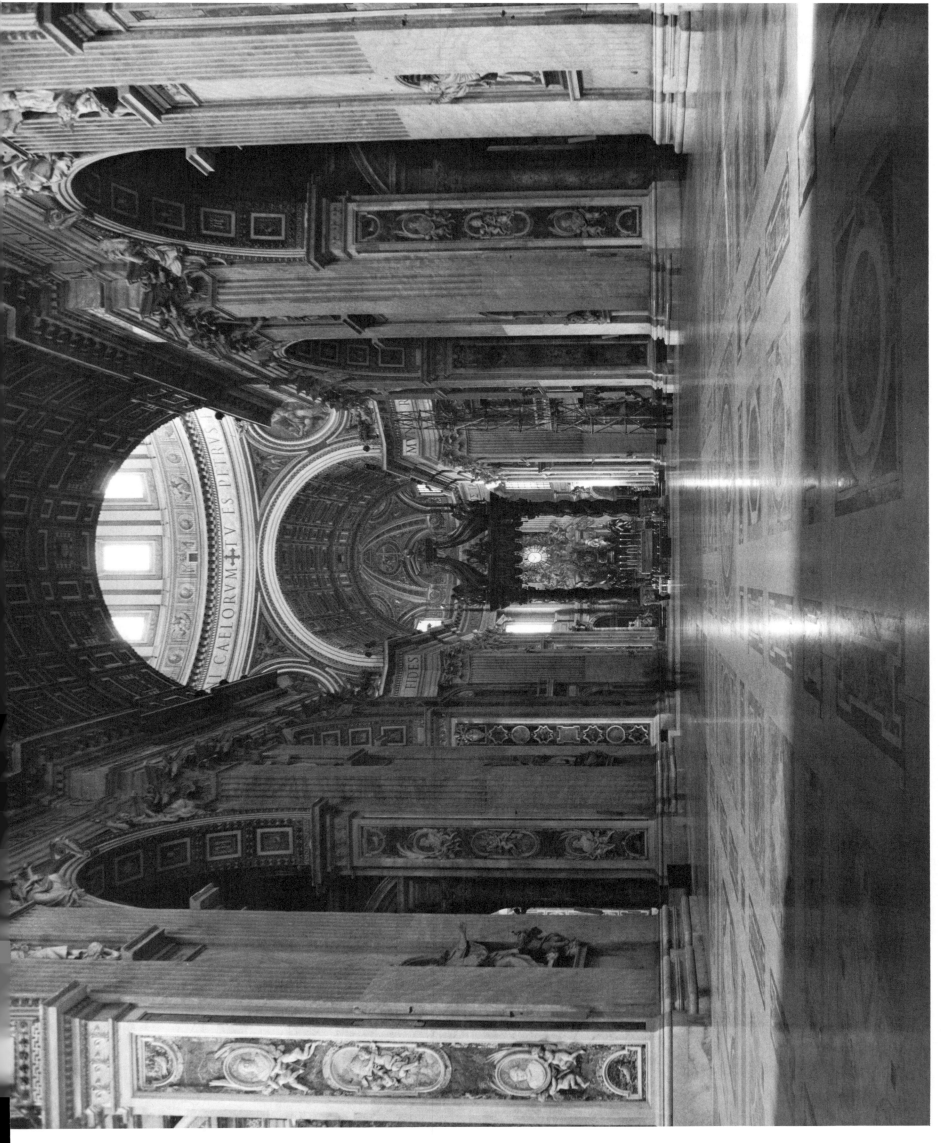

33 *View of the Interior of the Basilica of St. Peter in the Vatican*

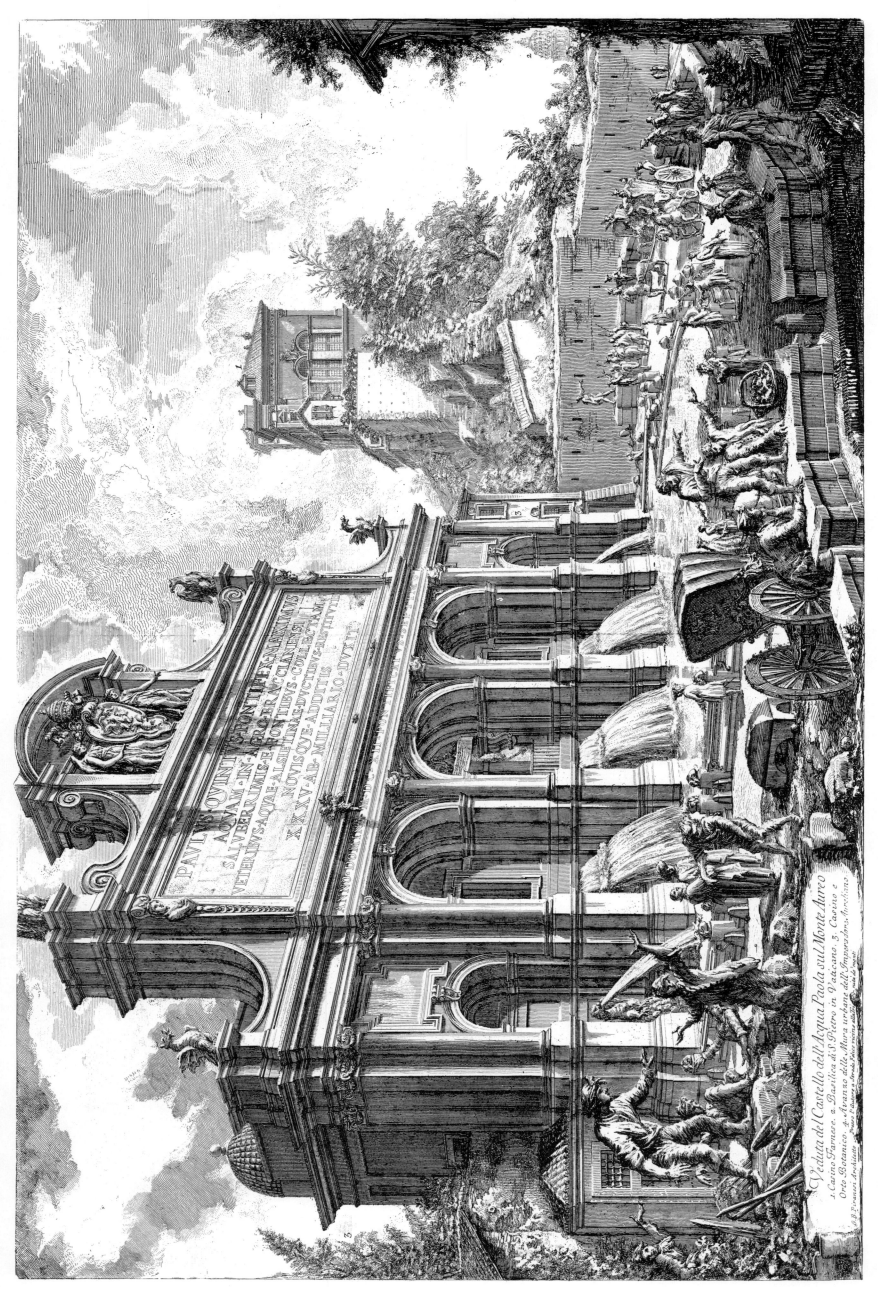

Veduta del Castello dell'Acqua Paola sul Monte Aureo

1. Casino Farnese. 2. Basilica di S. Pietro in Vaticano. 3. Casino e Orto Botanico. 4. Avanzo delle Mura urbane dell'Imperadore Aureliano.

G.B. Piranesi Architetto

34 Veduta del Castello dell'Acqua Paola sul Monte Aureo

34 *View of the Fountain of the Aqueduct of Pope Paul V on Monte Aureo*

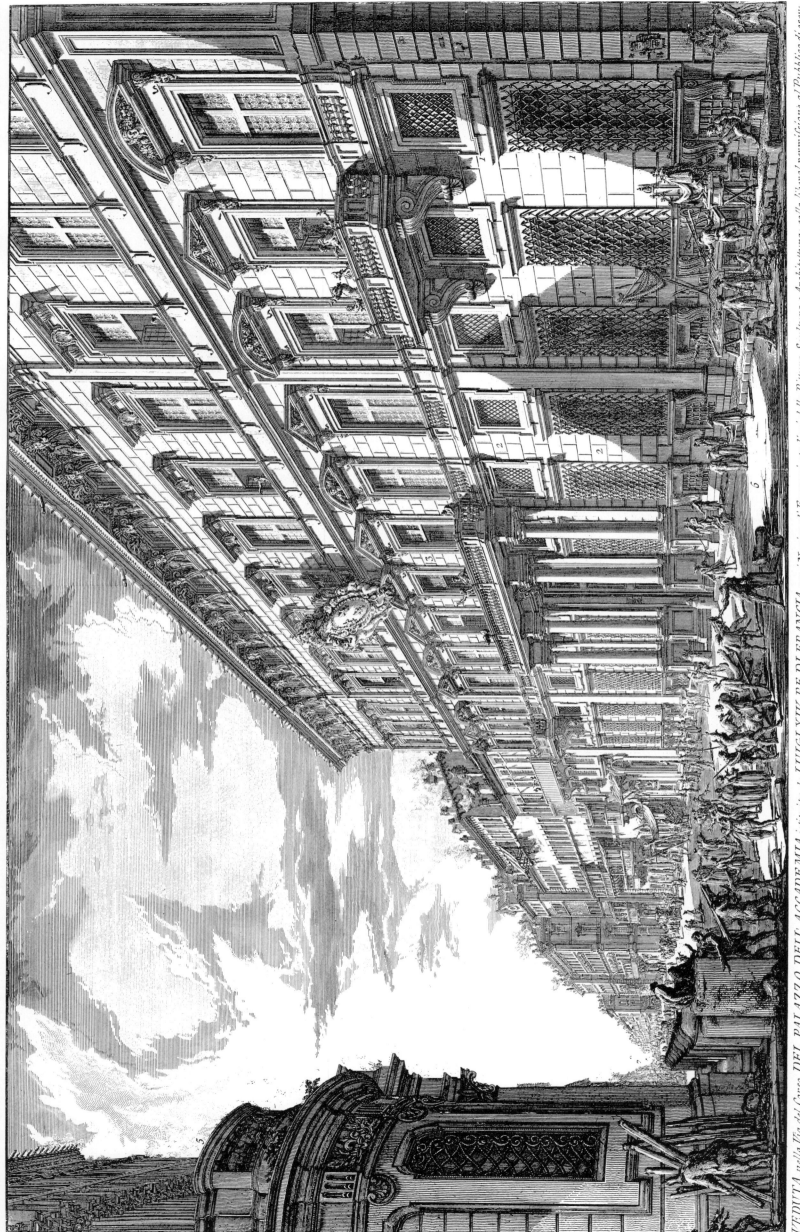

VEDUTA, nella Via del Corso, DEL PALAZZO DELL'ACCADEMIA istituita da LUIGI XIV RE DI FRANCIA per i Nazionali Francesi studiosi della Pittura, Scultura, e Architettura; colla liberal permissione al Pubblico di eser-
citarvisi in tali arti per il comodo della esposizione quotidiana del Nudo, e dei Modelli delle più rare Statue ed altri Segni della Romana Magnificenza, si antichi, che moderni. 1. Stanze ove sono esposti i modelli della Colonna Trajana, Statue Eque-
stri ec. 2. Bassirilievi. 2. Stanze per l'esposizione del Nudo. 3. Appartamento Regio ornato parimente di Medaglie. 4. Appartamento del Signor Direttore. 5. Palazzo Panfilj. 6. Via del Corso. 7. Porta del Popolo.
3. Busti. 4. Bassirilievi.
Gio. Batta. Romani riconosce alla Finta di 100 ec.
Gio. Batta. Francesi Architetto dis. inc.

35 Veduta, nella Via del Corso, del Palazzo dell'Accademia

35 *View, on the Via del Corso, of the Palace of the [French] Academy*

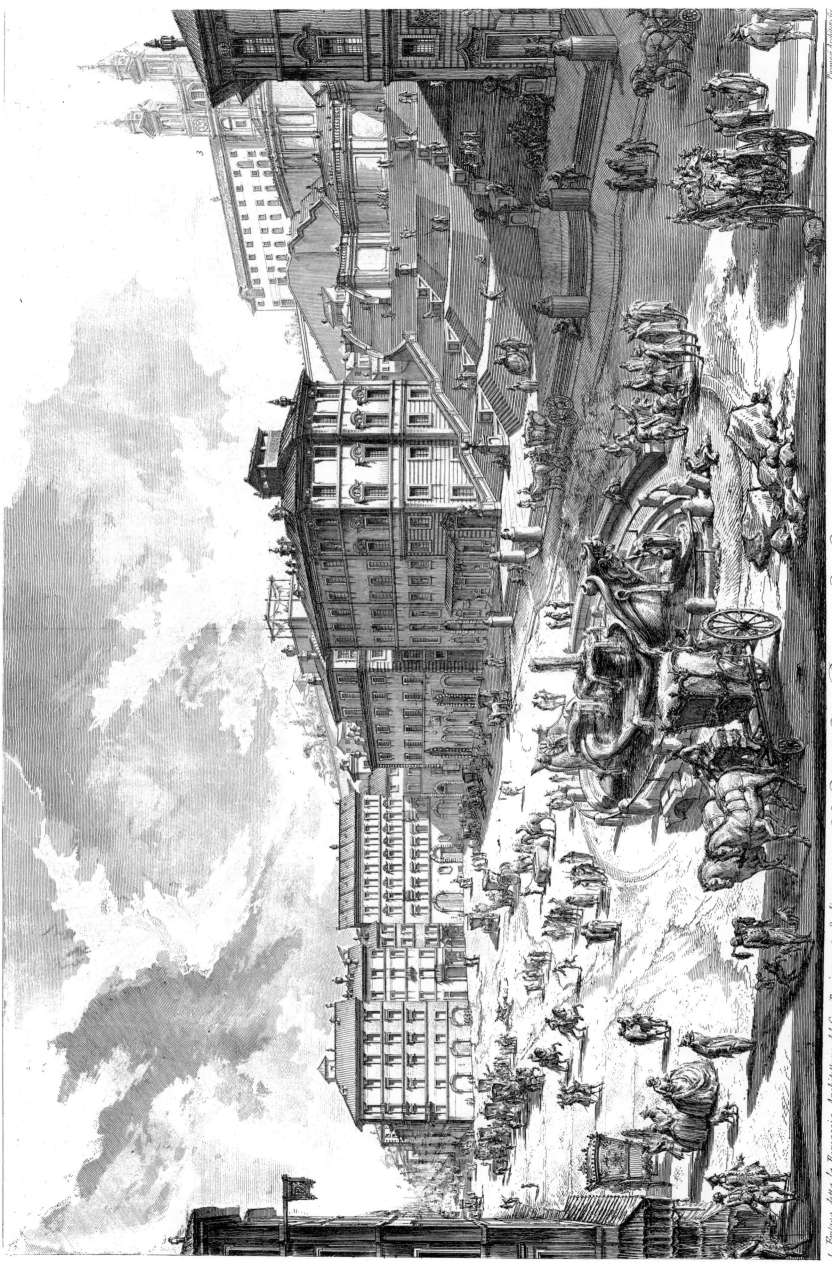

Veduta di Piazza di Spagna.

1. Fontana, detta la Barcaccia, Architettura del Cav. Bernino.　2. Scalinata,
che conduce sul monte Pincio.　3. Chiesa col monastero della SS. Trinità de' monti
officiata dai Frati Minimi di S. Francesco di Paola della Nazione Franzese.　4. Strada
del Babuino, che va' alla Porta del Popolo.　5. Obelisco stulla Piazza del Popolo.

Presso l'autore a strada Felice nel palazzo Tomati vicino alla Trinità de' monti

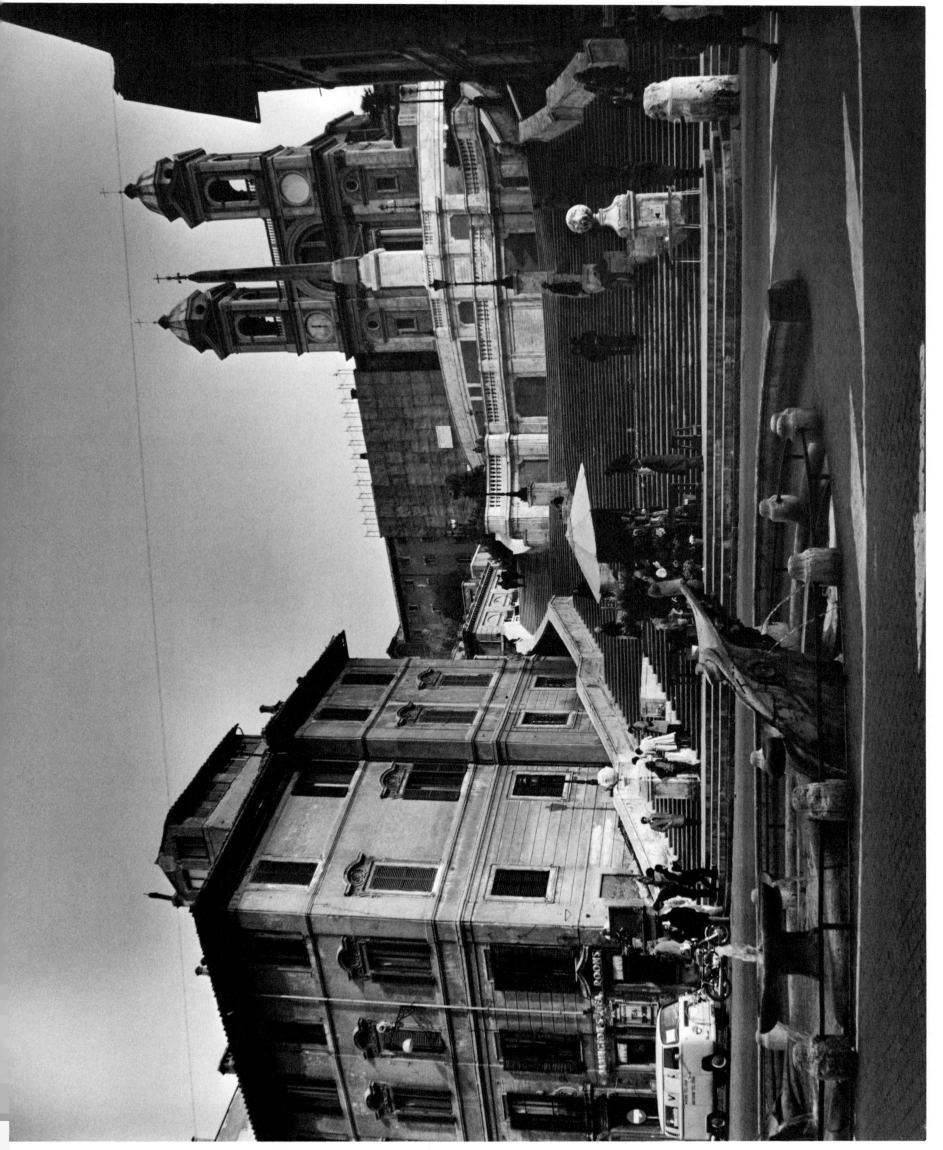

36 *View of the Piazza di Spagna*

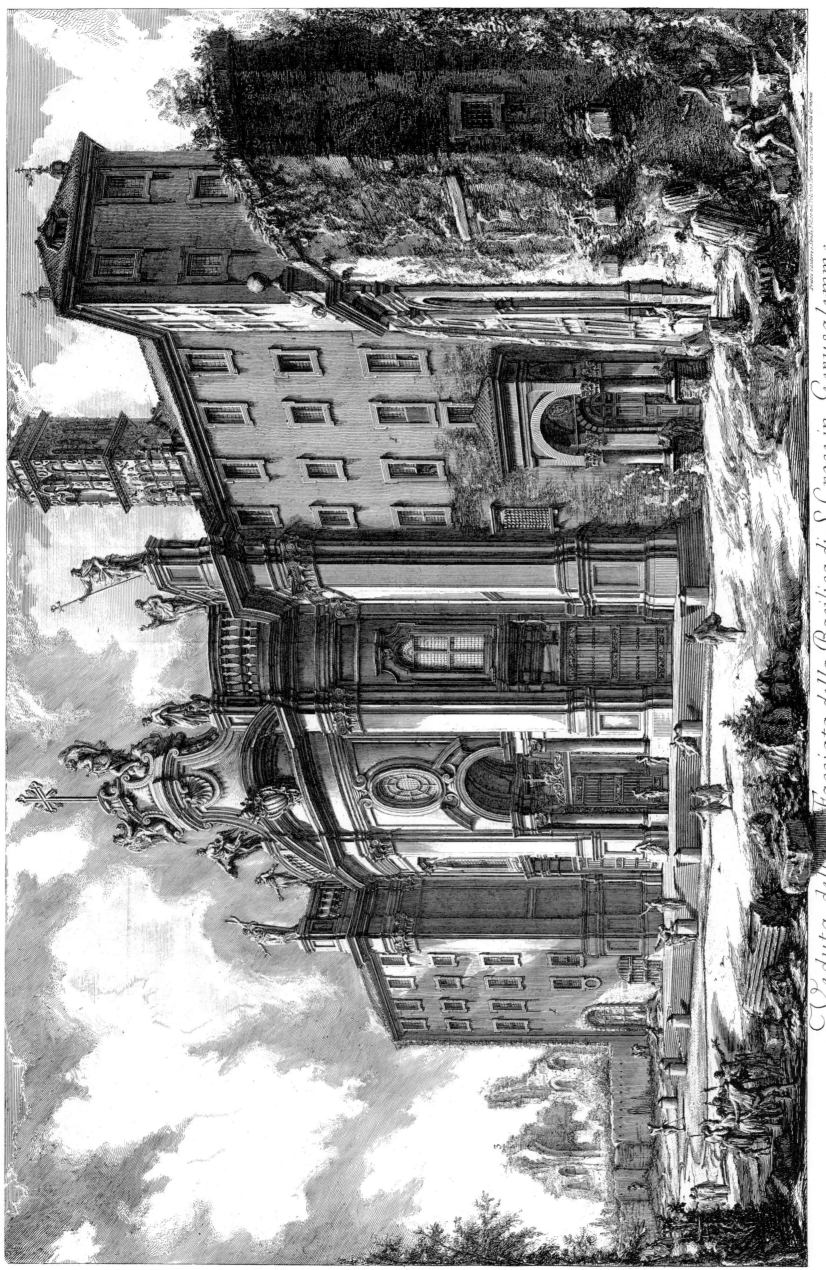

Veduta della Facciata della Basilica di S. Croce in Gerusalemme

1. Monastero de' Monaci Cisterciensi. 2. Muro moderno fabbricato sulle rovine dell'Anfiteatro Castrense. 3. Avanzi del Tempio della Speranza Vecchia.

cavat. Gio. Batista Piranesi Architetto dis. edine.

37 Veduta della Facciata della Basilica di S. Croce in Gerusalemme

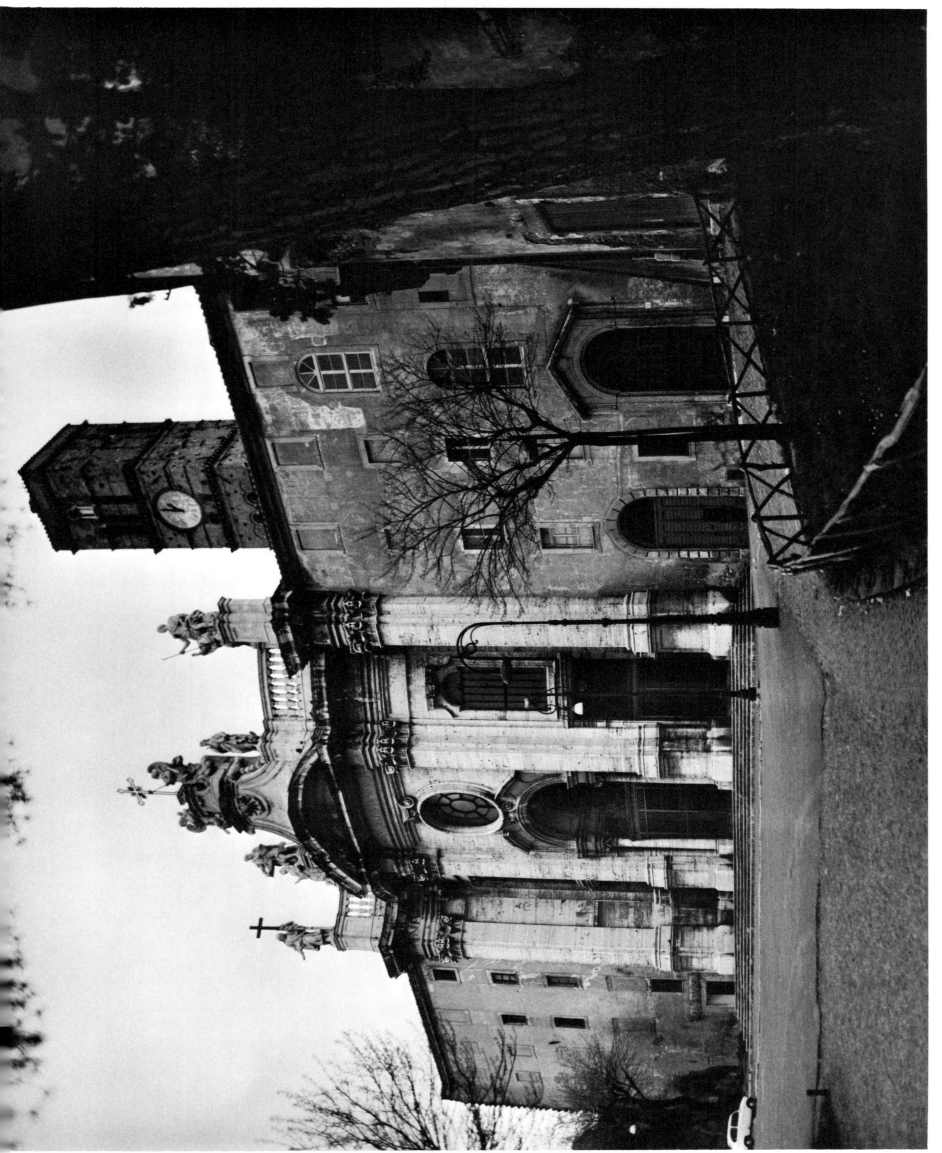

37 *View of the Facade of the Basilica of the Holy Cross in Jerusalem*

Cavalier Piranesi F.

Veduta in prospettiva della gran Fontana dell'Acqua Vergine detta di Trevi Architettura di Nicola Salvi

Veduta in prospettiva della gran Fontana dell'Acqua Vergine detta di Trevi

38

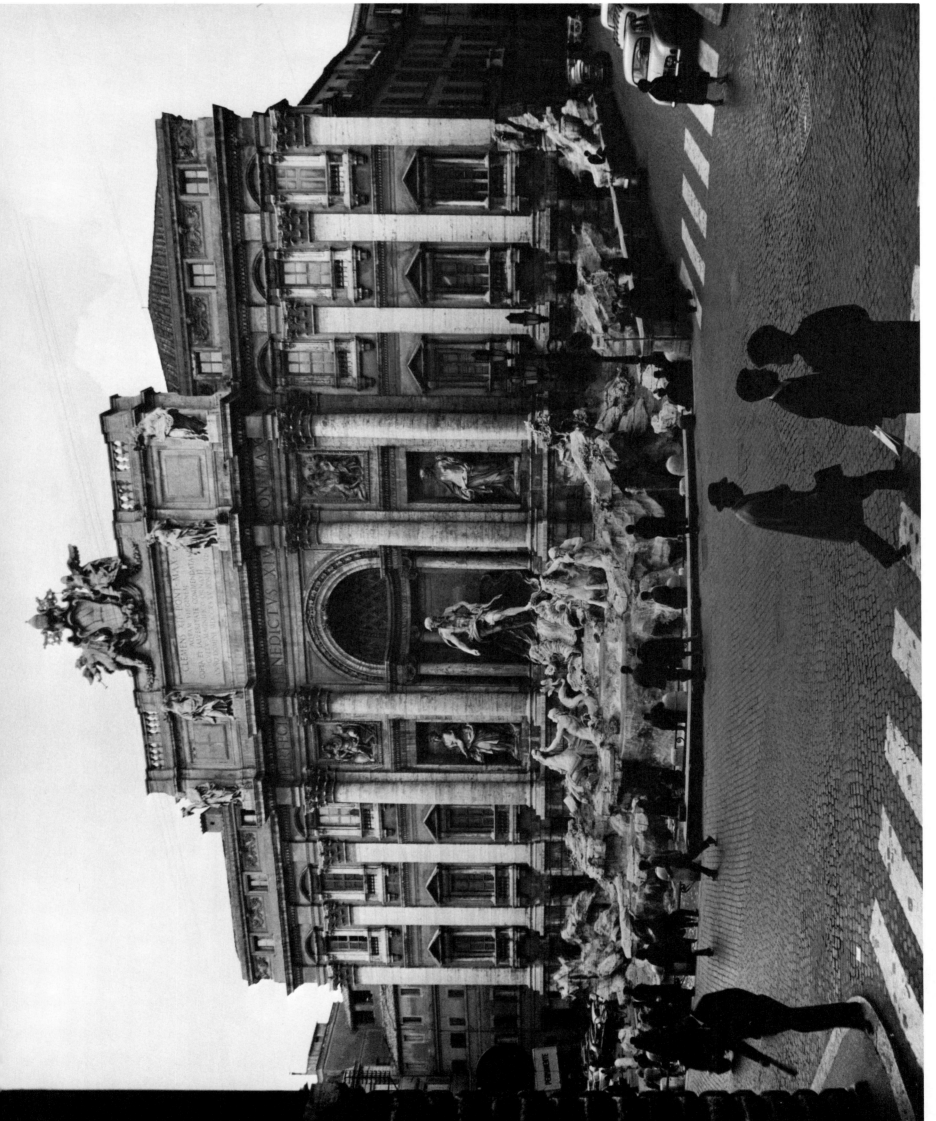

38 *View in Perspective of the Great Fountain of the Aqueduct of the Virgin, Called the Fontana di Trevi*

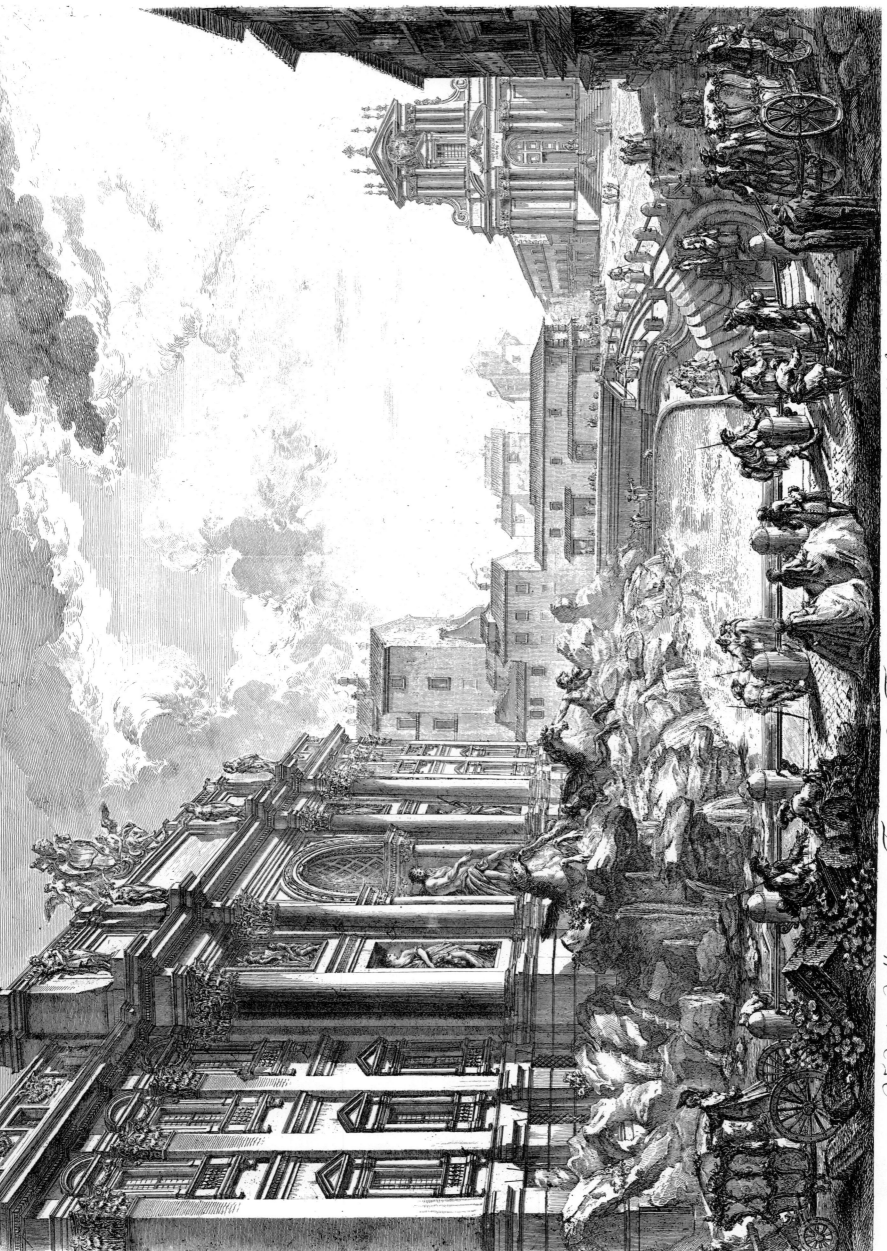

Veduta della vasta Fontana di Trevi anticamente detta l'Acqua Vergine.
Architettura di Nicola Salvi

Veduta della vasta Fontana di Trevi anticamente detta l'Acqua Vergine

39

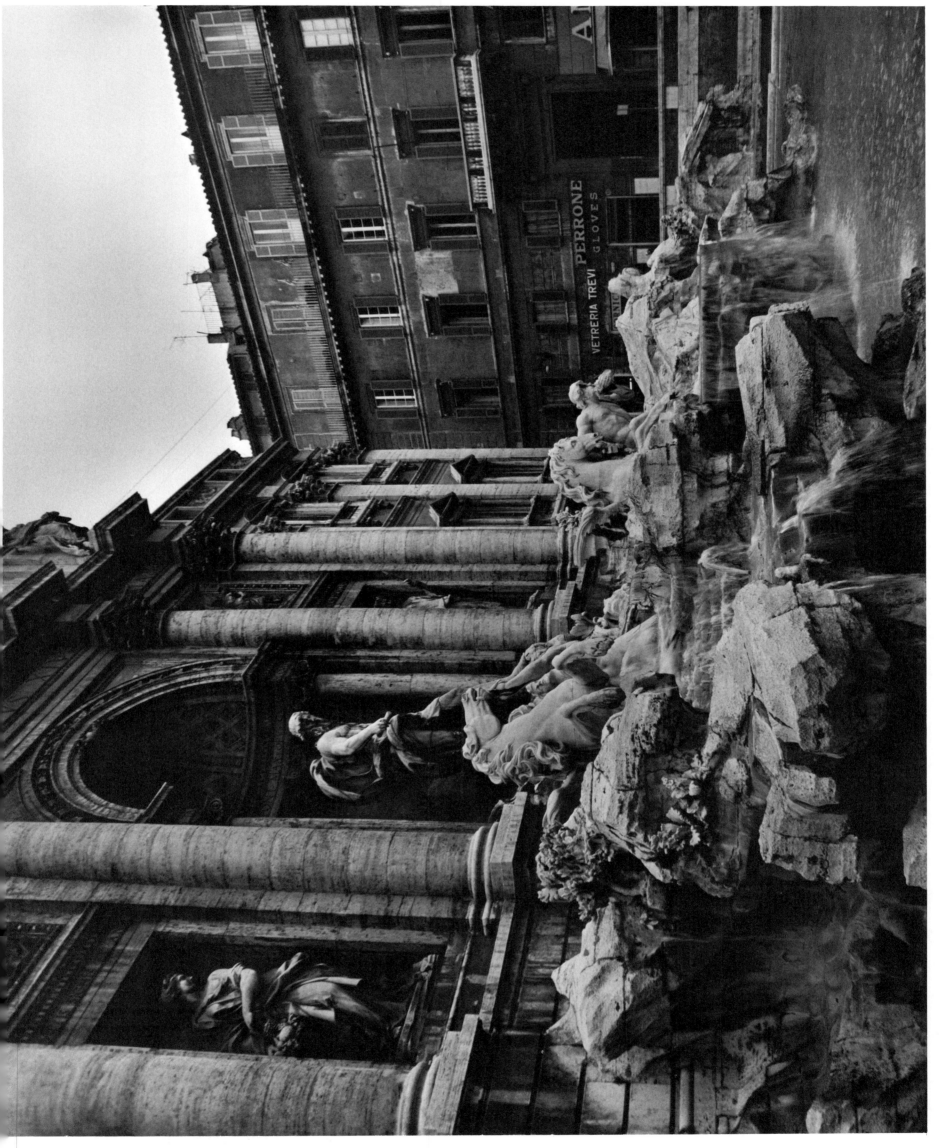

39 *View of the Vast Fontana di Trevi, Formerly Called the Aqueduct of the Virgin*

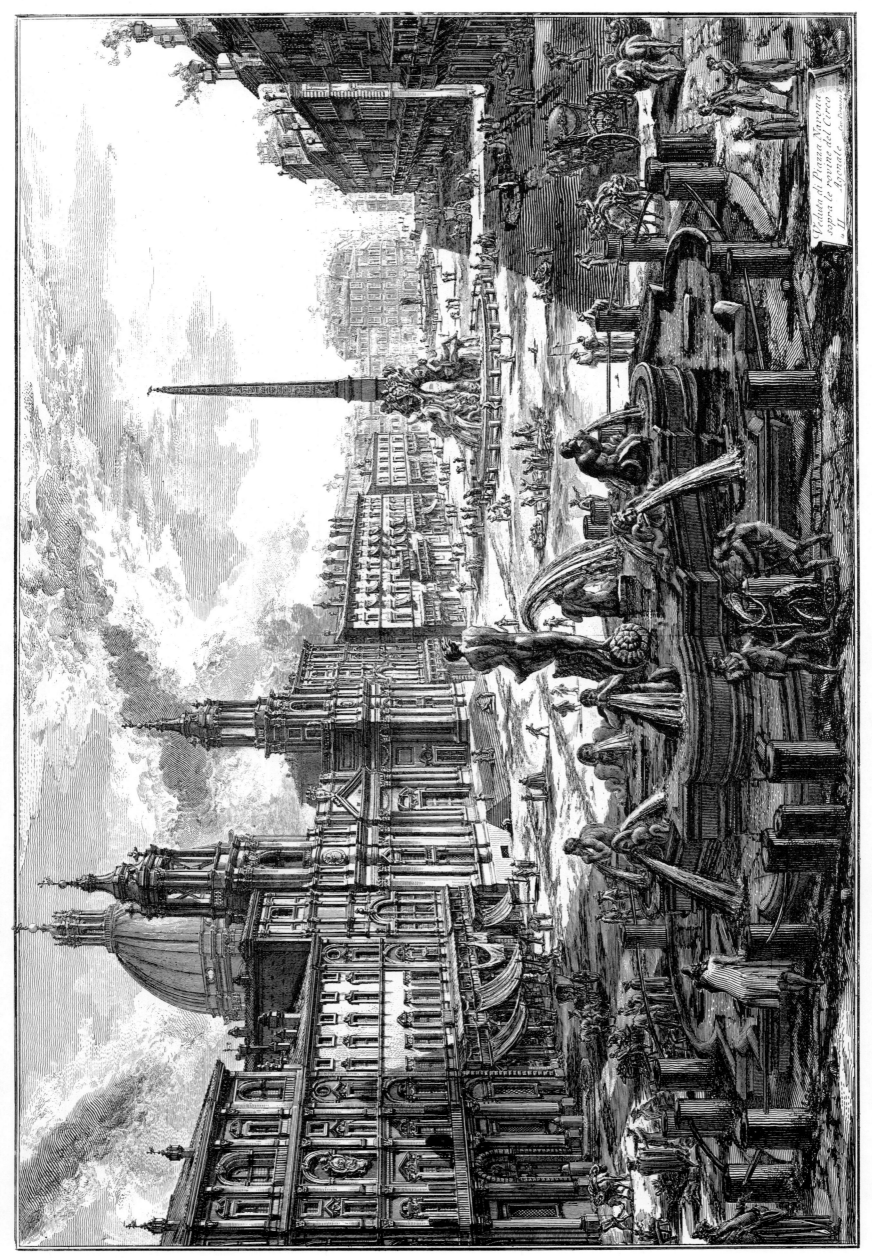

Veduta di Piazza Navona sopra le rovine del Circo Agonale

40

40　　*View of the Piazza Navona above the Ruins of the Games Stadium*

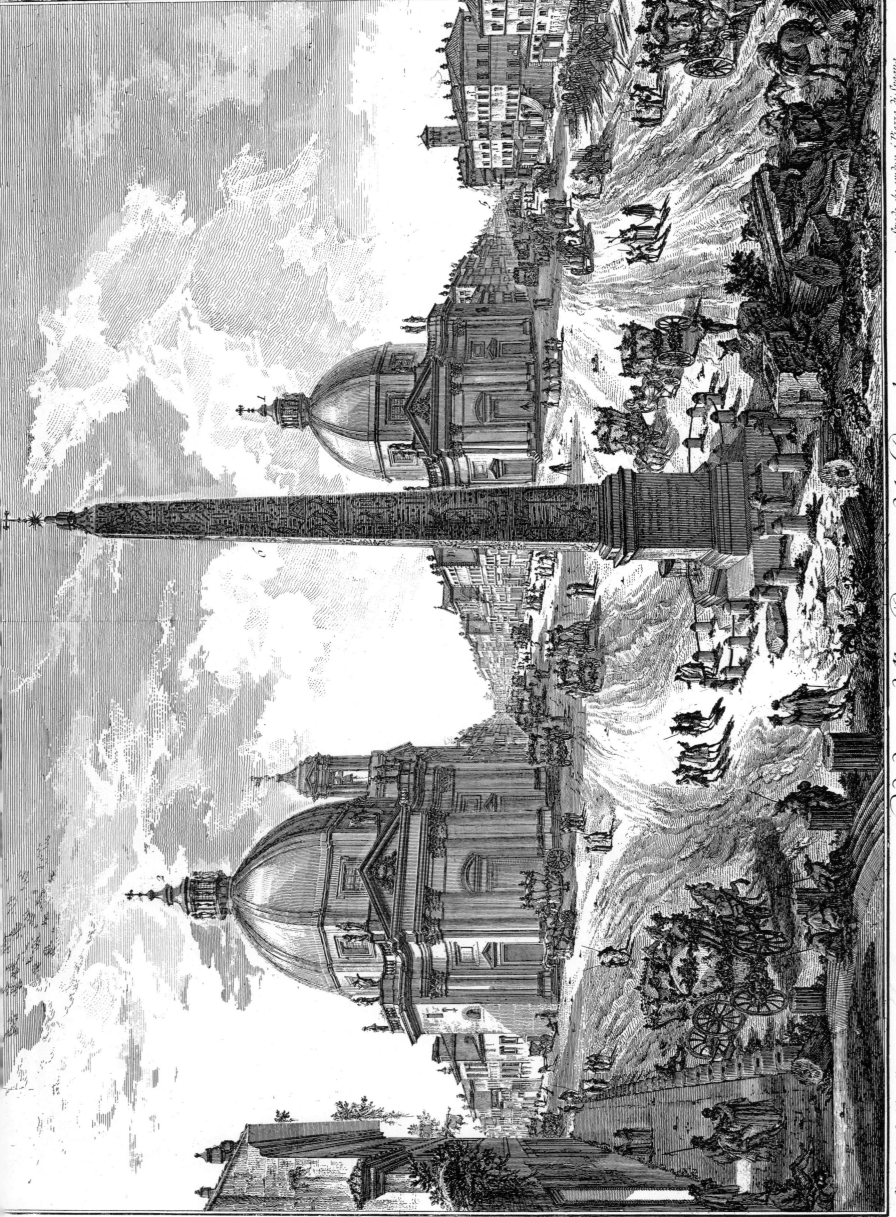

Veduta della Piazza del Popolo

1. Chiesa di S.M.S. Miracoli
2. Chiesa di S.M.S. Monte Santo
3. Strada del Corso, che conduce al Palazzo di Venezia

4. Strada, che conduce a Piazza di Spagna
5. Strada, che conduce al Porta di Ripetta
6. Guglia Egizizia inalzata in Città V.
7. Fabbriconuova Strada Felice vicino alla Trinità di Monti

41 *View of the Piazza del Popolo*